PICTURE PERFECT PRACTICE

A Self-Training Guide to Mastering the Challenges
of Taking World-Class Photographs

ROBERTO VALENZUELA

New
Riders | VOICES THAT MATTER™

PICTURE PERFECT PRACTICE: A SELF-TRAINING GUIDE TO MASTERING
THE CHALLENGES OF TAKING WORLD-CLASS PHOTOGRAPHS
Roberto Valenzuela

NEW RIDERS
1249 Eighth Street
Berkeley, CA 94710
510/524-2178
510/524-2221 (fax)
Find us on the Web at www.newriders.com
To report errors, please send a note to errata@peachpit.com
New Riders is an imprint of Peachpit, a division of Pearson Education

Acquisitions Editor: Ted Waitt
Developmental Editor: Nolan Hester
Production Editor: Lisa Brazieal
Interior Design: Mimi Heft
Compositor: WolfsonDesign
Indexer: James Minkin
Cover Design: Mimi Heft
Cover Photography: Roberto Valenzuela

ISBN-13 978-0-321-80353-5
ISBN-10 0-321-80353-1

9 8 7 6 5 4 3

Printed and bound in the United States of America

DEDICATION

I want to dedicate this book to my beautiful mother, who worked day and night to feed us and put a roof over our heads when life dealt us a bad hand. Without her, I wouldn't be here to write this book.

To my wife and best friend, Kim, your amazing love and constant support are the greatest gifts I have. For every moment I spend with you, I thank God for putting you in my life.

ACKNOWLEDGMENTS

This book was quite the adventure to write. I wrote it in the midst of the busiest wedding season of my life while also teaching workshops and seminars around the world. I dedicated so much time to this book that I owe my wife, Kim, my gratitude for not making me sleep on the couch. Kim has been a pillar in my life, the fuel that keeps me going, and the motivation to keep pushing myself. She has also been the subject of hundreds of my practice sessions throughout my career. The list of how blessed I am to be married to her could go on for 500 pages, so to keep things simple, I want to thank Kim for her patience, unwavering support, and unconditional love. I love you so much, sweetie!

I also want to thank my family, starting with my Mutti, my big bro Antonio, my older sister Blanca, my younger sister Susana, my brother-in-law Kent, my nephews Ethan and Caleb, and my niece Elliana. You guys mean everything to me. I treasure every moment we spend together, and I feel so blessed to call you my family.

I want to send a special thanks to my mother-in-law Christina for reading and editing every single chapter in this book. Thank you for fixing my bad grammar and for making the book read beautifully. This was truly a team effort; I would write and she would fix all my mistakes. Thank you so much, Christina!

My father-in-law Peter has been supporting my endeavors, no matter how crazy they may be. He has always been there providing me with the tools I needed to learn whatever it is I was learning at that time. Thank you Peter!

I want to say that I owe a lot of my success to my friends at Rangefinder (WPPI). Arlene, George, Bill, and Susan gave me the opportunity to launch my international photography teaching career. They believed in me and I will never forget what they did for me. I am forever grateful to them.

The first time I really got to know my good friend Skip Cohen and his wife Sheila will be a night I will never forget. Skip has been an invaluable friend and mentor to me. It is so nice to know that I can count on someone with experience as vast as that of Skip's. No one knows this photographic industry better than him. I am honored to call him a true friend and thank him for writing the foreword to this book.

A big thanks to the best executive editor on the planet, Ted Waitt, for giving me the opportunity to write this book. Also, thank you to the whole team at Peachpit who worked so hard to make this into a beautiful book and get it in your hands.

Last but not least, I want to thank all the beautiful brides and awesome grooms that have allowed me to be a part of their lives by documenting the beginning of their new families. I take my responsibility as your wedding photographer seriously, which is why I constantly try to better myself week after week to record your wedding day the best way I can every time. Thank you for trusting me with your wedding!

ABOUT THE AUTHOR

Roberto Valenzuela is a wedding and fine art photographer based in Beverly Hills, CA. His academic background is in economics and marketing. However, it was his 10 years as a concert classical guitarist that has given him a unique outlook on how to master photography, having used the same practice techniques to master his musical instrument.

Roberto Valenzuela is a multiple international award-winning photographer and three-time international first place winner. He serves as a photography judge for the 16x20 WPPI (Wedding and Portrait Photographers International), PPA (Professional Photographers of America), European photography competitions, and the WPPI International wedding album competition in Las Vegas, NV.

Roberto's private photography workshops and speaking engagements are held worldwide. His goal is to encourage and inspire professional photographers to practice their craft when not on the job, as any artist must in order to perform at an exceptional level. He is an active teacher and platform speaker at WPPI and has served as the keynote speaker at other international photography conventions.

He was named one of the top wedding photographers in the world by Junebug Weddings (one of the largest wedding resource websites in America).

Roberto will not turn down the opportunity to play a good table tennis match, and he flies his high-performance 3D remote control helicopters every Sunday afternoon. He can often be found at local bookstores looking for materials on something new that he wants to undertake.

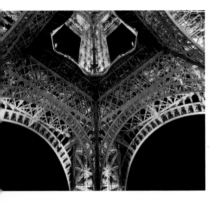

CONTENTS

PART 1: LOCATIONS

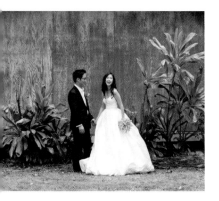

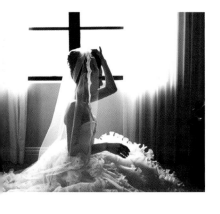

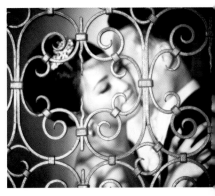

PART 2: POSES

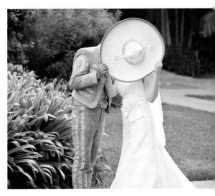

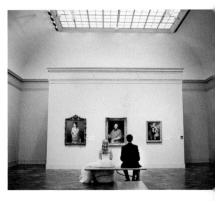

PART 3: EXECUTION

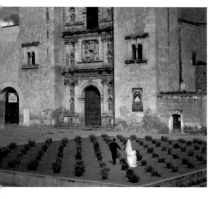

PART 4: DELIBERATE PRACTICE

FOREWORD

By Skip Cohen

The dictionary defines *foreword* as "a short introductory statement in a published work…." If I honestly stick to the definition of the word *short*, this is going to be very difficult to write!

So, let's go with the "introductory statement" part, which is also a challenge. Do I introduce you to one of the finest photographers in the industry? Do I sound objective and not let on that I consider him an incredibly good friend? Even tougher, do I talk about his amazing ability to teach and help so many of us become better, more creative artists?

The reality is that he's all of the above. When he asked me to write the foreword for his first book, it took me less than 10 seconds to answer, "Yes!" Lots of photographers have written books, but only a handful could create this level of genuine excitement for me. All you have to do is attend one of Roberto's programs and you'll understand.

This is no ordinary "how-to" photography book. This is about learning to train your eyes, your heart, and your mind. This is about developing such strong instincts that all the normal challenges in those photographic situations other photographers might struggle with simply become second nature for you.

Being an outstanding photographer covers the full range of what it takes to be a successful artist. Most important of all, it's about accepting and understanding that without constant practice and working to develop your skill set, you can never create the ultimate image.

Imagine a person deciding they were a professional musician simply because they bought the finest trumpet on the market, but they never practiced. How many hours a day do you think Wynton Marsalis practices? Do you think there's a single day that he doesn't practice?

The analogy of a musician is so appropriate because a huge chapter of Roberto's life includes being a classical guitarist. His philosophy as a photographer is no different, especially in his discipline and dedication. In fact, every word except for this foreword has been written by Roberto himself—no ghost writers, no assistants—just Roberto concentrating on the right choice of words to help you develop your true potential.

He was also an outstanding high school teacher, helping to teach his students that their only limitations were their own dreams. His innate ability to teach becomes so apparent in everything he writes and talks about in each workshop.

As you read the pages of this book, think of yourself on a journey. You'll start by visiting ideas on how to see the photographic potential in each location you photograph. The next stop will take you to posing and learning to blend the location, lighting, and the overall scene with the appropriate pose in order to capture a unique feel with each image.

Next comes taking everything from those first two stops on the journey and blending them all together, giving every image the potential for a flawless, stress-free execution. The last stop is developing your own system so you can practice and improve. Remember, your goal on this journey is to be comfortable in every photographic situation.

This is a very special book, but in all honesty, I'm not sure it's really as much about photography as it is about passion. Roberto never compromises on anything, including the quality and intensity of his images.

Jack Canfield, author of *Chicken Soup for the Soul,* is quoted as saying, "If you're passionate about what it is you do, then you're going to be looking for everything you can to get better at it."

Roberto never stops learning and exploring ways to fine-tune his skill set. His passion is virtually unmatched in our industry. So, sit back and enjoy the journey Roberto is about to take you on—a journey to make yourself not only unique, but a stronger, more creative artist.

INTRODUCTION

I wrote this book with a very specific purpose. It is meant to be a self-training guide for teaching yourself how to learn to no longer be intimidated by light, and to understand how to harness its photographic beauty regardless of the time of day, to be able to break down any location in order to find its hidden potential, and finally, to tackle any pose and achieve natural, flawless posing with anyone. If you are holding this book in your hands, the title must have spoken to you: *Picture Perfect Practice*. The word *practice* is an interesting word because it means different things to different people. For me, practice has been a lifestyle. I practice everything I want to learn. I am relentless about it, and it has paid off.

This book is about giving you the tools for scanning any scene and dissecting it for its photographic potential. It will serve you as a training guide where you will learn how to turn ordinary objects into stunning photographic elements. Through deliberate practice, you will learn to be more resourceful with your surroundings and light conditions. Where most see just a white van parked on the street, you will see it as a light reflector. Where people see an average office building, you will see it for its geometry, patterns, symmetry, and reflections, and you will know exactly how to incorporate those characteristics into your photographs. Photography is so interesting to me because it seems like the creative potential is endless.

The pages in this book contain a systematic program I developed out of photographic curiosity. We all know there are some artists out there who can create mind-blowing photographs anywhere and anytime. I wanted that ability! I have great respect for the art of photography because, to me, it allows you to create visual magic. But photography is like an untamed horse; if you don't have a system, the patience, and the dedication required to understand it, it will run away from you and leave a complete mess behind. But if tamed, it will reward you more than you could imagine. It was from this passion and desire that the learning system you are about to read was created.

Remember to keep a camera, a lens, and a flash readily available around your house so you can quickly practice a technique at a moment's notice.

I hope you enjoy this book. The pages that follow will prepare you to recognize photographic potential anywhere, react to it seamlessly, and execute your vision. I feel confident saying that if you complete the exercises in this book, your photographic vision and creativity will exponentially increase.

Have fun and good luck!

HOW TO READ THIS BOOK

If, with one word, I had to answer the million-dollar question I have been asked so many times—"How does one become a better photographer?"—I would have to say that the key to becoming an expert at anything boils down to one thing: practice! And not just practice, but *deliberate* practice. There is a considerable difference between the two. One will get you nowhere, and the other will change your life!

This book is best read cover to cover. I wrote the book with principles and techniques that will build upon each other as your knowledge and skill set increase. Once you have read the book, it will serve as a reliable reference guide for what to do in many problematic situations.

My main focus for this book is you! Throughout the book, I purposely chose photos that contained teaching substance. I was not interested in only showing you beautiful photography and telling you how I did it, or what camera settings were used. My desire is to take you through my thought processes, walk you through the necessary steps that go into creating remarkable photographs, and teach you how to become your own critic. Then, *you* see where there is room for improvement and how to achieve it.

The book is based upon a method where we will take a very detailed look at how to recognize the photographic potential of locations using the Location chart, a systematic approach to posing people using the Posing chart, and the technical and artistic execution of both charts combined using the Execution chart. All three charts work together like an orchestra to create beautiful photographs. But the entire system depends upon you actually practicing what you are learning. The deliberate practice section of this book will teach you how to correctly implement deliberate practice techniques and to maximize learning for every practice session.

Keep in mind that photography is subjective, and you might not agree with all the material in the book. The book is intended to give you a different perspective, so read it with an open mind. In art, nothing is set in stone. But this system I created has worked incredibly well for me, and it has been largely responsible for my successful career. My hope is that you find this book helpful, as well.

IS THIS BOOK ONLY FOR WEDDING PHOTOGRAPHERS?

No. This book is for photographers who photograph people. It is about giving you the tools and mindset to take remarkable photographs at any location, regardless of its aesthetic appeal. It will teach you how to break down a pose to create natural, finessed, and confident portraits, regardless of who is in front of your lens. I am a wedding photographer, so naturally many of the portrait and posing examples shown were photographed at weddings all across the world. Nonetheless, if you photograph children, high school seniors, lifestyle portraits, couples, fashion, travel or weddings, the principles taught here can be seamlessly applied to any form of people photography. As long as there is a person in front of your camera, this book is for you.

WHY DO I REPEAT PHOTOGRAPHS THROUGHOUT THE BOOK?

As you read through the chapters, sometimes you will notice the same photo appearing two or three times. This is because I ran out of photos to put in the book. Okay, I'm just kidding! It's actually because the principles of my teaching method build upon each other. Therefore, as you are learning the principles from all three charts, it is best to see them applied to the same photograph. This way, you can see the building blocks coming together to create artistic photographs that you will be very proud of.

THE LOCATION, POSING, AND EXECUTION CHARTS

These are the three charts that the whole book is based on. My system was designed to use the Location, Posing, and Execution charts together to best help you see what others don't when you are location scouting, creating and finessing natural poses, and putting together the building blocks to execute your best work yet! I carry these three charts with me everywhere I go.

LOCATION CHART

Geometry	Balance	Parallel Lines	Symmetry	Color Elements	Depth
Shadows	Silhouettes	Reflections	Patterns/Repetitions	Frames	Contrasts
Lens Flare	Paintings	Art Pieces	Translucent Surfaces	Walls	Textures

POSING CHART

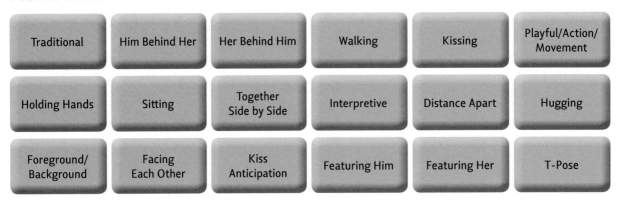

Traditional	Him Behind Her	Her Behind Him	Walking	Kissing	Playful/Action/Movement
Holding Hands	Sitting	Together Side by Side	Interpretive	Distance Apart	Hugging
Foreground/Background	Facing Each Other	Kiss Anticipation	Featuring Him	Featuring Her	T-Pose

EXECUTION CHART

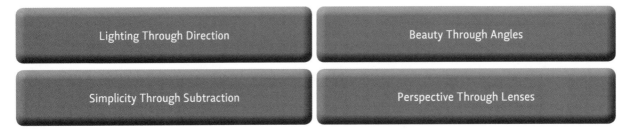

| Lighting Through Direction | Beauty Through Angles |
| Simplicity Through Subtraction | Perspective Through Lenses |

LOCATIONS

1

GEOMETRY

IT HAS TAKEN many years and thousands of photos for me to truly understand the hidden power of the geometric shapes present in our environment and the influence they have on a photo's overall impact.

You probably recall playing games as a child where you had to match the little plastic geometric shapes to their corresponding gaps. The plastic balls and the little wooden cars that we played with are all made of geometric shapes. Our eyes have been trained to immediately recognize these shapes. As adults, we are exposed to so much visual stimuli competing for our attention that our brains cope with this by selecting to see only what's important to us. Everything else becomes lost in the noise, including geometric shapes. It is our job as photographers to be able to see what most people cannot.

MOST POPULAR GEOMETRIC SHAPES IN OUR ENVIRONMENT

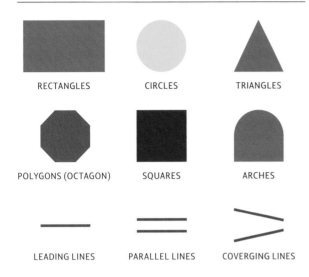

RECTANGLES CIRCLES TRIANGLES

POLYGONS (OCTAGON) SQUARES ARCHES

LEADING LINES PARALLEL LINES COVERGING LINES

1.1 The most common geometric shapes around us.

Some of the most obvious shapes are squares, rectangles, triangles, circles, lines, and arches (**1.1**). Then, we also have secondary shapes, which are the different types of polygons. Geometric shapes are so powerful that the very design of our camera's viewfinder is a rectangle. One of the reasons geometric shapes play such a strong role in the aesthetic qualities of a photograph is because we have been exposed to them since our earliest memories.

Thus, to see what shapes make up the everyday objects in our world, we must reach back into our child psyche. A dining room table becomes just a rectangle, a beach ball or an umbrella are now spheres and circles, power lines on the road are just converging lines, a window frame is a group of squares, and the front doors of our neighbors' houses are rectangles. Look at your surroundings right now. Wherever you are, start seeing objects around you as geometric shapes.

Take a look at image **1.2**. I was walking on a little street in Segovia, a small town near the center of Spain. I walked passed countless stores and picturesque houses. Nothing grabbed my attention as much as this scene. Even though I tried to ignore it, that random green square floating around the stucco wall just demanded my attention.

1.2

As you can see in **1.3**, there are other random shapes created by dirt or discoloration of paint. Because we can't exactly describe those shapes, our brains ignore them. But it is practically impossible to ignore that green square. Here are three techniques you can use when encountering geometry in a scene. Let's look at geometry for framing, geometry in the environment, and geometry for balance.

GEOMETRY FOR FRAMING

Framing subjects with geometric shapes is a great way to start implementing geometry in your work. We are all familiar with the traditional portrait of a bride standing indoors looking out the frame of a door. This is an example of using a rectangle for framing. You can also use a circular window to frame your subject. The list goes on.

In image **1.4**, I composed my shot to create a frame around the bride and her mother using the rectangular window frame, as if they were an actual painting inside the frame. I also quickly noticed that this scene is made up of many rectangles. The two vertical columns make up two vertical rectangles. The wooden railing in the

THE DARK SIDE OF GEOMETRY

Geometric shapes are a double-edged sword. Although they can be an asset to your work, they can also be a detriment. If the geometric shape repeats itself across the photograph, it becomes a style or a pattern that is easy on the eye. But if you have an easily recognized geometric shape in a random place in your frame, it will no doubt draw your eye to it, no matter where or who your main subject is.

Think of it like watching a cluster of clouds across the sky. When they take on a random shape, you don't really think anything of it. But as soon as a cloud takes the shape of something you recognize, such as a square or a circle, you can't help but look at it and acknowledge the shape. Try to avoid having a random floating geometric shape in your frame, unless you are using the geometric shape as a balance point in your composition.

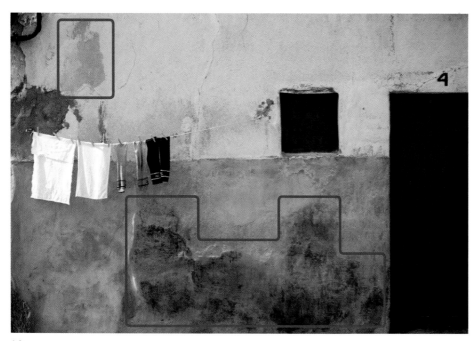

1.3

front is pretty much nothing but rectangles. The wall supporting the window frame is also a rectangle, and the whole photo is a rectangle. Note that had I not kept my camera's viewfinder parallel to the top and bottom of the scene, many of the rectangles would have disappeared and several right-angle triangles would have been introduced, destroying the composition (**1.5**). Not tilting your camera is important when framing with geometric shapes.

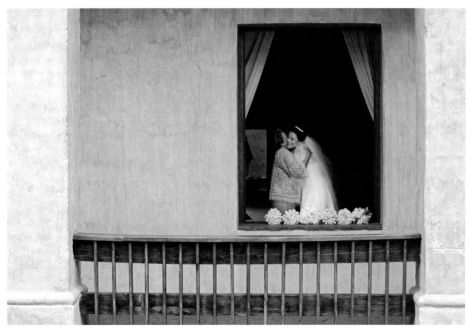

1.4

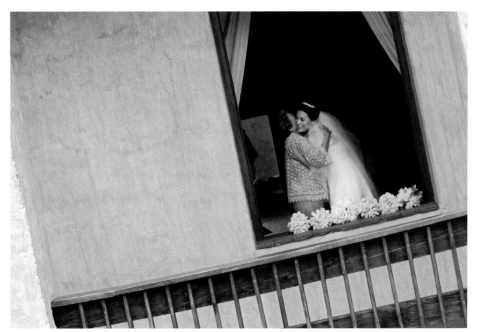

1.5

GEOMETRY IN THE ENVIRONMENT

The key to using geometry in the environment is to differentiate good geometry from bad. This is subjective because the possibilities are endless. However, I use a little trick to help me find good geometry.

Find geometry that is arranged in patterns. For example, look for five circles together, 20 triangles side by side, or a cluster of rectangles. In **1.6** you can see an example of using good geometry in the environment. This scene is composed of a pattern of rectangles. Some are horizontal and some are vertical. I carefully placed the groom so his head would be in the middle of a clear window and not intersecting a frame. Otherwise, in the photo he would have a metal pole coming out of his head. That position also allowed me to take advantage of the mirror to my left. This serves two purposes: the geometry creates eye candy throughout the photo, and the reflection balances the photo beautifully. Combining compositional elements in this way is the key to becoming a great photographer.

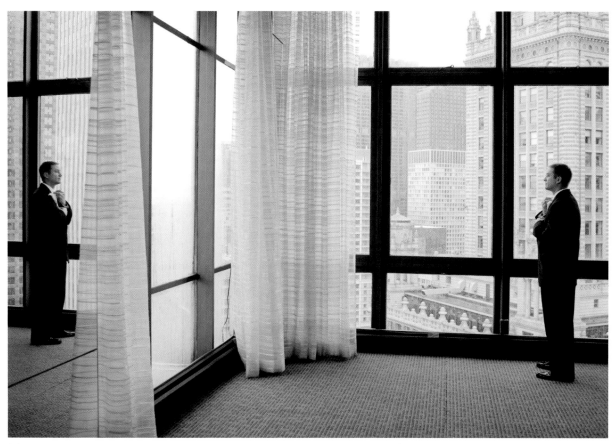

1.6

My photo of the famous Zakim Bridge in Boston offers another example of environmental geometry (**1.7**). Although the bridge is pretty much two big triangles, it can be difficult to see that because the suspension cables hang so far apart that the sky between them breaks up the pattern. To showcase the geometry, my wife Kim drove the car at 60 mph across the bridge while I took the photo from the sunroof. I used a slow shutter in order to close the gap between each cable, giving me a perfect triangle.

1.7

GEOMETRY FOR BALANCE

Using balance is a great way to harness the visual power of geometry. Remember that geometry is easily recognizable to our brain. It will demand attention in your photographs. Therefore, balancing geometry with your subjects will ease the weight of the side containing the geometry.

For example, consider a photo I took during the spring in Paris (**1.8**). As I walked along the Seine River, I noticed a couple cuddling and enjoying the sun together. Then, the circular lamps over the river caught my attention, so I kept walking forward. I wanted to find the perfect spot where I could balance the two, creating a much more interesting composition. Had I not included the lamp, the photo would have been flat and dull. Keep your eyes open wherever you go, and make a mental note every time you see good geometry that you can use in your photographs.

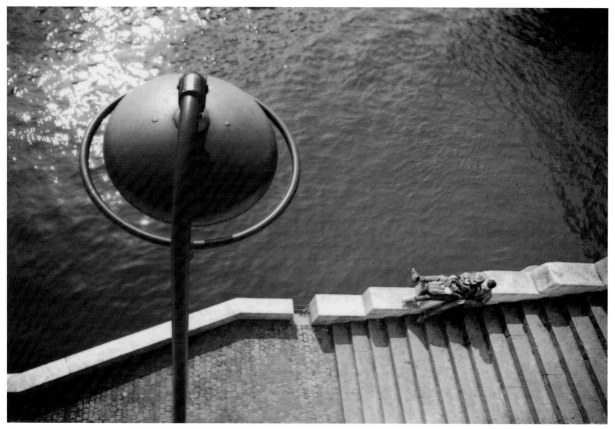

1.8

PUTTING IT ALL TOGETHER

Let your eyes wonder around image **1.9** and spot all the elements that we just talked about. The six arches on the sides of the couple gives us our geometric pattern, with exactly three arches to the left and three arches to the right, making the photo balanced. Finally, the middle arch frames the couple.

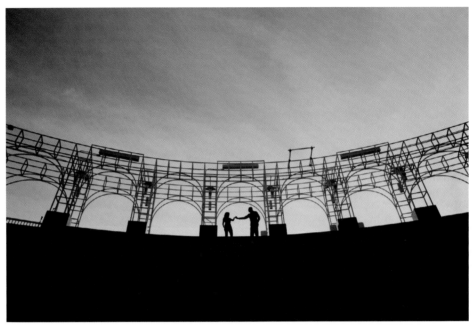

1.9

EXERCISE:
FINDING GEOMETRIC SHAPES

Exercise: Using any camera available to you, look around you and, ignoring everything else, concentrate on finding:

- Squares
- Rectangles
- Circles
- Triangles
- Converging lines

To get the most out of this exercise, try to find 5–10 of each shape, but do so in order. First look for just squares, ignoring everything else. Once you have reached your 5–10 goal, then move on to just rectangles, and so on.

Goal: 5–10 photographs per shape.

Explanation: This is kind of like "Where's Waldo?" but you are training your eyes to see shapes that they otherwise would completely ignore. By doing so in order, you keep your brain focused on a specific task. We are teaching our brains to ignore the thousands of distractions around us and to do only what we ask, nothing more and nothing less. Implementing geometric shapes into my work has yielded some of my most visually powerful photographs.

2

BALANCE

PHOTOGRAPHIC BALANCE is one of many compositional techniques available to you. Not to be confused with the rule of thirds, balance is a technique in and of itself. To use balance in a photo, practice how to harness the best balance properties of any location. This goal is easier said than done.

If you have too many elements on the right side of your photo, the "photographic scale" will tilt to the right, leaving the left side empty. If you place points of interest evenly across the frame, you will automatically achieve visual balance. Balance techniques are very subjective. As with all art, there is no right or wrong way of doing things. However, you can take advantage of techniques to make the overall feel of your photography more balanced. Ready to dive in?

On location, you are faced with thousands of objects around you. These objects come in all shapes, sizes, and colors. Figuring out how to achieve balance can be daunting. So let's break it down into three major components:

- Balancing with people (any person or people in your frame)
- Balancing with objects (any dominant tangible objects in your frame)
- Balancing with space (everything else: open area, negative space, landscape, etc.)

For a photo to be balanced, you don't need the objects to look similar—you just have to distribute their weight more evenly through the image. Balance is an issue of weight distribution. Let's take a look at some examples to better explore the various ways you can achieve balance.

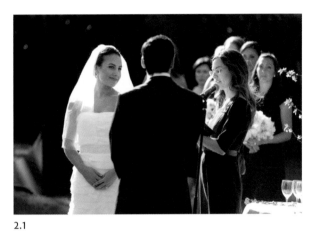

2.1

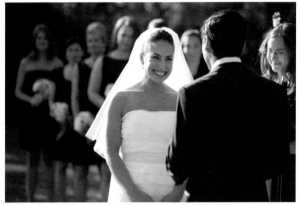

2.2

BALANCING WITH PEOPLE

Take a close look at **2.1**. Although at first sight the image looks good, it is not well balanced. There is too much "people weight" on the right and not enough on the left. Now take a look at **2.2**. I took a few steps to the left to improve the distribution of people in my frame. By making a small adjustment of my angle in relation to the bride, I was able to position all the bridesmaids on the left of the frame, and then balance their weight with the bride and groom on the right side of the frame. The result: a much more balanced photograph.

BALANCING WITH OBJECTS

Balancing with objects is a lot of fun, but it can be a little confusing. The tricky part is deciding which object(s) to use. Sometimes there is no question about what object to choose, because there is only one. Let's say it's a lonely tree on top of a hill. Put the tree on one side of the frame and your subject(s) on the other, and you're done.

But what happens when you have tens of objects to choose from, all with different shapes and colors and sizes? Now how do you balance your image? If the objects you should use as balance don't quite jump out at you, ask yourself these five questions.

FIVE KEY QUESTIONS FOR CHOOSING A BALANCE POINT

1. **Which object is the biggest and/or most dominant?** If you remove the groom getting ready from image **2.3**, the painting of Gandhi is clearly the most dominant object in the frame. So I chose the painting as my point of balance, with Gandhi on the right and the groom on the left. Notice how the photo is nicely balanced.

2. **Which object is the brightest?** I took this photo (**2.4**) in Beijing while taking a stroll down the street. I noticed the two men sitting in front of the little store, but my eyes

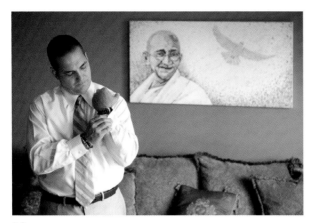

2.3

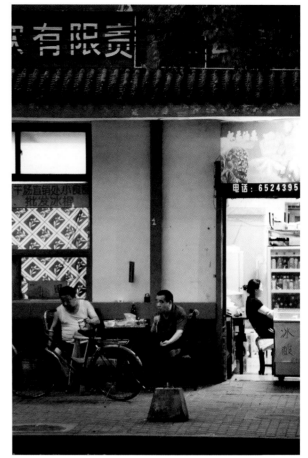

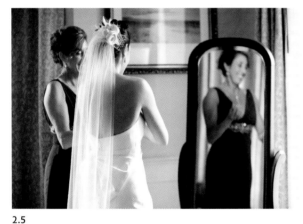

2.5

2.4

were drawn to the bright light coming from the inside where the woman was sitting. I zoomed in using my 70–200mm f/2.8 to balance the men on the left with the woman in the bright room on the right. That bright room by itself would be far too dominant, so the two men on the left do a nice job of balancing it out.

3. **Which object has the most dominant vertical lines?** This technique is trickier to spot, but hopefully with this example, it will make a bit more sense. Seconds before I took image **2.5**, I quickly glanced all around my viewfinder to find my balance points. I spotted the vertical line made by the right edge of the mirror. That vertical line became my balance point of choice. Vertical lines from objects create dividing lines. These lines, if balanced properly, can be very flattering to your composition, or if ignored, they will turn into a strong distraction. Notice how the vertical line made by the mirror is parallel to the right edge of the photograph. Also notice how the distance between the right side of the mirror and the right edge of the photograph is close to the distance between the left edge of the photograph and the mother of the bride. Both of these techniques create balance.

2.6

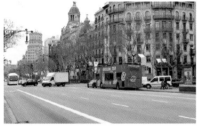

2.7

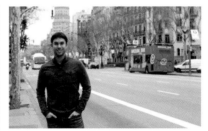

2.8

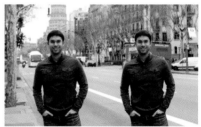

2.9

4. **Which object(s) create a pattern?** I chose this example to show how although patterns exist everywhere, spotting them is not always easy. In **2.6**, the pattern is created by the three figures on the right. There are only three elements, but it's still a pattern. Once I located the pattern on the right, I positioned the bride and groom on the left to balance the photograph.

5. **Which object has the most contrast?** When looking at image **2.7**, if you close your eyes for a second and then reopen them, you'll notice your attention is drawn to the bright red Barcelona tour bus. Although there is a lot happening in this scene, the red color of the bus overpowers the rest of the scene's neutral color palette. Because of the high-contrast color of the bus, it became my balance point of choice. I asked my wife to take a photo with the bus on the right and me on the left to balance the photograph (**2.8**). Let's take a look at what would have happened had I not noticed the high-contrast color of the bus and had stood to the right. The photo automatically becomes right-side heavy (**2.9**). It feels instinctively wrong.

HANDLING MULTIPLE BALANCE POINTS IN ONE SCENE

As you are reading, you may be asking yourself, "If any given scene has multiple balance points with many of the five characteristics discussed, how do you know which of the five to follow?" The answer can be quite subjective, but I suggest you look for the object that demands the most visual attention.

Practice spotting objects with the five balance characteristics everywhere you go, and identifying which object best balances your subject(s) will become increasingly automatic. For example, consider the following scene in Donegal, Ireland (**2.10**). There is nothing special about this scene, but if you look carefully, you will spot objects with all five balance characteristics. Instinctively, my eye is drawn to the bright white wall of the house because it's the brightest object in the scene. Therefore, out of all my choices present here, I select the white house as my point of balance (**2.11**).

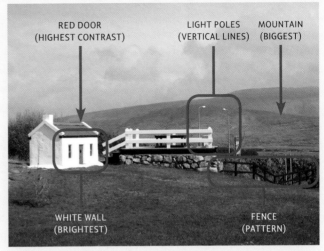

2.10

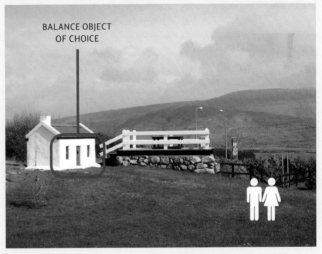

2.11

BALANCING WITH SPACE

Balancing with space is a technique in which you balance your photographs with either people or objects. Think of it as a two-step process. The first step is to balance the photo. The second step is to pay attention to the space between both the left and right edges of your frame and the people and/or objects you are using to balance.

For example, let's say you have two people in your frame; one person is on the left and one on the right. The person on the left is two inches from the left edge of the frame; the person on your right should also be close to two inches from the right side of the frame.

Both distances don't have to be exactly the same, but they should be close. Why is this distance important?

The answer lies in the fact that the edges of our viewfinders work as points of reference. Our brains easily detect any deviation from these reference points. We depend on this space perception to stay in balance ourselves, so it is very sharp. Pay special attention to the division of space in the frame before pushing that shutter button.

Let's take a look at an example (**2.12**). Here, I used the hanging wedding dress on the left and the bride getting her makeup done on the right to balance the frame. As you can see, the distance between the dress and the left edge is 2.1 inches and the bride's chair and the right edge is 2.2 inches. As I said before, the distances don't have to be the same; close enough will get the job done.

In contrast, look at image **2.13**. In this photo, the distances are far from equal. You almost want to pan the camera to the right to even it out but you can't. This imbalance makes the photo uncomfortable to look at.

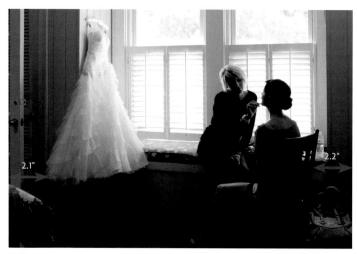

2.12

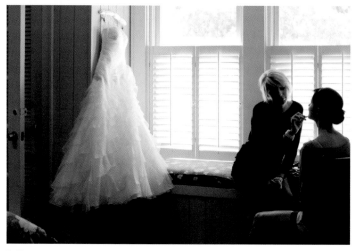

2.13

EXERCISE:
ALTERING YOUR ANGLE FOR BALANCE

Exercise: Find a mirror around your house. (A bathroom or a vanity area with a counter works well.) Stand in front of the mirror and place an object on the right side. Make sure you can see the object and its reflection and take a photo (**2.14**).

Now take a couple of steps to the left while looking through the viewfinder. Notice how as you move left, the object's reflection appears on the left side and the object itself on the right. Take another photo in this position. You have now achieved balance (**2.15**).

You can do the same exercise with a couple of apples. On your dining room table, place one apple about 12 inches in front of the other. The closest apple acts as a subject or a cluster of people, and the apple in the rear acts as another person or cluster of people (**2.16**). Now, with your camera's viewfinder in front of your eye, start moving to the left or the right until one apple is on the left and the other is to the right of your frame (**2.17**).

Move left or right enough so that each object is the same distance from the viewfinder's closest vertical edge. For example, if the left apple is 2 inches from the frame's left edge, the right apple should also be about 2 inches from the right edge.

Goal: Balance several pair of items around your house or office.

Explanation: A slight movement by you can go a long way in balancing a photo. The apples/canta-loupes in my example represent a cluster of people in a scene, and the fruit's reflection represents another cluster of people. By moving left or right, you can place one cluster of people on the left and one cluster of people on the right, thus achieving balance. Naturally, most of you know how to balance photos, but doing it subconsciously every time is a different story. These exercises reinforce what you may already know. By working through them, you will begin balancing automatically rather than having to think about it every time.

2.14

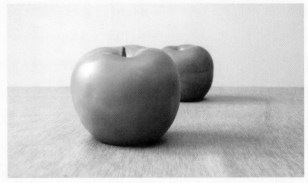

2.15

2.16

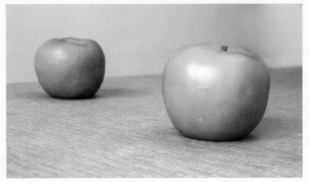

2.17

Exercise: This time, you are going to focus our attention on zooming and panning for balance. If you don't have a zoom lens, you can use a prime lens and zoom by walking. Look for two objects in your surroundings. (It is more fun if you are outside.) Balance the objects by isolating them from the rest of the scene using your zoom. I recommend a 70–200mm lens, or any lens that has a large zoom. You will have to pan your camera around until you see almost equal distances between the two objects and the left and right edge of your frame respectively (balancing with space). Any two objects will do.

Don't worry too much about choosing contrasting objects or strong vertical lines.

Goal: I recommend 20 sets of objects. This is pretty easy to accomplish. You can find 20 or more objects to balance within five minutes of your house.

Explanation: The core skill to grasp here is to isolate any two points of interest by zooming in tight. On a real shoot, you may face a busy scene with people, cars, storefronts, parking meters, and so on. In this chaotic environment, nothing will seem to be balanced. But if you look closely, there are balance points everywhere—as long as you can isolate them from the rest of the scene.

As you can see by these examples (**2.18–2.23**), it doesn't have to be anything fancy. These were taken on a random street as I was walking by. What's important is to be constantly aware of these objects and how to balance them to bring out their photographic potential.

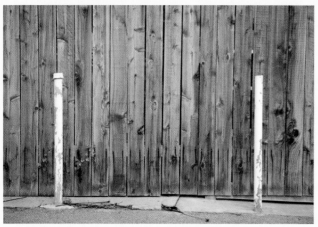

2.18 I found these poles and used them as my balance points. Note how the distance from the poles to the outer edges is almost equal.

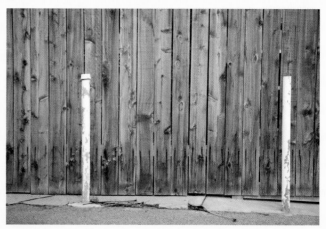

2.19 Here the poles are too far to the right and therefore not centered in the frame.

2.20 The two rectangles at the top are quite noticeable, which is why I used them as my balance points.

2.21 This is the same photo showing what it looks like when no attention is paid to composition or balance.

2.22 This photo was a bit tricky because the tree on the left and the large shadow on the right didn't make compatible balance points. I decided instead to zoom in and use only the tree on the left and balance it with its own shadow.

2.23 Now the photo looks cleaner and balanced. If I were to place a subject here with the photo balanced this way, it would make quite a powerful portrait. This is another example of how you can create amazing photographs in an average location.

EXERCISE:
MOVING OBJECTS AND PEOPLE AROUND FOR BALANCE

Exercise: The goal of this exercise is to get you into the habit of moving your subjects and/or the available objects in your scene to achieve photographic balance. This exercise is similar to "Using Zoom for Balance." This time, you don't need a camera but you do need someone to help you. Position your subject anywhere in a room, and then find one object for each of the five characteristics listed in "Five Key Questions for Choosing a Balance Point" on page 12), and move the object or the person around until you balance both.

Focus on finding good balance points to use for balancing your subject in the frame. Don't worry about lighting or expression—just concentrate on balance.

Goal: Create one photo for each of the five questions for choosing a balance point.

Explanation: Finding objects to match each of the five characteristics will probably not be easy at first. Your eye may not be trained to look for these balancing characteristics. A well-trained photographer will spot them in a heartbeat. So can you.

These objects may or may not all be in the same room, so get into the habit of moving things around when possible to improve your shot. You don't have to accept a room for what it is or what it has in it. There may be more visual techniques for choosing objects as balance points, but I find the tools listed here to be the most common and practical. Even if you don't have a camera with you, try to always ask yourself what object you could choose as a balance point and which of the five questions it answers. Engrave the process into your brain. It will pay off when you are under pressure at a shoot and your eyes are finding endless quality balance points! You will be in complete control and gain your client's trust.

3

PARALLEL LINES

PARALLEL LINES are probably one of the most overlooked photographic elements. When on location, you'll see natural horizontal and vertical lines created in your scene by various objects, such as cars, buildings, fireplaces, the beach, light poles, and other design elements. Some of these objects will have stronger horizontal or vertical lines than others. Line them up with your viewfinder to make them parallel and you will be harnessing their strong visual presence to your advantage.

Don't worry—you will not create any distractions from your subjects. When the lines are parallel, they don't raise a red flag to your eye, and your viewers' attention remains on your subjects as intended. Now, here comes the tough part. If you tilt your camera when there is a strong horizontal or vertical line in your scene, then the opposite will happen. It will create a sense of imbalance. Your subjects will appear to be tilting as if they were about to slide off the photo.

WORKING WITH HORIZONTAL LINES

The most pronounced distraction is the inevitable introduction of a right angle triangle in one of the corners of your photograph. This triangle breaks the harmony created by the parallel lines and it becomes a strong visual distraction. In image **3.1**, the ocean's horizon line is lined up with the top of the viewfinder, keeping both lines parallel. Look what happens when we tilt our camera (**3.2**). See the right triangle created by the sky. Distracting, isn't it?

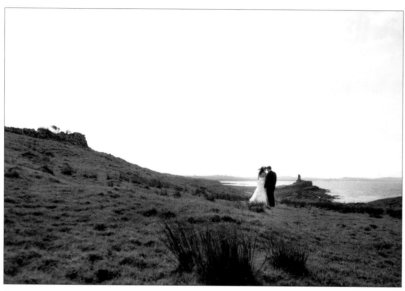

3.1

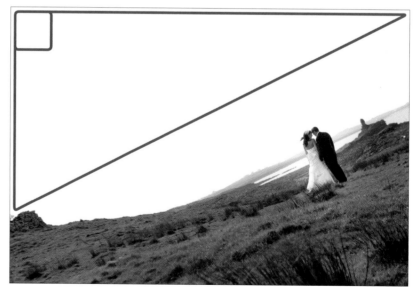

3.2

You may be asking yourself, "How come the rectangle is not a distraction if a rectangle is also a geometric shape?" The answer lies in the rectangular shape of the viewfinder.

When you align the strongest horizontal line in your scene with the top of your viewfinder (which is also a rectangle), no shape stands out and detracts from your subjects. The rectangles in your photo become a repeating pattern that doesn't divert your viewers' attention. A photo example will better explain this concept.

I chose image **3.3** because of its simplicity, so we can focus on the shapes created by parallel lines. The top of the stairs behind the couple made a strong horizontal line and therefore became my line of choice. I made sure the top of my viewfinder lined up as closely as possible to the top of the stairs to keep the lines parallel. See the black rectangle behind their head? See all the other rectangles in the scene, such as the doors and red carpet? None of these rectangles take attention away from the couple because all the shapes are the same, including the viewfinder. The example in **3.4** is identical to the previous one except that the horizontal lines of the stairs are now at the bottom of the frame instead of the top.

3.3

3.4

WORKING WITH VERTICAL LINES

At any given photo shoot, there will be many photos that you will take in a vertical orientation or portrait mode. The technique remains the same as when you're shooting in horizontal orientation, except this time look for strong vertical lines in your scene. Once you spot the vertical line, use the left or right edge of your viewfinder as your reference point to make the two lines parallel. Let's take a look at an example of a vertical photo with a vertical line.

In image **3.5**, there are two main vertical lines: the yellow one on the right, and the window frame on the left. I found the line on the left to be more dominant, because it contrasts with the lighter background of the windows. I quickly lined up the left side of the viewfinder to this line the best I could and took my shot. You can see by the red lines I've placed on the image how close to parallel the lines run. This is why it is important to look all around your frame to find the strongest vertical or horizontal lines before you push that shutter button.

The only vertical line in image **3.6** was that little piece of wall on the lower-left side. This line is visible due to the wall's shadow next to the groom's leg. That shadowing created a line with enough contrast to use it and make it parallel to the edge of the frame.

A NOTE ABOUT CAMERA TILT

There is nothing wrong with tilting your camera if that's indeed the look you are going for. Once in a while I use camera tilt myself to compose a photograph. When there is a horizontal or vertical line point of reference in the scene, I stay away from tilting because it seems distracting. However, if no such point of reference exists, or there is a limited sense of place in the scene, then I might go for a subtle tilt.

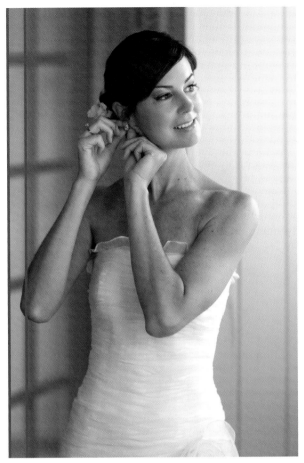

3.5

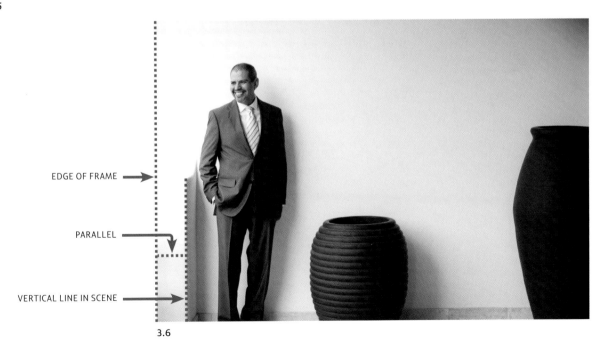

EDGE OF FRAME →

PARALLEL →

VERTICAL LINE IN SCENE →

3.6

Exercise: Go outside for a couple of minutes and look for a horizontal line created by a building. This line could be created, for example, by the way the brick is laid out or by the building's window frames. Any horizontal line will do. If you are at the beach, the horizon line automatically becomes your horizontal line.

Line up the top line of your viewfinder as parallel as possible to the horizontal line you spotted and take a picture. Now, hold the camera by its vertical grip (or just sideways), find a strong vertical line in your scene and line it up with the vertical line of your viewfinder. Make the appropriate adjustments so that the two vertical lines are parallel to each other. After you take your photo, look at your screen and notice the rectangles created by the parallel lines. Although you know the rectangles are present, it is a good training to really notice them, even count them.

Don't worry too much about making a symmetrical photo. Focus on just being aware of the strongest horizontal or vertical lines present in your environment. Your task here is simple; just make the top of your viewfinder parallel to any horizontal line created by an object in front of your lens.

Goal: 10 vertical photos using vertical lines, 10 horizontal photos using horizontal lines.

Explanation: There is nothing more distracting than a strong horizon line that's tilted. Going through this exercise will train your brain to be more aware of these strong horizontal or vertical lines in your location. These lines are everywhere, and paying attention to them will make your work more pleasing to look at. Lining up these lines so they are parallel to either the top of your frame (horizontal line) or the side of your frame (vertical line) will create a perfectly straight photo, thus keeping the full attention of your viewers on your subject.

4

SYMMETRY

SYMMETRY refers to a line that splits an object in half and, if both sides of the object are an exact mirror image of each other, then this object is said to be symmetrical. The line that splits a symmetrical object is called the *line of symmetry*. Symmetry is a powerful tool that lets you automatically create harmony and a sense of aesthetically pleasing balance and proportion in a photograph. You probably remember learning about symmetry in geometry class, but I rarely see photographers apply it in their work. That's too bad, because symmetry is a powerful photographic tool. Symmetry is all around us and has always been associated with beauty, so why not use it? Depending on how you are holding the camera and how much of a scene you choose to show, you can strengthen or weaken the symmetric properties of an object or scene. Although there are many types of symmetries, for our purpose let's focus on two types:

- **Vertical Line of Symmetry (VLS):** If an object's line of symmetry is perpendicular to the horizon line, it has a vertical line of symmetry.

- **Horizontal Line of Symmetry (HLS):** If an object's line of symmetry is parallel to the horizon line, it has a horizontal line of symmetry.

Exercise: Look around every room in your house (or outside) and discover anything that could have a vertical line of symmetry. Try your window frames, the backrest of your dining room chairs, a table lamp, and so forth. Using a zoom lens, try to zoom in to just show the VLS of objects.

Just focus on VLSs. Be sure to hold your camera vertically to enhance the visual effect.

Goal: 10 objects with vertical lines of symmetry.

Explanation: I find vertical lines of symmetry easier to spot than horizontal lines of symmetry. The trick is to find your symmetrical object of choice and center it in your frame. Ask yourself if anything present in your photo is taking away from the symmetry. If you tilted your camera, for example, most likely you have lost symmetry. Instead of straightening it in postproduction, get it right in the camera. Images **4.1–4.4** are photos I made while I was taking a walk and doing this exercise myself.

4.1 At a restaurant, I noticed the back of the chairs had VLS, so I zoomed in to show just the portion of the chair that is symmetrical.

4.2 By zooming in on just the back of the chair and keeping it centered in the frame, you create a very nice vertically symmetrical photo.

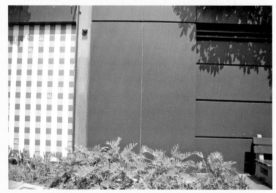

4.3 I noticed that the green wall in the center had a vertical line running right down its middle. This automatically showed me where the line of symmetry lay. I zoomed in to isolate just this portion of the scene. I placed the vertical line in the middle of my frame and took the photo.

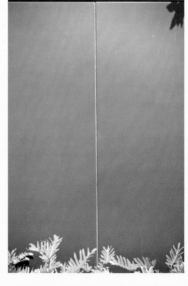

4.4 By zooming in on the green panel's middle line, you can emphasize its vertical symetry.

COMBINING VERTICAL
SYMMETRY WITH PEOPLE

Image **4.5** shows how I applied this symmetry skill on the job. I zoomed my lens enough to isolate just this vertically symmetrical portion of the interior. The only object that is taking away from my perfect vertical symmetry is the light fixture hanging from the ceiling. Notice it was hung a bit to the left. Although the light fixture is not centered, the rest of the scene is very much symmetrical. I positioned the bride in the center to add to the symmetry. Unfortunately, it also looks a bit posed.

Image **4.6** is almost identical to 4.5. However, I changed the overall feel of the photograph by keeping the symmetry in the composition but introducing a bit of tension. The bride being off-center creates the tension. Now the photo takes on a photojournalistic feel combined with a symmetrical composition.

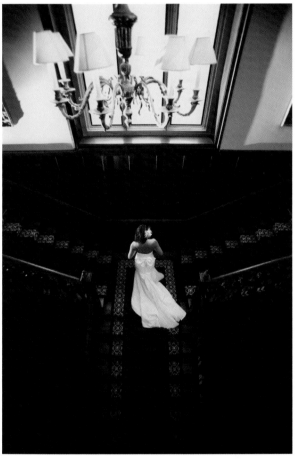

4.5

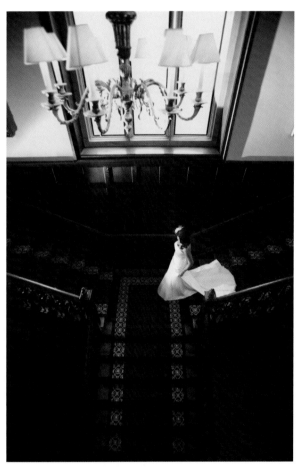

4.6

Exercise: This exercise is the same as the previous one except this time instead of VLS you are going to look for HLS.

Just focus on HLS. Be sure to hold your camera horizontally to enhance the visual effect.

Goal: 10 objects with horizontal lines of symmetry.

Explanation: You can always find HLS by looking at a reflection from a lake or any other body of water. Water creates a perfect mirror reflection of whatever is in close proximity to the water source. Think of how many photographs you have seen in magazines or books with reflections of water. These landscapes are beautiful partly because of the scene, but mostly because those images have symmetrical and balanced properties. The key to this exercise is to bring those same powerful properties to an urban scene that has no body of water. Easier said than done, right? But if you work on recognizing these properties everywhere you go, you will be better able to harness the symmetrical properties of any scene you are faced with. The work is a bit tedious, but it is well worth it! Images **4.7–4.10** are some of my examples doing this exercise.

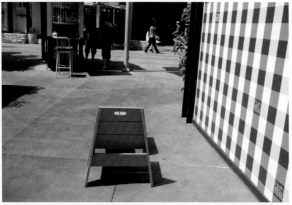

4.7 During my little walk, I noticed this orange chair from some distance. Because I was actively looking for HLS, I stopped to take a photo of the back of the chair.

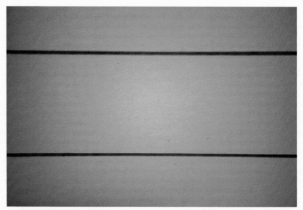

4.8 You can see how I isolated the symmetrical portion of the chair from all the other distractions. The back of this chair has a very clear HLS.

4.9 In this example, it was the blue shutters that had the HLS I was looking for.

4.10 Here are the shutters isolated for its HLS. Remember to place the HLS in the middle of the frame. That way, the symmetry will be centered.

COMBINING HORIZONTAL SYMMETRY WITH PEOPLE

Image **4.11** took place during a wedding in Maine. I had just a few minutes of clear weather to complete all the photographs of the wedding party and the portraits of the bride and groom before it started raining again. Since there were no raindrops disrupting the calmness of the lake, it created a gorgeous crystal clear reflection (HLS) of the landscape. This gave me a great opportunity to apply HLS using the wedding party. The key is not to see this scene as a big rock and a tree, but to see it for its horizontal symmetrical properties. That way, you can enhance the symmetrical feel of the photograph through your composition.

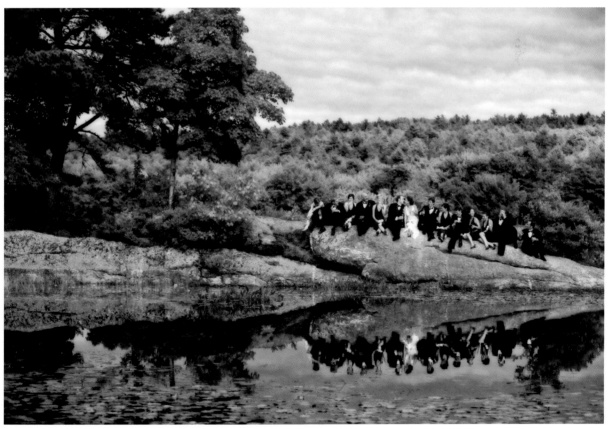

4.11

SEEING SYMMETRY EVERYWHERE

One day in Barcelona, Spain, I looked out my hotel window and noticed an abundance of both HLS and VLS in front of me (**4.12**). These symmetries are literally everywhere. We just have to train ourselves to recognize them and then apply them in our work.

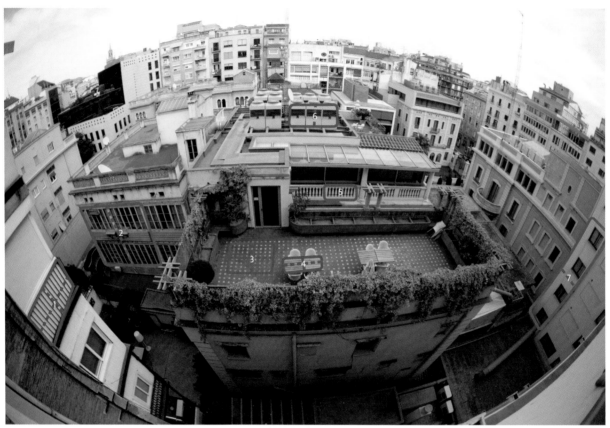

4.12 I've marked some of the symmetry I saw in just one scene alone. There are more, but this hopefully makes it clear how you can find symmetry all around you.

After having done these exercises over and over throughout my career, I can relax and let my training do its job. During my first trip to Paris, my wife and I were walking to the elevator that takes you to the top of the Eiffel tower. I was admiring the sheer size and beauty of this magnificent structure when I instinctively felt the need to take a photo of the Eiffel tower at this exact angle (**4.13**). As you can see by the photo, my training kicked in when my eyes gazed through the tower and my brain recognized the strong vertical line of symmetry at this angle compelling me to stop and take this photograph. Even when you are on vacation, your training will always be there with you.

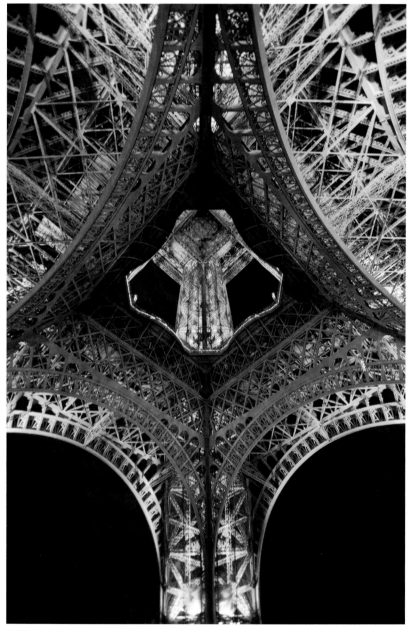

4.13

5

COLOR ELEMENTS

WHEN SHOOTING on location, photographers are faced with thousands of objects of all shapes and colors. Primary colors such as red, green, and blue are especially loud in nature, and special attention is required when dealing with them. Whenever any of these colors appear in the background of a photo, they are sure to be a distraction from your subject. To help you tackle this unavoidable issue, this chapter explores two methods: keeping contrasting colors to a minimum, and finding an area where the colors are at least part of the same family.

5.1 This is an example of what happens when you have a background with every color under the sun. Even though people appear in this photo, you hardly notice them because of the distracting shapes and colors all around.

KEEP CONTRASTING COLORS TO A MINIMUM

Before shooting, look at your scene and see if there is an area containing fewer colors. Imagine you're shooting a portrait of a high school senior and in the area behind your subject there is a red stop sign, a green car, some blue sky, orange flowers, and green grass (**5.1**). Distracting, right? As photographers, we need to remember to keep our visual message clear.

FIND AN AREA WHERE THE COLORS ARE PART OF THE SAME FAMILY

Sometimes on location, you simply cannot avoid a wide variety of colors in your background. But instead of blaming the location for its lack of color simplicity, keep looking until you find a place that has different colors that are all part of the same color family. Using color families keeps your eye from wandering and keeps the focus on your subjects.

Image **5.2** is a good example of looking for the same color palette in a difficult situation. The photo was taken at a resort in Tucson, AZ. Although the hotel is beautiful, it was hard to find a spot where I could photograph the bride and groom with a simple background. Everywhere I looked I saw colorful decor or small artwork on the walls. The paintings were too small to use as backdrops, and due to their strong colors, they were quite distracting.

So we walked to the back of the property where I noticed this scene. Although you can see many color tones here, they are all similar. The browns, greens, and yellows all have an earthy color palette. Having found my location, I shot away. I was comfortable knowing that as long as the palette stayed the same, I could try various poses and crops without the danger of introducing a distracting color.

Most locations have settings with similar color palettes—you just have to look for them. Training your eye to spot these locations takes practice and constant reinforcement (**5.3**).

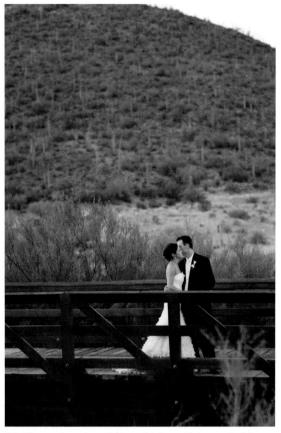

5.2 The earthy color palette in this beautiful scene in Arizona served as a nondistracting background for the couple.

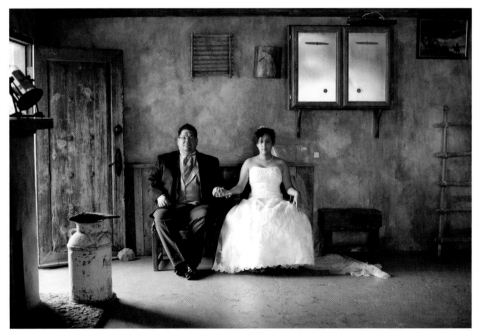

5.3 This background works well because almost every item in the room had a warm color tone. Though there are at least 15 different colors here, most of them belong to the same orange/warm color family. That's why they don't compete with the couple.

Exercise: Take a camera outside and search for areas with lots of colors. But focus on finding colors within the same family, such as all pastels or all earthy colors. Different shades of the same color work, but not a single color.

Goal: Find three areas with these characteristics in a busy urban scene and three in a landscape scene.

Explanation: You want to train your eye to spot clean backgrounds in busy environments. Developing selective vision is a crucial part of being a photographer. You want to be able to spot what would make a great background for a portrait in places where the average person would never think such a shot is even possible.

THE THREE-COLOR LIMIT

One of the must useful techniques I discovered was realizing that most great photographs have no more than three colors in the background. Even if the posing is excellent and the lighting exquisite, allowing too many colors in the background splits your viewer's attention between your subjects and the colors scattered all over the place.

While I was teaching this concept at my workshops, students made me aware that it's not easy to isolate background colors. That's because the eye is not accustomed to separating familiar objects from their colors. For example, if you go out to the street you will see cars. Your brain simplifies the scene and simply views those objects as "cars." However, you must train your brain to see as a photographer does, not as an average person would. So you must see those cars as little patches of color instead. When a red car goes by, tell yourself, "There goes a red patch of color." Similarly, a stop sign becomes a red octagon.

Here's a little trick I use that helps make familiar objects more abstract so I won't recognize them. I flip my lens to manual focus and completely throw the background out of focus. All the objects become unrecognizable, leaving only their color behind. I then count the colors of all the splotches in the scene. If there are more than three, I either zoom in to get rid of the extra colors, or I don't shoot there (**5.4–5.6**). If I see no more than three colors in the background behind the subjects, I flip my lens back to autofocus and shoot away.

I believe this technique has been responsible for much of my success in attracting higher-end clients. With a simple background, photos will have an elegant feel. Your main subject will stand out, and your visual message will be clear (**5.7**). Whether you are photographing a family portrait, a wedding, or a high school senior class, this technique is paramount.

5.4 This image illustrates an average scene on a busy street in Los Angeles. The scene has too many different colors, though the familiarity of the objects—a fence, trees, grass, and house—can make that difficult to see at first.

5.5 To get rid of the familiarity of objects, switch your lens to manual focus and throw the background as far out of focus as possible. Now, you just see the colors the objects make.

5.6 Now you can clearly see the color patches. If you were to place your subject in front of this scene, the subject would be competing with all these distractions.

5.7 This patch of red was not very big, and it was surrounded by the various colors of a typical room. By zooming in on just the red portion, you can turn the wall into a vibrant single-color background. Now nothing distracts you from the beautiful flower headpiece.

ABOUT THIS TECHNIQUE

This is just a technique available to you; it's not a rule that you must always follow. I break this rule if I feel more colors in the background will help my photo. I apply the three-color limit about 80 percent of the time. It is especially helpful for portraits. I break the rule if I can balance the couple on one side against the various colors on the opposite side, or when the different colors lie on either side of my subjects and so balance the photo (**5.8**).

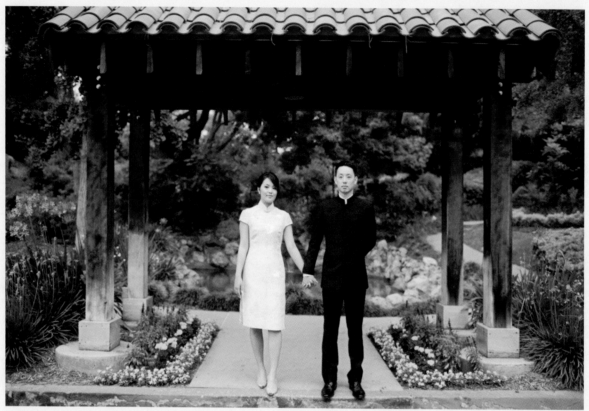

5.8 As you can see in this photo, there are at least 15 colors in the background. This is a good example when I decide to break my three-color limit. First, you can see how the rows of yellow flowers are perfectly balanced with the couple. Second, you see almost the same amount of light-tan rock on either side of the couple. As long as the background colors are balanced, even the red curb by their feet is balanced by the subtle red roof above them.

EXERCISE:
NO MORE THAN THREE BACKGROUND COLORS

Exercise: This is a fun exercise. With your SLR camera, attach a lens of your choice and go for a quick walk. Lift your camera and point it at an area with a depth that you like. Switch your lens to manual focus and use the focusing ring to throw the scene as out of focus as possible. Take a well-exposed photo, and your scene should now be a giant blur. Count how many color splotches you see. Then ask yourself, "Would that be a good background to use?" If you counted more than three colors splotches, the answer to that question for me would usually be no.

Goal: Photograph five areas that contain more than three colors in the background. You are going to use these for comparison. Take two shots per location, one out of focus and one in focus. Now photograph 10 areas with no more than three colors in the background.

Try locations with depth, walls, storefronts, etc. Locations with depth will be more difficult but more fun to find and more rewarding to use. For these 10, also take two photographs per location—one blurry, one focused.

Explanation: By also taking photographs with busy backgrounds, you will have a point of comparison. You will be amazed at how much cleaner the photos with no more than three colors will be. If you do this exercise once or twice a month, you will become very good at identifying the color splotches in locations, without having to take a photo at all. This will increase your efficiency, and the number of great photos you take per session will dramatically increase. By the way, different shades of the same color do not count as different colors. For example, light green, dark green, and emerald green all count as one color: green. But red, blue, and brown should be counted as three different colors because they are so different.

6

DEPTH

DEPTH IS DEFINED as the distance in front of and behind your subject(s). The opposite of depth would be positioning your subject directly in front of a wall. You can use depth to achieve a plethora of looks and moods. Some photographers define their entire style with the use of depth, and others with the complete lack of it.

When you are photographing on location, you have two main choices. The first is to find a colorful or interesting wall and position your subject in front of it. The second option is to break away from walls and use an open space. This chapter will give you tools to harness the beauty and impact that depth brings to a photograph.

I have found that many photographers are skeptical about venturing into an open space. I can see why. You leave the comfort of a shady, colorful wall for an open area with all sorts of things happening in the background. The sun may be hitting your subjects in the wrong areas, causing shadows under their eyes, for example. But such challenges have solutions. This chapter will address some of the most important challenges and show you how to solve them.

DEPTH AND THE ENVIRONMENT

The area surrounding your subjects is critical to the effectiveness of your photograph. Like most aspects of photography, the environment can either help you or work against you. As you are scouting locations to photograph, you must make a decision whether to include the environment. Including the environment requires that everything that shows up in your frame be part of the story you are trying to tell. If it's not helping you make your point, why include it?

It is easy to forget to look around you before you click the shutter to ensure you have no objects in your background that should not be there. For example, at a wedding when I'm photographing the groom and the groomsmen getting ready, beverage cans and food trays are typically scattered around the room. It is worth the effort to move things around to eliminate unnecessary objects in your frame that distract from your subject. It's fine to move things around (within reason). I always ask my clients first but doing so has never been a problem.

DEPTH WITH CONTEXT

As visual storytellers, our job is to tell a story about our subjects. If you saw a photograph of a stranger, how much could you tell about this individual just based on the information present in the photograph? Even though you may have lenses capable of large apertures to blur the background and isolate your subjects, they may not always be the most effective tools to tell your story. There are many times where the background is just as important as your subjects.

During a wedding in Santa Barbara, CA, I wanted to showcase the Persian culture in the wedding details, as well as the bride and groom's guests. I quickly changed my camera settings from f/2.8 to f/8 to get every guest in focus, including the details the bride worked hard on (**6.1**). The resulting photo contains valuable information about the couple, their religion, their families, and the type of environment they feel comfortable in.

6.1 Using a small aperture with a large depth of field to bring everything in the scene into focus helped tell the story of this couple through context.

DEPTH FOR MOOD

There is definitely a mood associated with depth. In my opinion, a photo of a couple with depth takes on a much more romantic mood than one with a couple in front of a wall (no depth). When you choose to photograph your subjects in an open area and use a shallow depth of field, a beautiful *bokeh* will appear behind them. (Bokeh refers to the aesthetic quality of the blur created by the lens). Three main elements must be present to get the most out of depth:

- **The scene you choose should be consistent.** It doesn't have to be consistent all around; it just has to have similar elements in the section present in your frame (**6.2**).

- **The light on your subject should be directional.** This can be accomplished with a reflector (**6.3**), a wireless flash (**6.4**), or the sun (**6.5**).

- **The lens and aperture should be carefully considered.** A prime lens and a shallow depth of field (f/2.8 or bigger) will obviously do wonders to the mood of a photograph by adding bokeh. All three must work in unison to create a truly great image.

6.2 This photo works because all the elements are similar in nature and belong together: leaves, grass, plants, trees, and so forth.

6.3 Using depth and a light reflector.

6.4 Using depth and a wireless flash tucked in the grass.

6.5 Using depth and natural directional light.

Exercise: With an SLR camera, set your aperture to f/11. Take a photo of a subject in front of a background that says something about that person. Be selective with your backgrounds. Because you are shooting at f/11, the background and your subject will both be in complete focus, so make sure that says something important about your subject.

Focus on conveying the most information about your subject through the context of your background. Don't choose a flat wall unless the wall is important to the story of your subject. The purpose here is to combine depth with context. Don't worry if the background is distracting, as long as it contains information about your subject.

Goal: Three photos with a great background that says something about your subject and three photos where the background does not say anything about your subject.

Explanation: It is important to know when to, and when *not* to, include the background for storytelling purposes. This exercise will make you more aware of when to bring the background into focus using a large depth of field, usually f/8 or f/11. You want to choose a background that says something about a person's occupation, religion, activities, hobbies, culture, or environment, just to name a few aspects (**6.6** and **6.7**).

6.6 Here is a casual photo I took in Paris of an elderly French couple who has lived in Paris their entire lives. Although the background is distracting, it contains valuable information about the couple's life, hometown, relationship, and environment.

6.7 I took this photograph of a family all riding on the same bicycle from inside a taxicab during my trip to Beijing. Although this photo has great content regarding the subjects, the background here says nothing about their lives.

DEPTH WITH MOVEMENT

Creating movement in photographs by panning your camera with a slow shutter speed is challenging but rewarding. It requires quite a bit of practice to get a feel for how much to slow your shutter with respect to the speed of your moving subject.

If the shutter is too slow, it will yield a completely blurry image, including your subject. If the shutter is too fast, it will freeze the frame and cancel out the movement you are trying to create. But when you hit that shutter speed sweet spot, it's gold!

Success usually depends on your subject's movement. On a sunny day, at ISO 100 I use a shutter speed of 1/30th of a second as a starting point and f/4.5 or f/5 as my aperture. The reason for that aperture is that I need my focusing plane to give me enough depth of field to move the camera and still nail the focus on my main subject. If you try panning techniques with a shallow aperture, say f/2.8 or wider, you might as well get comfortable because you are going to be there for a while trying to get your main subject in focus.

A NOTE ON OVEREXPOSURE

Slowing down your shutter speed to 1/30th of a second during the day will create overexposure problems. I always carry a Hoya Neutral Density 8 (ND8) filter to step down my exposure. On a typical sunny day, without the ND8 filter at ISO 100 f/5 your shutter speed will be around 1/320th. That's way too fast to show movement. Using the ND8 filter in the exact same lighting conditions, your shutter speed will now be approximately 1/30th, which is perfect for slow-shutter panning.

EXERCISE:
CREATING MOTION BLUR

Exercise: Go out on the street on a sunny day and ask a friend to walk in front of you at normal walking speed. Photograph your subject at aperture f/5 and a shutter speed around 1/30 at ISO 100 with an ND8 filter on your lens. The trick is to pan your camera at the exact same speed as your subject moving across the frame. Fire three exposures to improve your chances of getting one with your subject in focus.

Keep it simple so you can remember your settings. You should photograph a person walking, then running; a moving car; and someone riding a bicycle. Keep your attention on your settings for each scenario. Experiment with a slower shutter speed as well as a faster one, to see the difference in how the background looks.

Goal: Try to get at least five photos for each scenario listed above with your subject's face in focus. You do not have to shoot them all in one session, but you do want to accomplish this goal as soon as possible to keep this precise movement fresh in your head (**6.8–6.10**).

Explanation: You want to learn how it feels on your arms and legs to track someone moving while using a slow shutter speed. You have to move in a compass-like motion for best results. If you lose balance during the exposure, it will not work, so a wide stance is paramount. Panning at the exact speed as your subject is not easy. If done well, this technique will bring your photos to life with movement. They are very fun to do, and it's a great technique you can use anywhere. A child running or a bride and groom walking along a busy street will take on a whole new meaning with this technique. Learn the sweet spot for two or three scenarios. This way, when you are in the middle of a shoot and you decide you want to try this depth-with-motion technique, you will know exactly what to do.

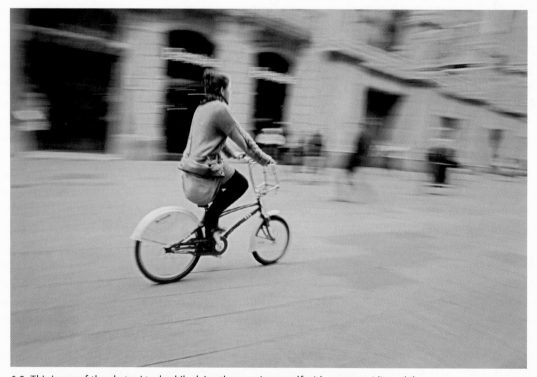

6.8 This is one of the photos I took while doing the exercise myself with a person riding a bike.

6.9 Here is my attempt at panning with a car moving around 35mph.

6.10 This photo was the result of trying to perform the exercise with a twist. Instead of panning my camera left-to-right or right-to-left, I tried tracking a person's walking speed while people walked toward or away from me while the shutter was open. I picked the man with the purple shirt to track. I didn't quite get him in focus, but it sure looks more interesting than a typical photo with all the movement frozen. This technique is another tool in your toolbox that you can pull out when photographing a portrait in a high-traffic environment. It's all about developing skills to turn a difficult situation into an opportunity.

7

SHADOWS

IMPLEMENTING SHADOWS in photography is where things start getting really interesting. I have seen photographs that have used shadows so creatively that it was a visual pleasure just to see. I felt as if my eyes were entertained everywhere in the photograph. The reason why shadows are so interesting is simply because you can create a visual message that is not so literal. Shadows bring a sense of mystery and graphics to a photograph, and the viewer must use his/her imagination to fill in the missing pieces.

THE BRIGHT SIDE OF SHADOWS

Most people tend to stay away from taking a portrait in harsh light, fearing that it creates unflattering shadows on a subject's face. But shadows are not a bad thing—they are just misunderstood. Shadows create shape, depth, and texture in a photograph. Without shadows your photographs would look completely flat. In fact, if you remove all shadows completely, you will have nothing but white paper.

USING DARK ROOMS OUTSIDE TO CREATE STRIKING PORTRAITS WITH SHADOWS

Wherever there are shadows, there are portrait opportunities. Depending on the occasion you are photographing, you may not be able to choose the time of day to photograph your clients. This is especially true in the wedding photography field. When shooting on location we are surrounded by great places to shoot, but we may walk right past them, because often the location appears to be not such a beautiful package.

Consider the following example (**7.1**). This is a photo of an open, old garage door in an alley off a typical suburban street. Even though the photo was taken in the middle of the day, notice how quickly the light falls off just inside the garage. Let's analyze what's going on with the light here. All that strong sunlight wants to go inside this room, but because these kinds of rooms are usually dark in color, the light cannot enter and reflect all around. This creates a high-contrast light source, where at the edge of the door it is extremely bright, whereas just a foot or two inside, it becomes very dark. Depending on where you place your subject, this kind of high-contrast lighting situation can provide endless portrait opportunities in a simple place that's available pretty much everywhere. You can take advantage of three angles in a room like this.

7.1 A garage with the door open provides the light behavior we need to shape a portrait with light and shadows.

1: SHOOTING FROM THE SHADOW SIDE

If you choose to shoot from the shadow side, you could, for example, just light a narrow portion of your subject's face (**7.2**). Because there is a high-contrast ratio, the side of the face that is lit will be quite bright, and if you expose for the highlights on the face, the other side will turn very dark. This is a great lighting technique when you are dealing with a person with a round face. This photo was taken at the same garage shown in image 7.1. Notice how I positioned my client with his body facing the dark side and his face turned toward the light.

7.2 Portrait taken from the shadow side of the room, illuminating just a portion of the face.

2: SHOOTING IN THE MIDDLE BETWEEN THE BRIGHT AND SHADOW SIDES

This angle is a creative way to split the light on the face with half of the face lit and half in shadow. This photo was taken not in a garage but in the entryway of a bar in Savannah, Georgia (**7.3**). While walking down the street, I noticed that the bar had a dark-colored interior, just like the garage in the previous example. The location may be different but the light behavior is exactly the same. All you need is a dark room with an exterior door or window. Crafting a person's face like this can chisel a jaw line or cheekbones.

7.3 Shooting from the mid-point of the bright and shadow points. Exposing for the bright side of the face.

3: SHOOTING FROM THE BRIGHT SIDE

If you choose to shoot from the outside toward the darkness of the room, it will create a beautiful quality of light falling on your subject. The key is to position your subject just inside the room where the light is still strong but hasn't had a chance to fall off yet. Here, I positioned my wife Kim just about 24 inches from the edge of the garage door (**7.4**). Notice how this angle lights up both sides of her face beautifully. The light falls off right behind her, leaving the background in almost complete darkness. For the next photo (**7.5**), I moved Kim closer to the outside light. Now she is about 12 inches from the edge of the garage door. Notice that her face is now brighter, and the garage behind her has disappeared. This is a great way to fill in shadows on a person's face and create a strong separation between the subject and the background. When you find a room where the light falls off very quickly, you don't have to worry about whether or not the room is aesthetically pleasing, because you won't see it anyway.

7.4 The light falls off right behind her, leaving the background in almost complete darkness.

7.5 Shooting from the bright side with the subject 12 inches from the edge and exposing for the face. The background is completely eliminated.

THE COLOR OF THE ROOM MATTERS

This is one of my favorite lighting techniques when shooting in a busy urban environment. However, the color of the room does matter. Brightly colored rooms will reflect light, and it will give a very different look altogether. The technique described here is about crafting a portrait with shadows; therefore, the room or garage should have dark, interior colors that subtract light, not reflect it.

Exercise: Begin by finding a parking structure near you. I recommend a parking structure, because it is probably the easiest type of room to find outside that contains the characteristics you are looking for. You will need a volunteer to help you. If you don't have someone to help, use a teddy bear or some other stuffed toy, and put it on top of a light stand. Go over all three lighting angles explained above. Start shooting from the inside of the structure—that is, the dark side. Then, shoot where the light and dark sides meet. Finally, shoot from the outside.

Position your subject in three different locations for every angle you shoot from. For example, one position can be closer to the light source and another can be farther away. Study how the light and shadows behave on your subject's face in each position. Always expose for the brightest side of the face.

We are studying light ratios on a person's face in this kind of environment. There's no need to worry about expressions or a flattering pose.

Goal: You should have a total of nine photos.

Explanation: Once you become familiar with these nine different looks, you will be able to create many other combinations. Most likely, you will have more combinations than you will have time for. By doing this exercise, you will know exactly how the light and shadows will behave on your subject even before you ask him or her to stand somewhere.

During a wedding, I wanted to create a high-contrast portrait of the bride. In image 7.2, I loved the way the light hit just a sliver of my client's face. But to get that kind of light inside a bride's hotel room, I would have to re-create that high-contrast environment. I needed a lot of light to squeeze through a small area. My solution was to turn off the lights inside the room and close the curtains almost all the way. I left one curtain open just a few inches to allow the bright light outside to squeeze through that little crack. Now, I had the environment I was familiar with, so I asked the bride to stand in the way of the light coming in, about three feet from the window. Three feet from the light source was one of the distances I was familiar with by doing this exercise. Naturally, I shot this portrait from the dark side of the room to showcase this beautiful strong light just grazing the bride's face (**7.6**).

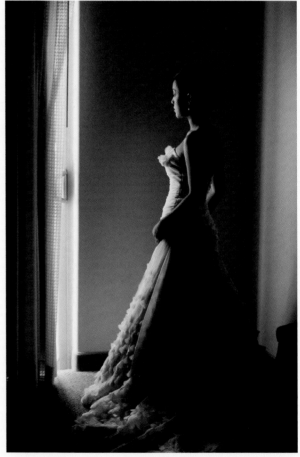

7.6 Recreating the test shot's high-contrast environment for a portrait of a bride surrounded by light and shadows.

NAVIGATE BY THE SHADOWS ON THE GROUND

When shooting outside during the day with nowhere to hide from the sun, I use my client's shadow on the ground to determine which angle I'm going to shoot from. This is an easy technique I use to backlight my subjects, but it is often overlooked. I've found it helpful when trying to create a beautiful portrait in a hurry. In an open area outside, the sun is so harsh that people can't even keep their eyes open without squinting, and the sun also casts unflattering shadows on their faces.

The solution is surprisingly simple; backlight them, or have the sun hit your subject's face at an angle. I usually choose to backlight to obtain that romantic feel so commonly associated with backlighting. I simply stand at the apex of my subject's shadow to find the point where the sun will be precisely behind them. That way, the sunlight won't spill onto the side of their face.

In image **7.7**, I used my trusty teddy bear to demonstrate how to find the apex of a shadow. The photo was taken around 5:30 in the afternoon, and the light was harsh and difficult to work with. What the sun did do was cast a nice long shadow for me to follow. I circled the apex to show the direction where I should stand to capture the perfect backlit shot.

You can experiment with photographing your subjects' faces at different angles, but if you have them face directly toward their own shadow, you will achieve the cleanest, most even light on the face. Naturally you will have to expose for the face. I would even overexpose the face by 1/3 or 2/3 of a stop.

In image **7.8**, I stood in the direction of the shadow, and I arranged the teddy bear so that it faced its own shadow. The sun is perfectly aligned at the back of its head and I have no light spill on the side of its face. It's a relief that you can get clean and even light on your subjects even with the worst lighting conditions outside. I overexposed the face by 2/3 of a stop, which caused the background to completely blow out. Depending on the time of day and your color balance, you can achieve a wide variety of looks by backlighting your subjects.

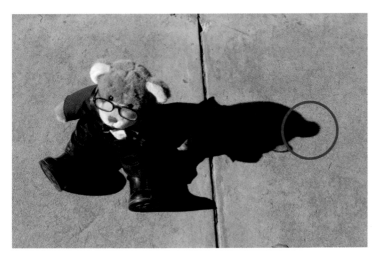

7.7 The circled apex shows where I should stand to capture the perfect backlit shot without light spilling onto the side of the face.

7.8 By facing the teddy bear toward its own shadow, I ensured that no light spilled on the side of its face.

Exercise: Give it a try. This technique is quick and easy, so there is no excuse not to have some fun with it. Go outside under the sun and have a friend stand anywhere. Stand at the apex of his or her shadow and take a photo. Find the correct exposure for your friend's face, usually a bit overexposed. Don't change the exposure throughout the exercise.

Now ask your friend to turn around slightly, as if standing on a turntable. Take another photo. Keep rotating your friend around a little at a time, and see how the sunlight casts different shadows on the face at different angles.

Remember to stand in the apex of your friend's shadow. Have your friend rotate little by little, but stay where you are.

Goal: Take five photos of your friend at different angles. Keeping the number to five will make it manageable for you to remember what the light looked like at each of the five points.

Explanation: This technique can be a lifesaver under difficult lighting conditions. If you are shooting in a wide-open area like the beach, it is important to know how to handle this kind of light and how many different aspects it can provide you. Here's an example of this technique in action during an engagement session in Los Angeles (**7.9**). We had been shooting inside my clients' home for most of the session, but near the end, we went outside to squeeze in a few more shots with a different look. I quickly found their shadow and stood in the direction of its apex. I posed them, corrected my exposure for their faces, and then took the shot. Notice how there is no light spill on their faces. The light is completely behind them, giving me even lighting. I personally crop tight on this type of shot. I prefer to show the light from the sun caressing the back of their heads but not show the sun itself. The sun is much brighter than my clients and therefore would become a distraction.

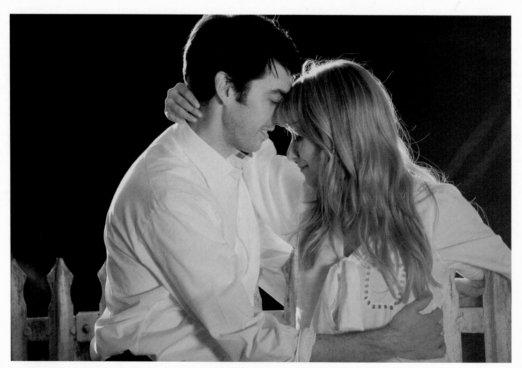

7.9 Here's an example of aligning the sun exactly behind my clients by standing at the apex of their shadow.

CASTING SHADOWS FROM OBJECTS TO CREATE GRAPHICAL INTEREST ON A PORTRAIT

Being resourceful at a shoot on location is crucial to getting the most out of any place. For example, in the wild predators use and eat everything in their environment. They use the grass to hide, the trees to sleep, animals to eat, and so forth. So, keep your eyes open at all times, because in photography everything can take on a different look depending on how the object is lit and the settings on your camera. To illustrate how important and exciting this technique can be, let's look at some examples.

I photograph fine-art nudes for clients looking for something artsy and abstract but not revealing. I've learned to cover parts of the body using objects or shadows. Initially I didn't see objects as potential coverings, and I never thought about "painting" the light and shadows on my subjects. This zebra-like nude, taken in the middle of the day, was created using only the blinds from a window. I opened and closed the blinds until the shadows they cast were painted just right on the model (**7.10** and **7.11**). The black background is simply a 10-foot-wide black paper roll I laid down to remove any distractions from the black and white stripes. I used no external lights or reflectors, only natural light.

7.10

7.11 This was taken mid-day using the blinds shown in 7.10.

I applied the same technique during an engagement shoot in downtown Los Angeles. While scouting for locations to use, I discovered this little piece of yellow wall. I didn't like the bright yellow color, but I loved the shadow the tree cast on it (**7.12** and **7.13**). This shadow created a very nice graphic on the wall that would be difficult to recreate on a set. I changed my color balance in my camera to a warmer tone to also change that bright yellow to a warmer tone. To emphasize the shadows on the wall, I had to expose for the highlights, leaving my clients in the dark, so I used an off-camera flash to throw light back on them. Now the wall, the tree shadow, and my clients are exposed correctly. Also notice how the shadow and my clients have balanced each other, with the shadow on the left and the couple on the right. If you need to review balance, refer back to the balance chapter and go through the exercises again.

7.12

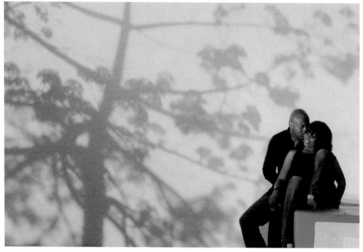

7.13 Here's how I used the wall shown in 7.12 to take advantage of the shadow cast by the tree.

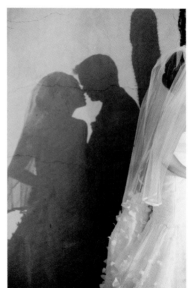

7.14 Here's another example of creatively using shadows.

USING AN OFF-CAMERA FLASH OR VIDEO LIGHT TO FORCE SHADOWS TO APPEAR WHERE DESIRED

Although the sun is the best light source to cast interesting shadows, sometimes the sun is not where you want it or it's already dark outside. The good news is that many modern stand-alone flash units enable you to control where you want the light to go. It's like having a portable sun in your pocket ready to use at your command. When you have this kind of control, almost anything becomes possible. You are limited only by your training and creativity. Keeping your eyes alert at all times will train you to see amazing photos where others would see nothing.

Examples **7.15** and **7.16** illustrate how a simple wall in an average hotel room can be transformed into something quite unique. The groom posed for me standing in front of a wall. I took the photo with a normal exposure and found the photo boring and stale. I thought, if I have a clean wall to work with, I could cast a shadow of the groom onto it. I closed the blinds and turned off the lights to eliminate any ambient light and used my video light as the only light source. The shadow was large and clear because of the clean wall, the high contrast in lighting, and the low angle position of the video light.

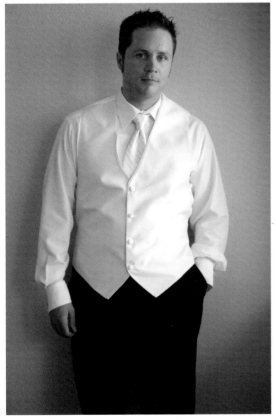

7.15

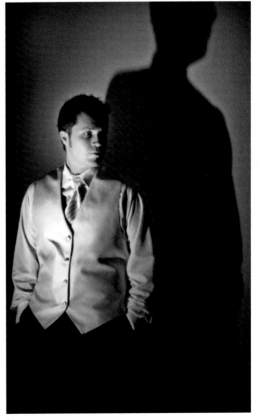

7.16

7.17 As a note to myself, I took a photo of my bedroom ceiling that sparked the idea to practice casting shadows on ceilings.

One early morning, around 4:30 a.m., I was lying in bed. I couldn't go back to sleep, so I just stared at the ceiling for a while. The streetlights from outside were coming through my window blinds, casting a shadow onto my ceiling. This was interesting to me, because I'm not used to seeing shadows on ceilings; usually the shadows are on the floor or on a wall. I live on a higher floor in a residential building; therefore the streetlights were directly below me. I had my Canon G12 on my nightstand, so I took a photo of the ceiling to keep a mental note (**7.17**).

The next day, I began experimenting with my off-camera flash and casting shadows on the ceiling of everything I could imagine. Fast-forward two weeks later. I was about to finish a wedding in the LA area, but I wanted to finalize the occasion with a bang, so I began to scout for unique locations. It was pitch dark, but I ran across this arch that had all the elements I needed for an exceptional photograph. I placed the flash on the floor to simulate the streetlights beneath my bedroom window, and I pointed the flash up toward the ceiling behind the couple. Here is the result of my observations that early morning and my practice sessions the following day (**7.18**).

7.18 How I implemented the idea from my bedroom ceiling during a professional job.

EXERCISE:
PAINTING WITH SHADOWS

Exercise: With an SLR camera, take a walk outside and focus your entire attention on the shape and graphic qualities of objects' shadows. Look for interesting shadows on the ground and on walls. When you find a shadow shape you like, take a photo of it. Ask yourself: where would you place your subject(s) in relation to the shadow? Do you want to use the shadow for balance, or do you want to place the shadow directly on your subjects? If you have someone with you, try both. Focus only on the different shapes and patterns that shadows form with objects in your environment.

Goal: Find a shadow on a wall and use it for balance. Compose the photo so that the shadow is on one side and your subject is on the opposite side. Now find a shadow with a more interesting graphic quality, and carefully place your subject within it to transfer the shadow pattern onto your subject, just as I did with the fine-art nude photograph on page 61.

Explanation: This exercise is about spotting and using the graphic qualities of shadows in your work. It will also teach you to see not just the objects around you but their shadows as well. Try using this technique at least once when doing a photo shoot outside.

EXPERIMENT WITH THE CAMERA SETTINGS

Different exposures will result in many different shadow/light behaviors. When you are painting with light and shadows, it pays to explore different options, especially with the ISO.

8

SILHOUETTES

A SILHOUETTE is defined as an outline that is dark against a much brighter background. But I believe a silhouette is much more than that. To me, a silhouette is all about form and contrast. When a photographic message can be conveyed through form, a silhouette is second to none. Since you don't have to worry about your subject's expression, you can focus on creating great forms. Silhouettes are quite dramatic, and they leave questions unanswered and some aspects of the photo to the viewer's imagination. Although it is a great photographic tool, I recommend using it sparingly.

VITAL COMPONENTS OF SILHOUETTES

For a silhouette to be successful, the right elements must exist.

A VERY BRIGHT BACKGROUND TO CREATE CONTRAST

A bright background is the first step to achieving a stunning silhouette. A great background can be the sky or any surface that is backlit. A photographer can backlight a background using natural light. Any room with a clean, light-colored wall also can be used by lighting it with a flash or video light, as shown in this chapter.

SUBJECTS OR OBJECTS SHOULD HAVE LITTLE OR NO LIGHT FALLING ON THEM

With respect to the brightness of the background, the subjects or objects should have very limited light on them, if any. This will ensure a stark contrast, resulting in a much more defined outline.

NO ON-CAMERA FLASH

If any light from your flash falls on your subject(s), it will clearly take away the necessary bright/dark contrast. It's fine to use a flash to light up the background, but make sure no light reaches your subjects in the foreground.

CLEAR AND RECOGNIZABLE SHAPES

Clear shapes are what make a silhouette a success or a failure. In a silhouette, the key to accentuating shapes is to separate them by creating gaps in the pose where the background can show through. I think of a silhouette when I come across an object with sharp and defined lines against a bright background. For example, visualize a Ferris wheel against the sky. The large number of little carts and poles holding it together creates a more visually stimulating photograph.

CORRECT EXPOSURE

The exposure settings on your camera must be correctly dialed in for a silhouette. Exposing for the shadows will completely destroy all contrast. An f/stop with a large depth of field, such as f/8 or f/16, would work quite well. That way, all the shapes and elements are in focus. Experiment with your f-stops to see what kinds of results can be achieved.

If any of these properties are missing, the photograph will look as if it were underexposed, it will be grayish in tone, and it will lack form (**8.1–8.4**).

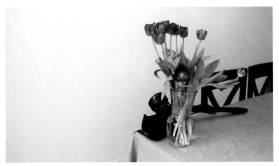

8.1 In setting up an indoor silhouette, start with a clean, light-colored wall. Camera settings: 1/25, f/3.2, ISO 400.

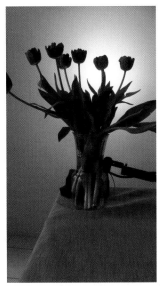

8.2 In this example, the background is well lit, but a nearby window has brought out too much detail in the flowers. That's why you need to make the room as dark as possible. Camera settings: 1/25, f/7, ISO 200.

8.3 In this shot, there's not enough light on the background to create sufficient contrast and separation between the flowers and the wall. Camera settings: 1/25, f/7, ISO 200.

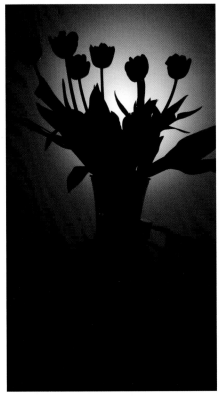

8.4 Here all five elements are executed correctly: I turned up the power on the video light to make the wall as bright as possible, turned off all other lights in the room, and closed the window blinds. Now, I have the contrast needed to create a clear outline of all the flowers and their stems.

CREATING THE OPPORTUNITY FOR SILHOUETTES

Not all the elements of a silhouette need to be immediately present in your environment. If you know what to look for, you can create some of the elements. The key requirement for an indoor silhouette is a translucent background that is lit from behind. If you come across a translucent background in a hotel lobby or inside your house, all you would need to do is place a light source behind it to light it up. Let's look at an example in images **8.5** and **8.6**.

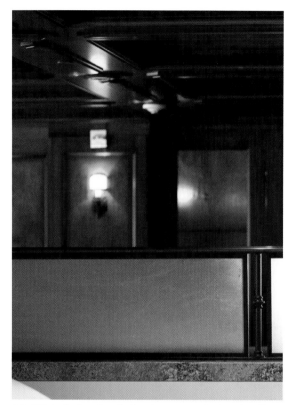

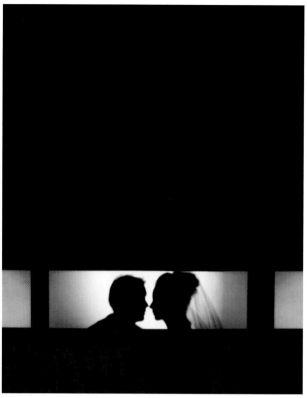

8.5 This is the interior of a hotel restaurant in Beverly Hills, California. Notice the rectangular translucent panel near the bottom of the frame. I asked my assistant to place my video light behind it at full power.

8.6 How do you create the necessary silhouette elements for your photo when they are not naturally there? By exposing for the brightest point, the whole background goes dark, crafting a perfectly clear silhouette of my clients.

This is just one example of many. It is important to remember not to be limited by what you see in front of you. Sometimes, the magic is there but it takes effort. A little tweak here or there can be all you need to create a beautiful photograph.

PARTIAL SILHOUETTES

There are occasions when you want the feel of the silhouette but you still want to give the viewer a hint of detail. This is where partial silhouettes shine. I'm a fan of this technique because it's elegant and achieves a romantic result.

Start by finding the minimum exposure value where your subject begins to silhouette, and then either slow down your shutter speed or change your f/stop to add about one stop of light. This should allow just enough light to give a hint of detail in your subjects. Be aware that the added light on your subjects will require that you also pay attention to their facial expressions. The five elements listed earlier for composing a silhouette are still necessary for a partial silhouette; the only difference is the extra stop of added light.

In image **8.7**, I created a partial silhouette indoors. And in **8.8**, I went outdoors for a candid photo taken one rainy afternoon in Ireland. Since the paving was wet, it reflected the bright sky, turning the area from black to a bright white. Furthermore, the girl walking with her shopping bags was wearing black clothing. This contrast is what inspired me to think that a partial silhouette would look great. Timing was crucial, as it is with most photographs. Being able to recognize the five elements coming together in a scene and instantly react to them takes constant practice and reinforcement.

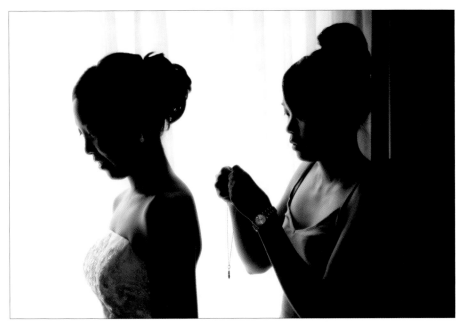

8.7 A partial silhouette taken indoors. I placed my subjects about 12 inches from the curtain to increase the light contrast.

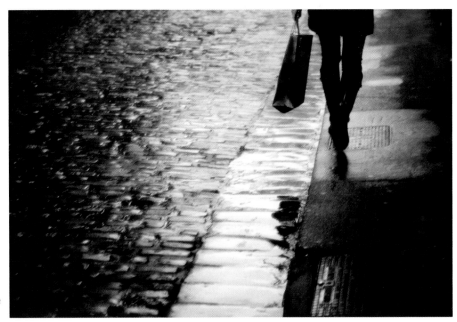

8.8 A partial silhouette taken outdoors.

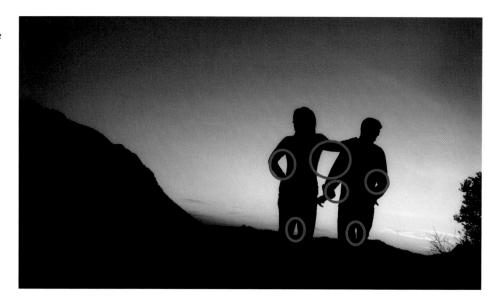

8.9 The gaps created by arms, legs, and heads make the figures more recognizable and interesting.

POSING SILHOUETTES

Posing silhouettes is fun, and it's quite different from posing with a regular exposure. As I mentioned earlier, clear, distinguishable shapes are important here, not facial expressions. Whenever I am posing a silhouette, I create gaps in the body where the background can show through. For example, keep your subject's elbows bent, make sure there is a small gap of space between the legs, and usually have your subjects turn their head to create a profile. If the arms are held straight down along the torso, viewers can't tell where the waist ends and the arm begins. Position the body to create as many gaps as possible.

Image **8.9** illustrates where gaps can be made by bending joints, elbows, knees, and so forth. There are a total of six gaps where the background shows through. These gaps will make the figure more interesting. If the couple simply stood together with no gaps in the pose, they would look like one big, black block.

In **8.10**, I illustrate how to pose a close-up silhouette. In a close-up scenario, there will not be many ways to create gaps in the pose, so make the one or two gaps you can create count. This photo of the couple on the beach has only one big gap between them, but it creates enough separation to clearly distinguish the woman from the man. I also turned the man's head away from the camera to create a more candid feel in the photograph. Notice how clearly the woman's profile shows up against the background.

You can use your knowledge of how to pose a subject to maximize a silhouette in photojournalism. Image **8.11** was taken in Mazatlan, Mexico. I was crossing a bridge over a river when I saw this man walking below. I knew I wanted a silhouette because of the brightness of the water and the solitary man walking across it. I thought it would make a nice melancholic composition. I didn't pose this man, but I waited until his knees and elbows were bent at their maximum angles from the natural movement of walking in shallow water.

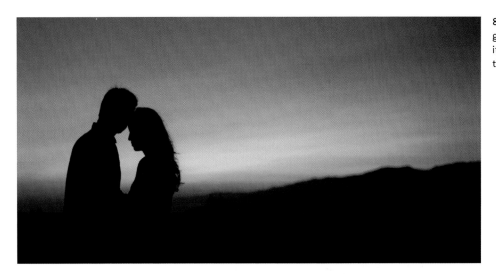

8.10 There's only one big gap between this couple, but it lets you clearly distinguish the woman from the man.

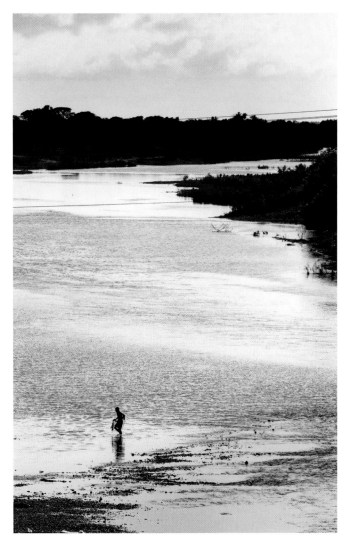

8.11 I didn't pose this man but waited until his knees and elbows were bent at their maximum angles for this silhouette.

CREATING CONTRASTING SILHOUETTES

Creating light contrasts with silhouettes is an advanced technique that requires extra work to hone your skills and to be able to do it on location. If this technique is executed correctly, it can create spectacular photographs. It requires at least two subjects of interest in the photograph. One person should be in silhouette, and the other should be lit. How the second person is lit is up to you. The most common methods are to use a video light, an off-camera flash, or, of course, the sun if the situation permits. Let's take a look at examples of all three.

Image **8.12** shows an example of a silhouette contrast using the natural light. This photo was taken during a wedding in Cabo San Lucas, Mexico. As we walked down the street, I noticed a little restaurant with a wooden door. I peeked inside and the room was darker than I had anticipated. This created a perfect scenario for a contrasting silhouette. All I had to do was position the bride by the door to allow all that light from the outside to illuminate her beautifully, and then position the groom around 10 feet away from the door, where it was dark. I exposed for the bride, automatically turning my groom into a silhouette. That's all! It is quite simple if you know what to look for.

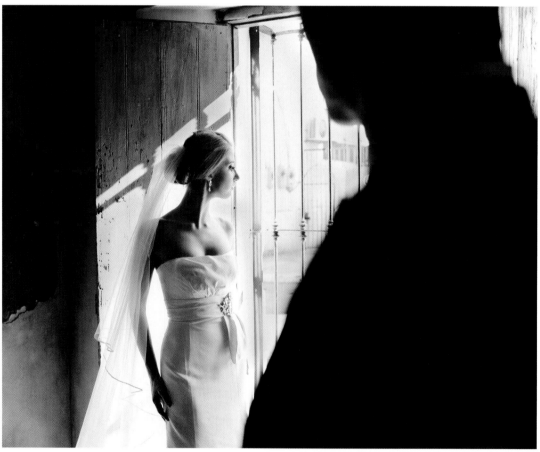

8.12 Exposing for the brightly lit bride automatically turned the groom into a contrasting silhouette.

Image **8.13** shows a contrasting silhouette using off-camera flash. This photo was taken during an engagement session in Pasadena, California. I stumbled upon this room where I noticed a beautiful mirror. There was a window nearby, but the light outside was dim and the window was not letting in much light. I enhanced the window light by using an off-camera flash. The flash is positioned outside the frame to create the illusion that it's all window light. The flash also brightened the curtain, creating a perfect background for a silhouette. I positioned the groom 10 feet in front of the brightest portion of the curtain and pressed the shutter. The mirror reflection was a nice touch to create balance in the photograph.

Image **8.14** shows a contrasting silhouette using a video light. The two elements of interest in this photograph are the couple and the trees in the foreground. I wanted to expose for the tree branches, but I wanted the couple in silhouette. I placed a video light on a stand behind them and exposed for the trees.

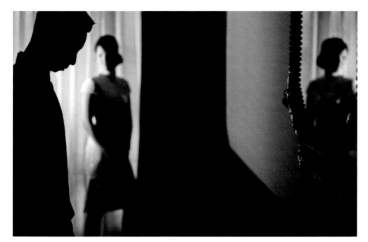

8.13 An off-camera flash creates the illusion of a bright window, creating a perfect background for the silhouetted groom.

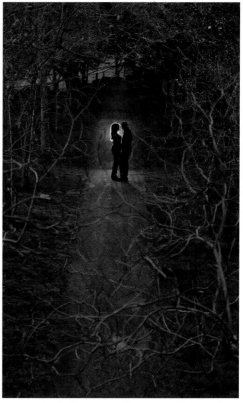

8.14 A video light on a stand creates a silhouetted couple without erasing details in the foreground branches.

REFLECTIONS USING A SINGLE MIRROR

A mirror is the most obvious source of a reflection. However, that doesn't mean it can't be used in a powerful way. A single mirror can be used to show two sides of the same person or two people's point of view, or to create balance in a photograph.

TWO SIDES OF THE SAME PERSON

Oftentimes, when photographing on location, you will find a single mirror in a hotel hallway or inside a house. This mirror can be used to show a physical feature of a person or showcase, for example, an accessory that individual is wearing in the reflection. These are just a couple of the countless possibilities to try when using a single mirror in your composition. Image **9.1** was taken inside a hotel lobby in Santa Barbara, California. There are many aspects to admire in this beautiful bride—her jewelry, her gorgeous headpiece, and her elegant jawline. The only way to showcase all of these elements in a single shot is to use a mirror. Looking at the reflection, you can now appreciate how beautiful her jawline is. As you can see, all of the elements I wanted to feature in this portrait are now visible. If you are a children's photographer, you can take a photo of a child holding something behind his or her back and use the reflection of a mirror to complete the story and reveal what it is the child is hiding.

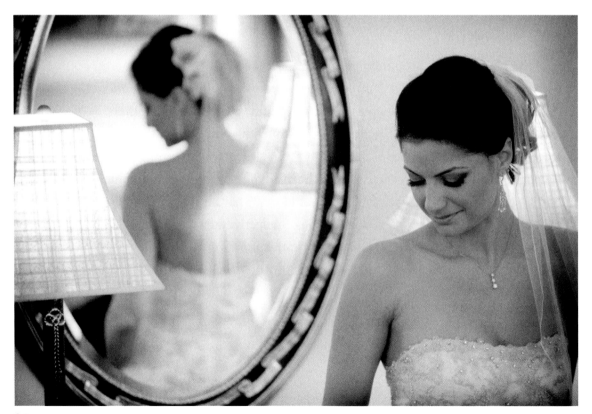

9.1

CAPTURING EXPRESSIONS AND RELATIONSHIPS THROUGH A MIRROR

Perhaps the story you want to tell is in the facial expressions or the body language of two or more people. Using a single mirror's reflection to demonstrate the relationship between two people is a powerful way to tell a visual story. But it is a story that doesn't answer all questions, because you can only see the faces of the people in the mirror or the other person. It is one or the other, and that's the beauty of it!

While photographing a wedding in Donegal, Ireland, I noticed how involved and proud the bride's mother was while her daughter was getting ready (**9.2**). It was a team effort between the two. Finally, when the bride was completely dressed in her gorgeous gown, she turned to the mirror for one last check. This is the moment where recognizing how a mirror can help you tell a story comes in handy. I quickly moved to include both the bride spreading her long veil and her proud mother in the reflection admiring how radiant her daughter looked on this long-awaited day. The expression of the bride's mother is priceless, and all it took was a single mirror to make it possible.

If the mirror is not fixed to a wall and it can be moved, then move it into position to tell your story. Ask if you need to, but usually nobody will have a problem if you move objects around for photographic purposes.

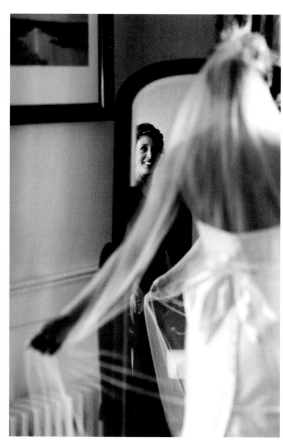

9.2 Photographing expressions and relationships through a single mirror.

TELLING MULTIPLE STORIES THROUGH A SINGLE MIRROR

This, to me, is the greatest asset of mirrors or reflections. Being able to tell different stories in a single photograph is fun and visually powerful. To execute this technique correctly, one story should be happening within the mirror and another story elsewhere. Naturally, both have to be visible in the same photograph.

In image **9.3** I quickly noticed the mirror to the left and the fact that it was adjacent to another room. This is an ideal setup for this technique. I asked the groom to continue putting on his tie, but I moved him to where I could see his reflection in the mirror. The father of the bride was sitting in the other room quietly reflecting on the day ahead. These two represent the most important men in the bride's life and a photograph in which both are thinking about the meaning of the day, at the same time and in the same photograph, would be priceless! This technique requires that both subjects be well lit. Creating separation between the background and your subjects is even more important here than in other situations.

If only one section of the photograph is well lit and the other is not, use a wireless flash or a reflector to create that much needed light. Whenever I walk into a room with a mirror, I automatically think "double stories" instead of "that's a nice mirror." Taking full advantage of the objects around you is what separates the good shots from the great shots.

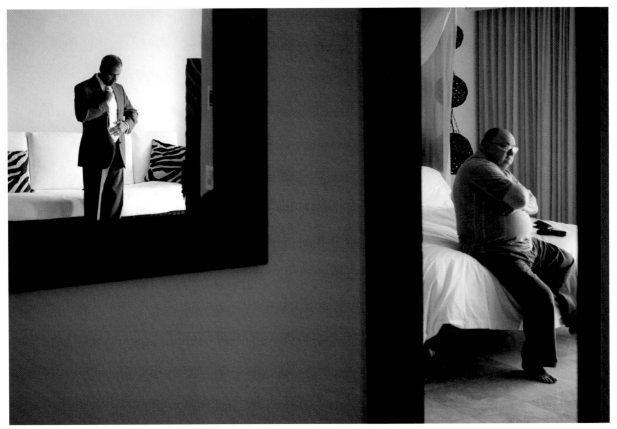

9.3 Image with multiple stories using a mirror.

EXERCISE:
STORIES THROUGH REFLECTIONS

Exercise: Grab two objects you can carry around. If you have two teddy bears, that would be great! Walk around your house with your camera and find all the hanging mirrors. These could be vanity mirrors, bathroom mirrors, or decorative living room mirrors. For each mirror you see, place a teddy bear (or any object of your choice) in a place where you can see its reflection in the mirror. Place the other teddy bear elsewhere as long as it does not show on the mirror and you can see both teddy bears in your frame. Take a photo. Now use a wireless flash or a video light and illuminate one of the teddy bears with it to see how much of a difference it makes with and without the flash. You might have to experiment with your settings until your exposure is right.

Goal: Repeat the process for every mirror you see around your house. Remember, for every photo you take, one teddy bear should be seen in the mirror's reflection, and the other should just be in the frame. If you can balance the two, that would be even better!

Explanation: This exercise is time consuming and challenging, but it will make you familiar with how the different shapes and sizes of mirrors behave. It will also teach you where the two subjects need to be with respect to the mirror in order to create the stories.

CREATING BALANCE WITH A SINGLE MIRROR

As we discussed in the balance chapter, it is pleasing to the eye to have objects of importance on both the left and right sides of photographs. This creates another great application for reflections. By having your subject on the left and its reflection on the right, it creates perfect balance. It also creates visual interest throughout the photograph, not just on one side.

During a wedding in Chicago, I walked to the top floor of the hotel where the groom was getting ready to see his fiancé for the first time (**9.4**). Although the view from that room was an attention grabber, I focused on the elements inside the room. There was a long vertical mirror on the left side. This was all I needed to create balance through reflections. I asked the groom to take a few steps forward until I saw his reflection in the mirror, then I took the photo. In this situation, there was enough light to create separation between the groom, the background, and his reflection, but that is not always the case.

In image **9.5** (which I also discussed in the previous chapter), there was no light hitting the bride. This photo was taken almost at nighttime. The mirror gave me the idea for the pose, but for it to work, I had to use a wireless Speedlite on the left side to illuminate the bride. The light from my flash then looked like natural light and her reflection on the right became strong and clear. Both sides are now balanced. Also notice how I am starting to combine elements—in this image, you see a reflection with balance and a silhouette together creating a single exposure.

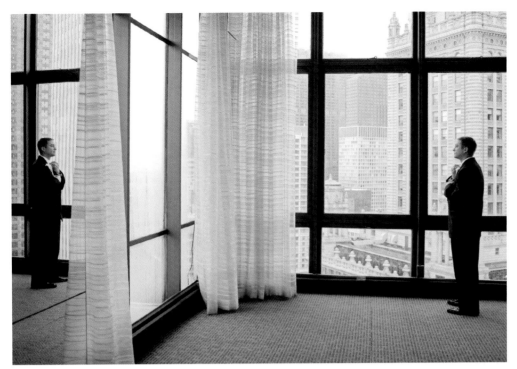

9.4 Image balanced with reflections using natural light.

9.5 Image balanced with reflections using a wireless flash.

REFLECTIONS USING TWO MIRRORS

Now let's take a look at a two-mirror situation. Two mirrors can provide a unique way of looking at the whole room in one shot. They also can show different views of a bride's dress. If the mirrors are scattered across the room, you could challenge yourself and try to have a story in each mirror. Pushing yourself to attempt techniques that are out of your comfort zone will make you more skilled at your craft. Your arsenal of techniques will just keep getting bigger and bigger.

Another technique worth learning is how to best photograph a situation where two mirrors face each other. Image **9.6** shows an example where a bride's room was furnished with double mirrors. However, there was no natural light in this room. The light used here to illuminate the bride was a Lowell video light.

When I first started practicing with double mirrors, I used to make the mistake of placing the subject in the middle of my frame and not paying any attention to balance. I also used to tilt my camera, causing the repetitive reflection to magnify the tilt effect. My subject looked as if he or she was going to fall out of the frame.

9.6 Image using double mirrors indoors lit by video light.

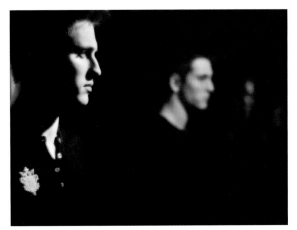

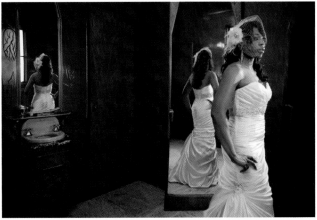

9.7 Image using dark panels to replicate the double-mirror effect.

9.8 Image using double mirrors for both angles and balance.

After much experimentation, I found these guidelines be helpful in a double-mirror scenario:

1. Avoid camera tilt. Keep the subject parallel to the edge of your frame.

2. Place the subject on the far left or right, creating balance with the repetitive reflection. This will also increase the amount of reflections in the frame.

3. A 50mm lens gives you the right combination of perspective without much distortion. Plus, it is wide enough to accommodate a large number of repetitions.

In image **9.7** the reflection came from a couple of dark panels that I found in a room. The panels were not mirrors, but they had strong reflective qualities. I moved the panels around until I saw a repetitive reflection. In this case, the black panels were so reflective that any other light source would have been distracting. I wanted only the model lit, so we turned off all the lights in the room and used a video light to illuminate him.

The moral of the story is that the double-mirror look does not have to come from mirrors. Learn to use the objects around you in ways that you normally wouldn't. Although these panels were not as reflective as a mirror, they were reflective enough to create this effect. Image **9.8** is an example of how the mirror on the right was used to offer a different angle of the wedding gown, and the mirror on the left was used to balance the photograph. That created a point of interest on each side of the composition.

USING BEVELED MIRRORS

By now, you realize how many different ways you can use mirrors in photography. But so far, we have only discussed the mirror itself. Most decorative mirrors used in interiors are framed and beveled. The bevel is that small section where the mirror is angled just before the beginning of the frame. This is a very popular design used by mirror manufacturers, because it gives the mirror an elegant look.

Almost every hotel room that I have ever been in has a framed, beveled mirror. At first sight, the bevel doesn't do much, photographically speaking, but take a closer look, move yourself around the bevel, and study what you see. Here is an image of a typical mirror at a hotel room (**9.9**). The callouts mark the bevel in three places. Notice how the bevel interrupts the reflection. When you begin practicing photographing with beveled mirrors, the challenge is to know where to stand with respect to your main subject to take advantage of the effect the bevel creates. The angle of the bevel and its thickness can determine where you should take the photo.

Image **9.10** shows the fruits of my labor. At a wedding in Santa Barbara, the hotel room, as expected, had a decorative beveled mirror. I positioned the bride and myself as close as possible to what I had practiced, and made the necessary adjustments to fit the image within the size and angle of the mirror's bevel. Had I not experimented with the mirrors in so many different ways, this photo would have never occurred to me. This portrait of the bride became one of her favorites from her wedding.

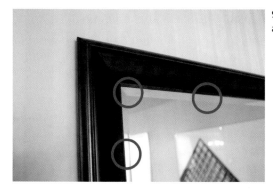

9.9 Image showing the mirror's bevel and how it distorts the reflection.

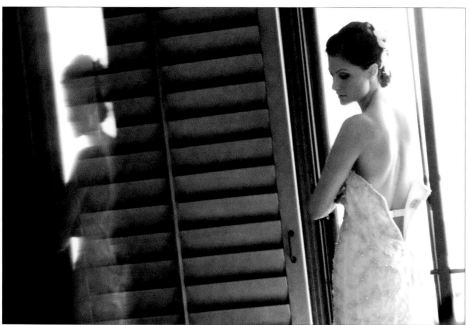

9.10 Image created by correctly using the mirror's bevels.

REFLECTIONS FROM WATER

Water is probably the most common type of reflection seen in photographs. For a water reflection to work well, the water must be still and the winds calm or absent. Photographers often use a body of water to reflect the landscape above or a masterpiece of architecture. Although using a large body of water is a great way to achieve a clear reflection, it is by no means the only way.

Sometimes, a more subtle reflection from water is far more interesting. If you offer a reflection with water using a different twist, it will grab your viewer's attention. But using a lake, pond, or river does not always yield a good reflection. Certain elements need to be present for the reflection to be effective. The weather and the time of day are crucial factors.

The sun must be in a position where it is illuminating the landscape you want to reflect but not the water itself. A circular polarizer filter will be handy to eliminate unwanted reflections. Although helpful, you will lose about 1.5 stops of light while using one. I find the best reflections occur after it rains. The light becomes golden, and the quality of light after a rainstorm is hard to beat. This was exactly the case during a wedding in Maine (**9.11**).

It had rained all day during this wedding. The skies never quite opened up, but it did stop raining for an hour or so. I knew this light condition was ideal for a great reflection shot, so I asked the resort if we could borrow a golf cart to take the wedding party to a lake. I had two wireless Speedlites behind the group when the photo was taken. The job of the Speedlites was to add a bit more separation between the people and the environment. This type of photo not only has a beautiful reflection in it, but it also has horizontal symmetry (as discussed on page 31).

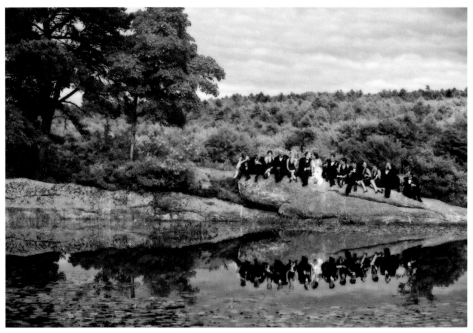

9.11 Reflection with a large body of water.

Now, let's move away from large bodies of water and into the world of small puddles (**9.12**). This couple asked me to shoot their engagement photos in downtown Los Angeles. They wanted a real sense of the city with all the cars, traffic, buildings, and people. I could have taken this photo a few feet away and it would have been fine. However, there was a man cleaning the sidewalk with a hose and I just couldn't resist.

I illuminated the couple with a wireless Speedlite to strengthen the reflection in the small puddle. If I had another Speedlite handy, I would have placed it behind them to also create separation between them and the buildings behind them. The reflection itself does not need the extra light because it is reflecting the bright sky. The sky created a natural separation from my subjects.

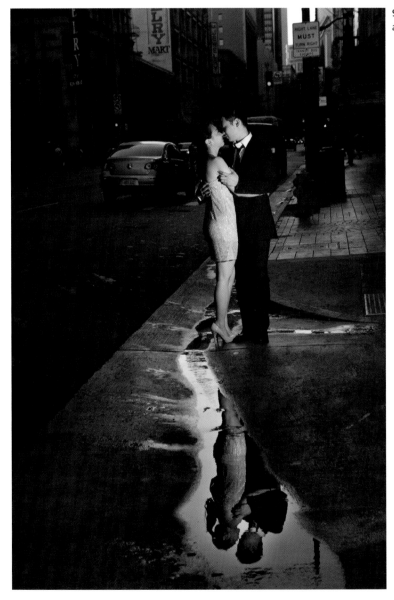

9.12 Reflection with a small puddle.

FINDING REFLECTIONS IN UNLIKELY PLACES

Although taking advantage of mirrors and water for their reflective qualities is valid and visually stimulating, people come to expect it in photographs. A reflection in a mirror might be neat, but it's not unusual. After all, that's what mirrors are for, right? This section deals with reflections where people don't expect them.

These types of reflective surfaces appear all around us, but we don't think of these reflections in the same way as we do mirrors or water. These reflections are more obscure and they require some extra work from you to master them. Materials such as lacquered furniture, wineglasses, cars, or framed pictures all have reflective qualities that we can take advantage of.

Consider image **9.13**. The reflection on the right-hand side does not come from a mirror; it's actually nothing more than the protective glass of a picture hanging inside a hotel room. Standing in front of the framed photo, you see the desert landscape depicted as the artist intended. But by positioning your camera parallel to the glass just an inch away from it, the picture will disappear, leaving behind the reflection from the protective glass.

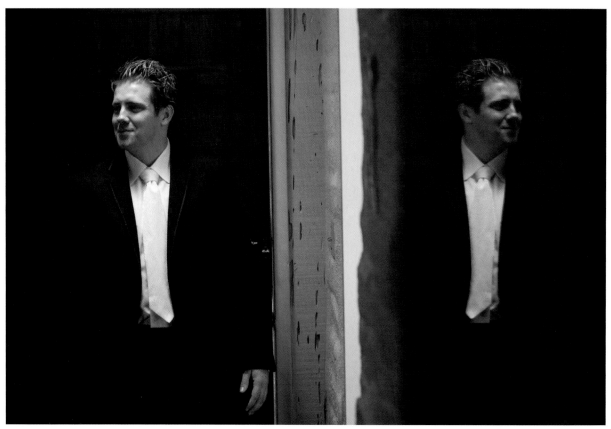

9.13 Image of a reflection created by the glass of a decorative framed photo.

Image **9.14** was taken using the lacquer finish of a piano. At the end of a wedding at Orange County's Ritz-Carlton, I walked by this room that had a table with a shiny finish (**9.15**). The reflection here might be subtle, but it adds another element of interest to the photograph. I used a wireless Speedlite behind the couple to create separation.

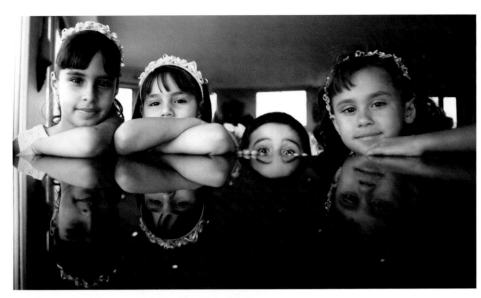

9.14 Image of a reflection using the top of a piano.

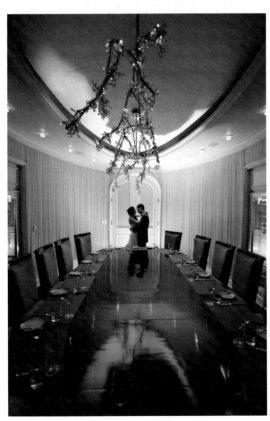

9.15 Image of a reflection using the reflective finish of a table.

I was inspired to take image **9.16** simply because of the long and narrow mirror near the hotel lobby. The mirror was too narrow to reflect a whole person, but we don't always have to show the entire person. I positioned the bride so she would be on the right-hand side of my frame, and I asked her to get on her tiptoes to showcase just her lips in the reflection on the left.

The last example, image **9.17**, I took at a wedding in San Diego. The bride and groom rented an historic vehicle to take them to and from the church. One of the first things I noticed was the chrome finish on many parts of this car. I told myself, "These are all potential reflections." What made me decide to use the chrome headlights was their shape, which created a bit of a fisheye effect on the reflected landscape.

9.16 Small mirrors can create big results.

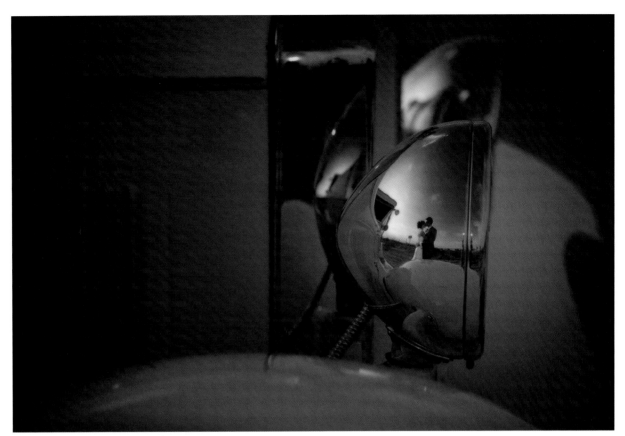

9.17 Image of a reflection using the chrome of an old car's headlights.

A NEW WAY OF SEEING THE OBJECTS AROUND YOU

If you can learn to see objects for their photographic potential instead of for what they actually are, you will become an outstanding photographer!

Exercise: In this exercise, we are going to focus our attention on finding reflections in unlikely places. Pour yourself half a glass of wine, take it outside, and study the reflections it creates. The reflections from a wineglass will be upside down, but as long as you can see a reflection, you could use it to tell a visual story.

Look at the rims of cars, or any part of the car with a chrome finish. Become familiar with which materials are reflective and which are not. Next, use a light source such as a wireless flash, a reflector, or a video light and experiment with how you can enhance the clarity of the reflection from different surfaces. Be sure to write down your results and to not erase any images from your camera during the exercise. The progression of your photos can teach you a tremendous amount.

Goal: Find at least 10 different reflective surfaces. Mirrors and water don't count in this exercise. Once you find the reflective surface, you want to know how to enhance that reflection by supplementing light from any of the light sources listed earlier. Natural light does not count here, unless it is being bounced from a reflector.

Explanation: The skills you gain from this exercise will not only help you quickly identify reflective surfaces, but also teach you how to enhance the reflections with different types of light. Many people can find a reflection somewhere and take a photo, but few take the time to attempt to enhance that reflection. Even fewer know exactly how to do it. I assume you want to be a part of that rare group. After this exercise, I can assure you that you will never see reflective surfaces in the same way again. You will now look at these surfaces or objects from the point of view of an artist!

10

PATTERNS AND REPETITIONS

ALTHOUGH CLOSE, patterns and repetitions are not exactly the same concept. A pattern requires a larger number of repetitions for it to be considered a pattern. A repetition can be something repeated just once or twice. Both have important applications in photography.

Patterns exist everywhere. On an average day, you are probably exposed to numerous patterns. You may not be especially aware of them, because they are just a part of life. But to a photographer, patterns are crucial to creating a sense of infiniteness.

INCORPORATING PATTERNS INTO PHOTOGRAPHY

Photographing on location, you will be exposed to a lot of visual chaos. The different types of objects, colors, and shapes present in any scene can be overwhelming. The problem lies with your vision span. Your peripheral vision can span about 120 degrees. Although that's good for your survival, it's not so advantageous for photography.

Being able to spot and use patterns in photographic composition brings harmony to an otherwise chaotic scene. Patterns are easy on the eyes, and they serve as great backgrounds for your subjects. However, in order to use them, you must first learn to see the environment around you with tunnel vision.

Tunnel vision allows you to focus on a small area of the environment, thus enabling you to see patterns. You must train your eye to see patterns and repetitions everywhere you go. To the naked eye, a pattern ends as soon as you turn the other way, but in a photograph, you can't turn around. If, for example, the entire frame is covered with a single design, the viewer cannot see where the pattern begins or ends. Furthermore, patterns are not distracting, because by their very nature, they are easy on the eye. Posing a person in front of a pattern will most likely not take away from your subject.

BREAKING A PATTERN TO ISOLATE A SUBJECT

A break in a pattern is distracting, because your brain is quick to notice these disruptions for your own survival. For example, if you are reading a book inside at home with the TV on, the pattern of the continuous sound coming from the TV fades into the background. But what if you suddenly hear a loud noise that does not fit the pattern of the TV noise? You quickly react. The same thing happens in photography.

EXERCISE:
FINDING PATTERNS THROUGH TUNNEL VISION

Exercise: Use tunnel vision to find patterns. Go outdoors and walk around. Focus on finding designs within anything—bricks, plants, trees, leaves, flowers, designs, etc. Take a photo of each pattern you find. Let your eyes zoom in and train them to recognize patterns in any environment.

Goal: Find at least 15 patterns. They are easy to find, so this exercise should not take too long.

Explanation: It takes practice to go against your nature to want to see as much as you can to find patterns; you must narrow your vision to a tunnel at any time and any place. On a paid photo shoot, you may be too nervous to consciously find the patterns in your environment. Practice this goal constantly until it becomes second nature, and it will still happen when you are under pressure.

A pattern in the background of a photograph fades out, and your subject becomes more prominent. But if there is a break in the pattern, you will likely notice it and it will annoy you while looking at the photograph. On the flip side, breaking a pattern with something that doesn't belong can be a very effective way to force your viewers to pay attention to the object that breaks the pattern.

Imagine looking at a photograph taken from above with 50 open, green umbrellas—and a single red one. Take a look at image **10.1**. It is impossible to not notice the red circle, right? This is a simplified illustration of what happens from the viewer's point of view when a pattern is broken. Use your imagination to think of how you could incorporate this effect into your work. The possibilities are almost endless. Remember, breaking a pattern is a technique that can work for you or against you; it all depends on how you use it.

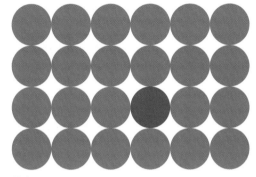

10.1

COMBINING PATTERNS WITH GEOMETRY

Patterns can be random shapes and colors, but they also can take the form of geometric shapes that you recognize. Both are effective tools, but a geometric pattern brings yet another level of visual harmony to your photographic compositions. By using geometric patterns, you are creating composition building blocks that will add to the impact and beauty of your work.

EXERCISE:
USING BROKEN PATTERNS

Exercise: It is much easier to find simple patterns around your neighborhood than it is to identify a broken pattern. However, incorporating broken patterns into your work can be a real treat! A broken pattern could be, for example, a row of trees that are all of similar heights except for one that is much taller, or a white picket fence with one board of a different color.

For this exercise, you may need to walk or drive farther to find such broken patterns. Once you find one, use what you learned from Chapter 2, "Balance," in using the broken pattern. Place a subject at various distances from the object that breaks the pattern. Be sure not to erase any photos—you want to keep them all to analyze them later.

Goal: Find three broken patterns and use what you learned in the balance chapter to create a well-balanced photo with the broken pattern.

Explanation: Think of photography as building a house. You need a foundation, and then you build on it. That's exactly what you are doing here. You are using patterns as your foundation. The broken pattern is another piece, and what you incorporate from Chapter 2 is yet another building block. When all these elements come together, the result is an outstanding photograph!

Non-geometric patterns can include a wide variety of shapes or graphics. Because these graphics are not in a shape you can easily describe, they require more of your brain's attention to make sense of them. The result is a more interesting design than a geometric pattern, but it also competes with your main subject for attention. This issue can be easily remedied by using light to guide your viewer's attention back to your subjects.

Image **10.2** is a clear example of using geometric patterns. The diamond shapes were name plaques honoring those who donated money to construct the building. Because the diamonds were backlit, I was able to darken my exposure to create a strong contrast between the wall and the diamonds; this way, the diamond pattern will be radiant against an almost black wall. I used a video light to illuminate the couple and to keep the warm color tones of the photo.

It will be easier at some locations than others to find a useful pattern. Image **10.3** of the library gardens in Orange County illustrates this point. If you stare at the photo carefully, you find patterns everywhere; the red roof tiles, the cream bricks that make up the wall of the house, and the bamboo plants on the right, just to name a few. Clearly the roof pattern was out of reach and the cream color of the bricks did not provide enough contrast, so I decided to choose the bamboo on the right. They were up high, so I asked the couple to stand on the red brick border surrounding the bamboo sticks.

10.2

10.3

Image **10.4** is the result of narrowing your vision to ignore the rest of the scene and focus only on the pattern, color, and contrasts of the bamboo sticks. Because the viewer cannot tell how much bamboo is there, the photograph creates the illusion that I took it in a forest—even though the location was a small patch of bamboo sticks in the middle of Orange County.

This quality of creating illusions is where patterns and repetitions shine in photography. In this case, we had a small patch of bamboo to work with, but when you're photographing in a large field, it is important to take time to find the cleanest area. Look for a part of the field that will enhance the pattern of the flowers or plants present.

Consider image **10.5**. From this angle, it is difficult to pick out the patterns hidden in that cluster of bushes, especially near the ground where the mess becomes even more evident. Notice how the bushes near the bottom are different types and sizes. That's not ideal, so move around and find a section where most flower stems are the same, and a pattern can easily be picked out. In image **10.6**, from the same area, most of the flower stems are similar and a clear pattern of green stems and yellow-white flowers is apparent.

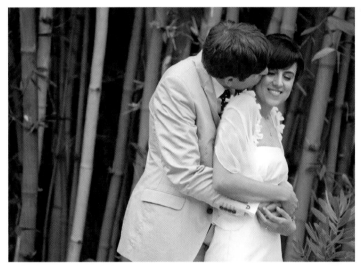

10.4

10.5

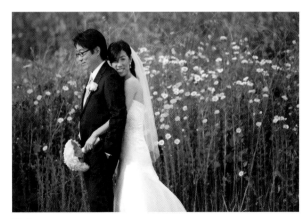

10.6

USING A FLASH TO BRING OUT THE PATTERN

I spotted this pattern of yellow and blue vertical lines inside a hotel in Santa Barbara (**10.7**). Lines are geometric, so it caught my attention. At first, they did not appear to have much potential, because the lighting was dull and flat. The potential for a great photo was there, but it needed help.

I solved the issue by placing a wireless flash behind the couple pointed toward the vertical columns at a 45-degree angle. The couple was illuminated by window light and a reflector (as discussed on page 122). Photography is about solving problems. The ideal location with perfect lighting does not exist. You must use your photographic tools and your imagination to bring out the best in all types of locations. All locations have the potential to be part of a great photograph, but it takes considerable skill and dedication to visualize the scenario, and most importantly, to execute it.

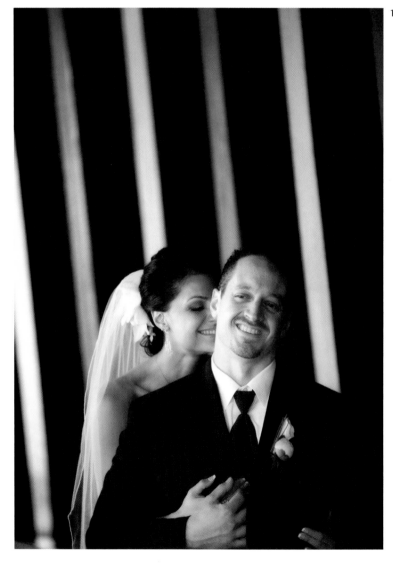

10.7

COMBINING PATTERNS WITH GEOMETRY AND SYMMETRY

Now that you understand how to work with patterns using geometric shapes, such as lines, diamonds, circles, or rectangles, you are ready to stack your photographic building blocks even higher. You will now combine geometric patterns and symmetrical patterns at the same time. Patterns like this may not be perfectly symmetrical, but they contain enough symmetrical qualities to work.

Image **10.8** is an example of a location with symmetry and geometry in the pattern. I used a reflector to bounce light back to the groom. Compare the difference in the feel of the photograph to the nonsymmetrical patterns. The photos above have more tension in their composition, whereas the symmetrical patterns are more peaceful and harmonious. You can always add a bit of tension to symmetrical patterns by moving the line of symmetry off center. The symmetrical pattern in image **10.9** shows how the vertical line of symmetry was moved to the right. This wall is perfectly symmetrical, but by moving the line of symmetry to one side, you can achieve a combination of harmony and order, with a spark of tension.

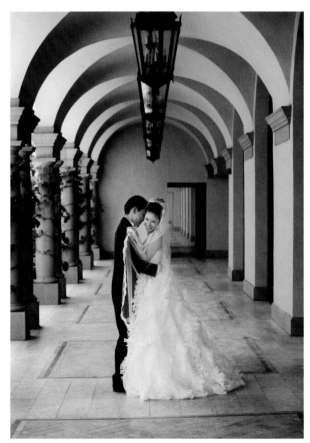

10.8

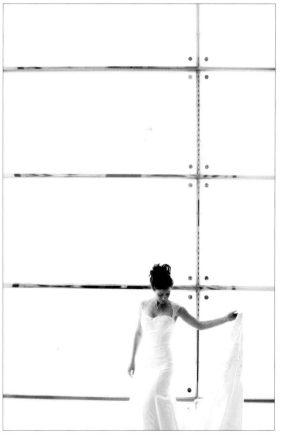

10.9

WORKING WITH REPETITIONS

By definition all patterns are repetitions, but not all repetitions are patterns. Repetitions are most commonly seen in nature photography, such as repetitive trees reflected on the water or water lilies floating on a pond. I'm going to take the aspects I like so much about those repetitive natural elements in landscape photography and apply them to portrait and wedding photography. I'll explain two main methods of applying repetitions to people photography. The first is to place your subjects within the repetition or near the repetitive elements. The second is to position your subjects so that they themselves become part of the repetition.

POSITIONING SUBJECTS WITHIN OR NEAR THE REPETITION

This technique requires that you incorporate your subjects and the repetitive elements in a place where they are independent of each other. In other words, the subject(s) would be next to, in between, or mixed in with the repetitive elements.

In image **10.10**, you can see how the couple is positioned between the two rows of trees. If the couple were posing by one of the trees, the photo would have a very different feel with much less impact. Posing a subject in between repetitive elements creates a feeling of security, as if the two rows of trees were providing shelter or protection for the couple. On the other hand, posing a subject next to a repetitive element would serve as a guide or a leading line to the subjects.

10.10

Let's look at another example of the same concept. Image **10.11** shows a couple sitting in between rows of chairs. Although the environment is very different from the previous example with the trees, the feeling of protection is the same.

POSITIONING SUBJECTS TO BECOME PART OF THE REPETITION

Now, let's look at the technique from a different point of view. Instead of our subjects being in between or in front of the repetition, position them adjacent to it. By having your subjects stand or sit adjacent to a repetition, it will appear as if they are also part of the repetition. This will depend greatly on what object is being repeated.

Take a look at image **10.12**. I purposely positioned the groom at this exact spot to continue the row of vases in front of the white wall. If you look at this photo from 5 feet away, he almost appears to be a third vase on the left. Or, if there had been a third vase here, it would be in the same spot as where the groom is now standing. There are two different ways of looking at it, but the results are the same. During a wedding in Savannah, Georgia (**10.13**), I spotted this row of Toi Toi grass plants and decided that this would be a good place to implement this technique. I simply had the couple stand adjacent to the plants as if they were plants themselves.

10.11

10.12

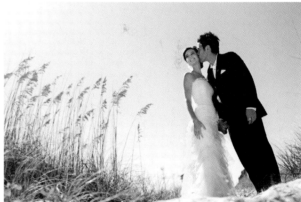

10.13

Exercise: Take a stroll in your neighborhood and notice if the elements around you create a pattern or a repetition. If it is a pattern, ask yourself whether the pattern is nongeometric, geometric, or both geometric and symmetrical.

Goal: Photograph five patterns and five repetitions.

Explanation: Both patterns and repetition are effective tools for creating a significant impact in a photograph, but they are used differently and yield distinctive results. Therefore, it is important to be able to distinguish the two quickly.

11

FRAMING

IF YOU OWN AN SLR, chances are you are familiar with framing. *Framing* is a basic photographic technique that draws the viewer's attention to the main subjects by framing them with something else. When you visit a framing store, you pay close attention to the various options to frame your cherished photographs. You look at color, thickness, style, and the different frame materials. Your goal is to find a frame that draws attention to the photograph without distracting from it. Naturally, the best choice depends on the photograph itself.

In photography, all these style elements remain the same. The frame itself can tell a story or say something about the subject being photographed. There is much more to it than an aesthetically pleasing frame. To master framing, learn how each type of frame changes the mood and affects the storytelling qualities of your photographs. This chapter takes a close look at a variety of framing techniques to better tell your visual story.

CREATING ACTION INSIDE A FRAME

Captivating moments can happen anywhere and anytime—but when they occur within a framing device, that's photographic gold. Look around for possible objects that you can use as framing devices, and then photograph a strong moment within your chosen frame. That moment can happen naturally, which may take a long time and luck, or you can make it happen.

A candid pose is far more effective than a clearly posed one with the subject aware of the camera. Photographing through a frame is a way to take a sneak peek at something the viewer is not supposed to see. Think of it as a barrier between you (the viewer) and a moment in a person's life seen through a small crack in that barrier. This surreptitious feeling is the most powerful aspect that framing brings to your photographs.

To better illustrate this, take a look at two photographs (**11.1**, **11.2**). The first one is cropped to show you an action without a frame. The second shows the same moment, only this time framed. The cropped photo shows a bride taking a last look at the dress she worked so hard to select for her big day. The bride's attention is focused on the dress, not the photographer, so the photo looks candid. There is no barrier; we have a front row seat watching the action.

Compare the unframed image to the framed one. The framing element immediately changes the scene's overall feel. The two doors guide you to a moment on the bride's wedding day. It appears as if she was going about her business, when you walked by and caught sight of the moment. It turns out this photo was indeed candid. However, I had previously placed the dress in that exact location so that this candid moment would happen naturally.

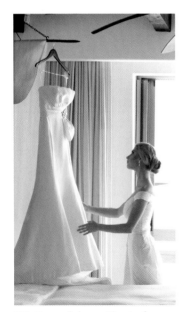

11.1 Cropped close without a frame, the photo gives the viewer a front row seat.

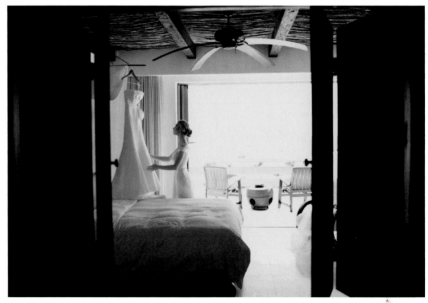

11.2 When framed by the doors, the overall feel of the scene immediately changes.

The doors separated the bathroom from the bedroom. I stepped inside the bathtub to see what the scene might look like from that perspective. I then moved the dress within the bedroom and waited in the tub until the bride was ready to put on the dress. The photo might look completely candid, but it took quite a bit of effort to make sure this moment would happen.

CREATING FRAMES

Framing devices are usually easy to find in most situations, but frames also can be created. To create frames on a shoot, you must train yourself to know what kind of objects make great frames. Moving objects around is a great way to start creating frames. Another image taken at the Montage Beverly Hills hotel illustrates this concept (**11.3**).

I had already taken several portraits of the groom when I decided to take a framed portrait for variety. I could have used the rectangular mirror in the room to frame the groom, but it just wasn't creative enough. As I looked outside, I noticed the sliding doors leading to the balcony. They were wide open, so I brought them together to create a nice frame for the groom. The dog at his feet was an unexpected bonus.

11.3 I pulled the balcony's sliding doors closer together to create a nice frame for the groom.

Just as I created a frame by partially closing the hotel doors, you can do the same outdoors. At a wedding in Tucson, AZ, I had limited time and limited options inside the hotel, so I took a stroll outside (**11.4**). I wanted to create a frame, so I asked my assistant to grab the end of an ocotillo plant and pull it down. This action created an arch. The frame was set, so I just asked my couple to pose within the arch (**11.5**). I focused on the ocotillo plant to achieve that candid, "secret moment" feeling.

11.4 With limited options in the hotel, I turned to the surrounding desert.

11.5 The frame was created by using an ocotillo plant as an arch for a seemingly candid moment.

EXERCISE:
USING OR MOVING OBJECTS TO FORM FRAMES

Exercise: It's your turn to try this technique. Move around such objects as curtains, chairs, and doors to create frames that were not already there.

Goal: Create three different frames using objects around your house.

Explanation: Be creative and don't be afraid to try things. Even if the frame you created does not look like much of a frame, at least you will have a better idea of what works and what doesn't. After performing this exercise several times, you will know how to move certain household objects to create interesting frames. Some objects will not even need to be moved to create a frame; it may only require that you look at the object from a different angle or perspective. For example, think of the legs of a wooden chair from a normal perspective. They're just part of a chair. But if you get down to the floor level, the legs and the chair create a rectangular frame. Create an action inside that frame and you'll have a creative photograph.

NATURAL FRAMES

Natural frames include tree branches that frame a building or other natural elements, such as a pair of trees. Although easy to find, natural frames are nonetheless effective and beautiful. They say something about the landscape or the time of year, depending on the color of the leaves and flowers. Postcards are notorious for using natural elements to frame man-made structures.

This photo was taken at Tiananmen Square in Beijing (**11.6**). Originally, I was standing right next to the wall looking up. From that angle, the building appeared very tall, but not interesting. By backing up, I was able to use the tree branches to frame the Forbidden City and also cover some of the white space above. To my good fortune, a nice couple came peacefully riding along. I waited for them to cross my frame to show the contrast of a modern society against an ancient world. The sizable difference between the couple and the magnificent structure also helps emphasize contrasts.

SEEING OBJECTS FOR WHAT THEY CAN DO, NOT FOR WHAT THEY ARE

Creating frames by bending tree branches or closing sliding doors requires looking at the objects around you in a different light. If I had seen that ocotillo as just a plant, I would've never thought that I could bend it to create a frame.

11.6 Using the tree branches as a frame, I waited for the couple to show the contrast of a modern society against Beijing's Forbidden City.

Image **11.7**, which I discussed in the chapter on silhouettes, also uses tree branches as frames, but this shot was more difficult to spot. For this frame to work, it had to be lighted separately. To the naked eye, these trees were nothing more than a rubble of leafless branches. But if you look carefully, the branches left a small, oval-shaped gap. I positioned the couple inside this gap and used two lights, one to backlight the couple and the other to illuminate the frame. The point: Frames exist everywhere, but some frames require your help to show their potential. Keep your eyes open and ask yourself if the frame you are using is right, or if it might require some extra light.

11.7 Again with trees as a frame, I had to use two lights to make the photo work.

Exercise: Find an object that can be used as a frame. Take a photo with your subject inside the frame. Then use an off-camera flash to light up the frame. Compare the two.

Goal: Find three frames that work best as they are, and three frames that require more light.

Explanation: Some frames work better with extra light and some don't. You won't know which frames would look great with an extra punch of light unless you develop the experience necessary to tell the difference. This exercise will also help you imagine how a frame would look if you add light to it. In this image I used the sun and an off-camera flash to light up the area framing the couple (**11.8**). This photo wouldn't have worked without the added light on the arch. Being able to recognize this under pressure will make you more efficient at creating dynamic photography quickly and efficiently.

11.8 I used the sun and an off-camera flash to light up the arch framing the couple.

DOUBLE FRAMES

Much like reflections, frames can be used to tell two or more stories in the same photo. All you need is more than one frame within your viewfinder to divide the photo into multiple stories. The frames don't have to be the same kind for this technique to work. One frame could be a doorframe and the second a tree branch. Clients crave the type of creativity displayed by a photo that has multiple stories happening simultaneously within different frames—and are willing to pay for it. Because most amateur photographers probably wouldn't think of taking a photo with multiple stories, it's a great way to separate your work from the rest of the field.

During an Indian wedding in Los Angeles, I noticed two doors side by side at the bride's house (**11.9**). On the right side, the bride was having her hair done by her sister. On the left side, her father, mother, and uncle were getting ready as well. The bride and her sister were in a good position so I let them be; on the left side, I asked the mother of the bride to button up her husband's vest so that I could see both stories unfolding.

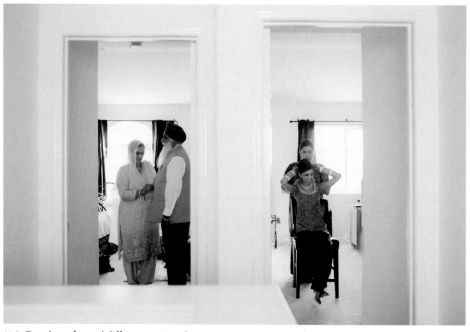

11.9 Two doors framed different stories playing out next to one another.

COMBINING FRAMING TECHNIQUES

Sometimes, the action happens at the right place at the right time; other times, we have to take control and make it happen.

Exercise: Find a place where two side-by-side frames sit close enough to capture both within a single photograph. Place someone inside each frame. Have both people look at the camera on your first shot. Then have just one person look at the camera, with the other person concentrating on something else. Finally, ask both people not to look at the camera. How do the photos differ in feel?

Goal: Find 10 to 15 places where double framing occurs. Some of the double frames should be indoors and others outdoors.

Explanation: During a photo shoot, the pressure is high and chances are you might miss many double-framing opportunities, unless you practice recognizing them. It is also important to visualize the different feel of having subjects look, or not look, at the camera. Double frames are more effective when both parties inside their frame are busy doing something and not aware of the camera. Having one person in one of the frames look at the camera can also create a very interesting photograph.

ABSTRACT FRAMES

Abstract frames are similar to applying a texture effect in post-production. Although I'm not a fan of textures placed over images in Photoshop, I enjoy being able to create a similar effect using the materials available when taking a photograph. What's needed for implementing an abstract frame is a textured material with gaps. It is inside these gaps that you can feature your subjects.

For example, I found this piece of frosted glass with an abstract design (**11.10**). I quickly analyzed it to see if it could be used as an abstract frame. You can see the gaps between the design. I wanted to feature the bride's beautiful and elegant face, her belt and hands, so I positioned her accordingly. An off-camera flash behind the bride removed distractions from the background. Without the abstract frame, this photo would be far less interesting. That's the power of abstract frames. Incorporate them in your work; you and your clients will love the results.

11.10 I positioned the bride behind the gaps in the frosted glass design.

FRAMING WITH PEOPLE

Positioning people around the main subjects not only creates a frame, but also adds meaning to the frame. Framing with people and framing with meaning go hand in hand. There are two ways of framing with people.

In side-by-side framing, other people are placed next to or near the main subject with all of them within or close to the same focal plane. This technique creates a feeling of camaraderie, and it clearly displays somebody's inner circle (**11.11**). As you can see in this photo, all the surrounding bridesmaids guide your eyes to the bride. The key is having people in front of, as well as behind, the bride. Otherwise it wouldn't be a frame, and it would also be off-balance.

In foreground-background framing, the other people used to create the frame stand close to the camera, with the main subject placed farther from the camera. Usually, the focus is on the main subject, throwing the frame of other people out of focus. But try focusing on the frame of other people just to see what kind of results you get. In this example, the Guru Maharaj performs a pre-ceremony prayer in the background, while a couple of guests create a foreground frame (**11.12**). Foreground-background framing often provides a peek at some action from somebody else's perspective.

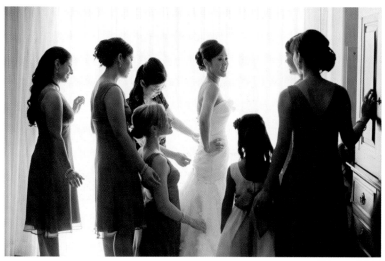

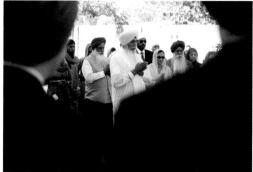

11.11 In this example of side-by-side framing, the surrounding bridesmaids guide your eyes to the bride.

11.12 Foreground-background framing provides a peek at the action from somebody else's perspective.

FRAMING WITH MEANING

The primary purpose of a frame is to draw the viewer's eye to the main subject. However, you can add emotional value when the frame itself consists of people or items meaningful to the person being photographed. It's not always possible, but keep your eye open for it. I'm always amazed at the emotional reaction my clients have when they see a photo framed by people they love. It doesn't have to always be people; anything meaningful to the person yields the same result.

In this example, the bride was simply opening an accessory box (**11.13**). But from the way she was staring at the jewelry, I could just imagine how long she had envisioned herself wearing it on her wedding day. About half an hour earlier, I had asked my assistant to hang the wedding dress next to the curtain. I wanted it there because it would create a frame whether the bride moved to the left or to the right of the dress. There was no other place for her to go, so any action that occurred naturally would be captured within the frame of her wedding dress and the curtain.

In image **11.14**, the father of the bride is putting on his future son-in-law's turban before the ceremony. These are the two most important men in the bride's life, and wearing a turban is an important cultural, symbolic, and religious element in a Sikh ceremony. I chose this angle to frame this symbolic moment with the father of the bride. You must anticipate the angle where the action and the frame will come together. Move around and try different angles. With experience this process becomes much faster.

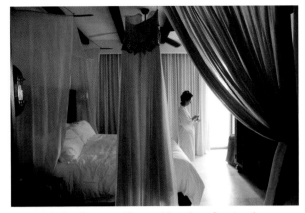

11.13 With the curtain and her wedding dress framing the scene, the bride's simple action gains emotional power.

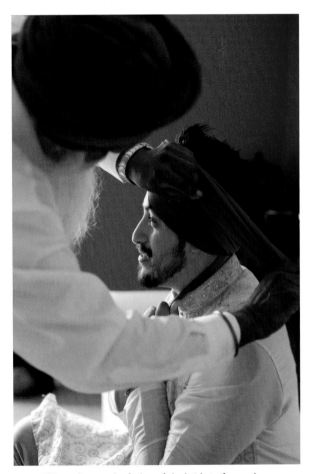

11.14 This angle uses the father of the bride to frame the symbolic wrapping of his future son-in-law's turban.

THINKING AHEAD IS THE NAME OF THE GAME

Learn to set up frames ahead of time in locations where the most important action is likely to happen.

A behind-the-scenes photo shows how I positioned the groom's two sons to form a frame around their father (**11.15**). As soon as I met the boys, I noticed they were close in height. I wanted the attention on the groom, so I decided to turn the boys into silhouettes. But there was not enough light contrast between the groom and the boys. I needed a lot more light on just the groom, so I pointed an off-camera flash at him from the same direction as the window light (**11.16**). That change enabled me to expose for the groom and still silhouette his two sons, forming a meaningful frame.

11.15 A behind-the-scenes photo shows how I positioned the groom's two sons to form a frame around their father.

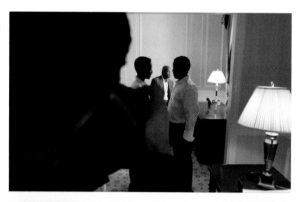

11.16 By pointing an off-camera flash at the groom from the same direction as the window light, I got a good exposure while still silhouetting his sons.

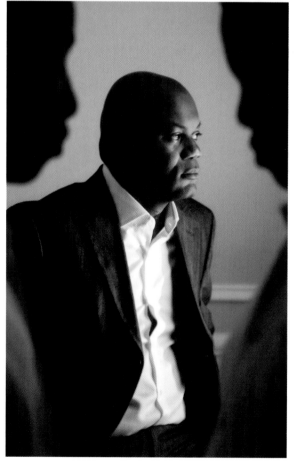

12

PAINTINGS AND ARTWORK

CREATING STRIKING IMAGES at all sorts of locations can be a challenge. The average room inside a house or hotel consists of the same elements: furniture, decorative mirrors, lamps, paintings and artwork, windows, and so on. We must become able to use these items in ways that yield amazing photographs. This is where paintings and artwork come in very handy. Paintings and artwork are versatile because they come in so many designs, shapes, colors, and sizes. They make outstanding backgrounds and can make an average pose look fascinating. Paintings are also a great alternative to photographing people in front of walls. A simple wall is usually no match for a wall with a mural; a hotel room wall cannot compare to a large painting in the lobby. I love to use paintings inside and outside because they have a way of creating the illusion that the person being photographed is in a very different environment.

CHOOSING THE RIGHT ARTWORK

When I walk into a room, one of the first things I look for is the artwork hanging on the walls. I need the cleanest or most interesting backgrounds for my clients, as quickly as possible. I often compare weddings to a pressure cooker because the pressure is always building, the expectations are sky high, and time is never on my side. Therefore, anything that makes for an interesting background must be used for its maximum potential. I also look for artwork that will provide a strong visual contrast with my main subject and that's big enough to fit behind my subject's head and shoulders. The surface of the painting or artwork should not be so shiny that it will cause blown-out highlights scattered around the image. Whereas other traditional backgrounds are pretty, paintings create a juxtaposition that is unmatched.

REMOVING CONTEXT

One of my most favorite aspects of photography is the ability to remove much of the everyday context that makes a location appear average. Imagine photographing a model in a typical street where there is also a large mural. If you zoom in just enough to only show the model, the mural behind her, and nothing else, people tend to have a "Wow, where is that?" reaction when they see the photo. That's exactly the shock value that using paintings and artwork as backgrounds brings to your toolset.

I found this painting at a park in downtown Los Angeles (**12.1**). These square murals ran along one of the walls, but all of them were too high to use as backgrounds for my clients. The solution: moving the plastic chairs in front of the painting and having my clients stand on them. This elevated them enough to enable me to create an interesting composition (**12.2**). Poles apart in value and artistry, the two images reveal the difference between showing too much context in a photograph and only showing the painting.

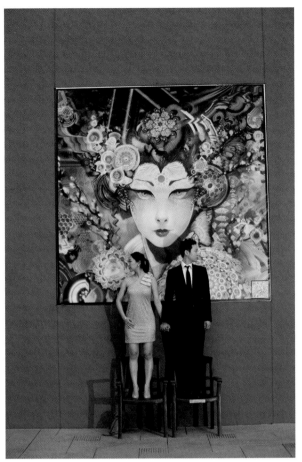

12.1 The mural was too high to use as a background until my clients stood on a pair of chairs.

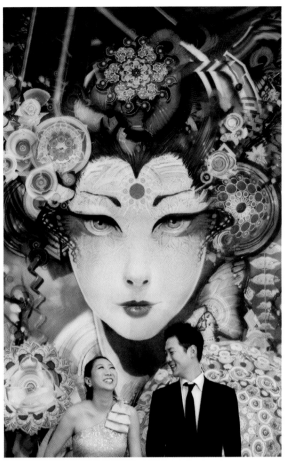

12.2 With the surrounding context excluded, the couple and mural made an interesting composition.

EXERCISE:
REMOVING CONTEXT

Exercise: Too much context can strip all the mystery from a photograph, making it less interesting and, sometimes, boring. Try finding objects and photographing them without showing where they are. For example, shoot a cluster of bamboo stalks, showing only the sticks but not the roots or the ground. Photograph a painting without showing the frame, which would reveal that it is just a painting. This exercise is about creating mystery in your photographs by removing the context and adding a new perspective.

Goal: Photograph 20 items with and without context. You should have a total of 40 photographs.

Explanation: It's important to have a photo showing the context and one without it. For training purposes, you want to be able to clearly distinguish between the two. If someone can help you, photograph them the same way I did in 12.1 and 12.2. This way, you can compare the two. Removing context in photographs is one of my favorite and most useful techniques. I try to use it on every assignment.

COMPOSITION WITH PAINTINGS AND ARTWORK

When thinking about composition, you must treat paintings or artwork as any other background. The same rules of composition, balance, and symmetry apply. If you feel rusty on these topics, please refer back to the appropriate chapters. For me, the most important compositional element when using a painting as a background is balance. The rule of thirds is a close second. Using a painting or piece of wall art as a background can be dynamic, but without the right composition, the photo can lose its charm.

I spotted the large portrait of Picasso at an art gallery in Beverly Hills, and I just had to use it (**12.3**). The original portrait placed Picasso slightly to the right, so I asked the bride to stand on the left. That way she wouldn't cover part of his face, which would look awkward. My goal was to create a contrast between Picasso and the bride. Picasso's expression is serious, so I asked the bride to smile. Picasso is looking at the camera; I responded by having the bride look up and away from the camera. Picasso's portrait is large, so I used my Canon 70–200mm f/2.8 to make the bride appear much smaller. Those are the kinds of contrasts that give a photo the shock value you want.

12.3 My goal was to create a contrast between Picasso and the bride. He looks serious, so I asked the bride to smile.

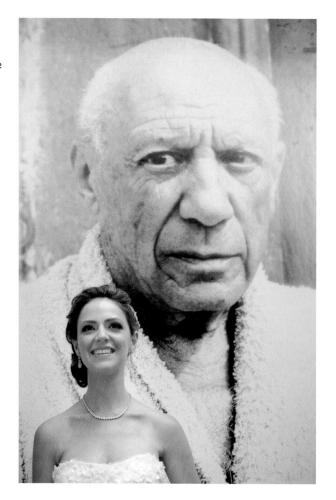

In image **12.4**, the painting's colorful energy dictated that I choose a lively, romantic, and happy pose. Because the design in this photo was somewhat random, there was nothing I could use to balance the photo. In a situation like this, I use the rule of thirds for composition. The rule of thirds is great, but it's not the only effective option.

This next example illustrates a similar situation where the design of the artwork is random (**12.5**). However, in this case, I decided to place the bride on the left and the groom on the right to create perfect balance. If the design of the artwork had been heavier on either side, I would have placed the bride and groom closer together on the less busy side. Either way, creating balance with the artwork is your primary goal.

12.4 This painting's colorful energy dictated that I choose a lively, romantic, and happy pose.

12.5 While the background image is as randomly organized as the one in 12.4, this time I posed the couple in perfect balance.

Let's look at a more complicated case (**12.6**). The dark door on the left created a strong contrast with the wall painting by the famous artist Ted DeGrazia. I had a strong element on the left (the door) and on the right (the painting). To keep this photo balanced, the only option was to place the bride between the two elements.

12.6 With strong elements on the left and right, I posed the bride in the middle to keep the photo balanced.

TECHNICAL AND LIGHTING TIPS

Lighting paintings and artwork require extra attention. Paintings usually hang under spotlights or track lighting, which point straight down at the painting. If you photograph a person in front of such a painting, most likely your client will have unflattering "raccoon eyes."

The other lighting challenge is how to create a separation between the painting and the person. This separation lighting must come from a different direction than the light illuminating the painting. Otherwise, the separation will be unsuccessful. I use an off-camera flash or a reflector. The angle of the off-camera flash depends on the type of photo and the position of the couple.

A good rule of thumb is to stand next to the painting and angle your flash so that most of the light falls on the person and very little of it falls on the painting. As long as the direction of the light on your subjects is different from the light on the painting, you are in business. In fact, every photo in this chapter with paintings as backgrounds was lit with an off-camera flash.

To show what a difference it makes to use off-camera lighting, take a look at this artwork inside a hotel lobby in San Diego (**12.7**). I simply exposed for the painting and took the photo. Both the bride and the painting are under the same light source. The result is quite poor; there is no "pop" to the image. All the other elements are executed perfectly except for the lighting.

In the second photo, taken just seconds after the first, the only difference is the off-camera flash (**12.8**). Notice how much the bride pops. It adds not only dimension but excitement as well.

12.7 With the bride and painting under the same light source, the result is quite poor with no "pop" to the image.

12.8 In the second photo, taken with an off-camera flash, the bride really pops.

The third photo uses the same idea, except that this time I used a reflector to light my clients instead of an off-camera flash (**12.9**). The reason for using a reflector was simply because the yellow and blue bars in the background had a very unattractive old carpet glued to the wide side of the bars. As I mentioned on page 98, I used a flash to illuminate the background, but I needed to light the background and the subjects separately. With the reflector I was able to see exactly where the light was falling on my subjects and not on the bars in the background.

12.9 This time I used a reflector to light my clients instead of an off-camera flash.

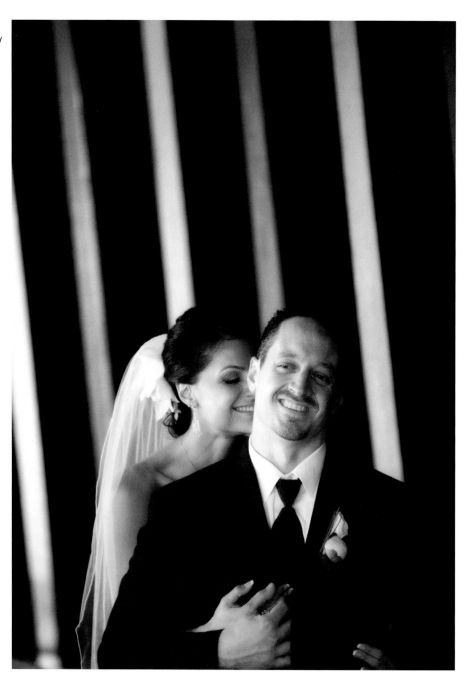

Exercise: When you take a photo without any external light source, you are essentially photographing your subjects and the background under the same light. This exercise focuses on creating a distinct separation between your subjects and the background using only light. Position a person or object you want to photograph about five feet in front of a wall. Stand about one foot behind your main subject and, with an off-camera flash and a wireless transmitter such as the Canon ST-E2 or a PocketWizard, light up your subject without lighting up the wall. Try to zoom the flash head to focus the light output on a more specific area.

Goal: Your main goal should be to expose the background and your subjects perfectly with an extra punch of light on your subjects. The extra light on your subjects should be subtle, just enough to make them a bit brighter than the background. Remember not to allow too much light from your flash to fall on your background. If this is done correctly, you will have perfect separation between the background and your subjects, using only light. Try this technique with five different types of background surfaces, including paintings and walls.

Explanation: This is one of the most important techniques to master as a photographer. It requires that you know your equipment and execute a shot with wireless flash quickly and efficiently. Simply knowing how a piece of technology works does not make you proficient at using it. Only experience and practice will do that. During most of my wedding assignments, I have my second shooter hold a flash with a PocketWizard attached to it ready to go at all times. Creating that separation of light is what gives photographs that wow factor!

13

CONTRASTS

MANY INDUSTRIES commonly add contrasting elements to their products because people respond positively to contrasts. Consider the menu at a fine restaurant; it's full of contrasting flavors and textures. Sweet and sour has been a popular combination for ages. I even had jalapeño ice cream at a restaurant in Tucson. The sweet flavor of the chocolate was followed by the slightly burning sensation of the jalapeño-infused ice cream. Eating that dessert became an experience. At a photography gallery, I saw a photograph of a little girl sitting next to a full-grown elephant. The photo was so captivating that I couldn't stop staring at it. What made that ice cream so special to eat, and that photo of the little girl and the elephant so stimulating is simple: contrasts!

To bring contrasts into your photographs, just think opposites. Photograph a small child with something large, a scene with motion except for one person standing perfectly still, something bright amid everything else dark, or someone smiling while everyone else is frowning. Thinking about opposites makes creating contrasts easy. Use contrasts in your work and you will see how people's eyes light up when they see your photographs. This chapter explores several kinds of contrasts and how you can apply them to your work.

OLD AND NEW

When shooting on location, pair old buildings or old décor with something new. A modern couple posing alongside an old building would be ideal. Hotels often decorate their lobbies or libraries consistent with a specific time era. The old décor gives these public areas charm and gives you the opportunity to create an old-new contrast.

In a brochure at Donegal, Ireland's visitor center, I saw an old abandoned town with houses build out of basic materials. This was a perfect place to take an old and new contrast photograph (**13.1**). This pose is typical for that era, just a man and his wife standing next to each other looking straight at the camera for their portrait. The couple's arms are straight down and there is not much of an expression in their eyes. But obviously the bride is wearing a strapless dress and the groom is wearing a tie with a clip, both modern elements. I focused on the wheelbarrow to throw the bride and groom slightly out of focus. Early cameras required that people stand still for long exposures, often resulting in slightly out-of-focus images. So in image 13.1, I played along with the old and emphasized it with the pose.

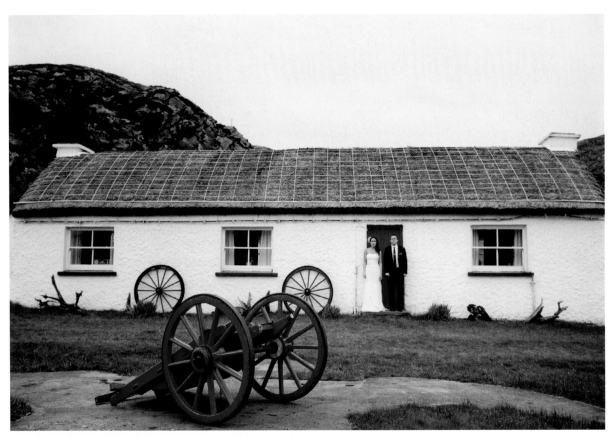

13.1 The modern couple's old-time pose—arms straight down without much expression—creates a nice contrast amid an old abandoned town.

In image **13.2** the bride and groom are holding hands walking away from the camera. The image is nice, but it's just a couple walking in a grassy area without contrasts. Now, look at the same photograph with the previously cropped-out Irish ruins next to the bride and groom (**13.3**). The ruins are majestic on their own, but they are even more impressive when you put the ruins in perspective with the new modern couple.

13.2 A nice image, but with the surroundings cropped out, it's just a couple walking in a grassy area.

13.3 With the ancient ruins back in the picture, there's a clear contrast of old and new.

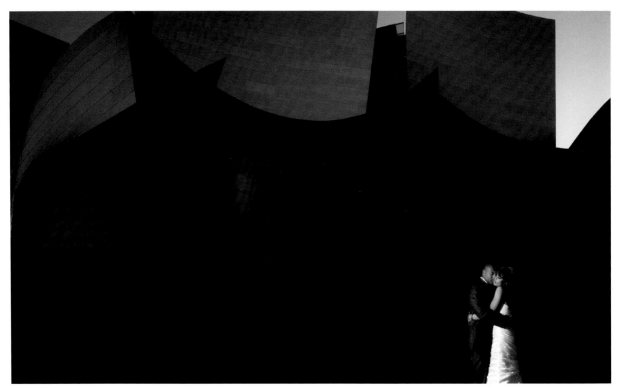

13.4 Placing something big behind something small can make the large object look even bigger and the small object even smaller.

BIG AND SMALL

When something big is placed next to something small, the large object looks a lot bigger than it really is and the small object looks much smaller. During a wedding in downtown Los Angeles, my clients and I went to the famous Disney Concert Hall to take some photos (13.4). I looked up at the building, and I knew I wanted to emphasize its size. Wide-angle lenses can make objects look bigger than they are and, depending on the angle, also smaller. I changed my lens to a 16–35mm and took the shot at 16mm. I used an off-camera flash to underexpose the building and light up my subjects. I'm a big fan of off-camera flash because it creates that important separation between your subjects and the background.

KNOW YOUR LENSES

Knowing your lenses inside and out will allow you to more easily create contrasts. Become familiar with how your zoom lenses behave at different focal lengths.

BRIGHT AND DARK

The use of bright and dark is probably the most common form of contrast in photography. It is simple to do and very efficient at creating interest. A silhouette is a form of bright and dark contrast. This technique only requires that one side of your subject's face be much brighter than the other side. During weddings, I often have to close all the window curtains and turn off lights to make a room completely dark. Then I slowly begin to open the curtain little by little until the right amount of light illuminates my subject.

This photo of the groom was taken using this darkened-room technique (**13.5**). Another way to achieve a similar look without completely darkening the room is to use your off-camera flash at a high-power setting and turn on high-speed sync. This enables you to shoot the scene at a shutter speed fast enough to darken the room but still correctly expose your subject.

13.5 You can create contrasting light by darkening a room and allowing light to reach only one side of your subject's face.

Image **13.6** combines contrasting light with the use of balance. The dress is well lit by the window light, but the bride is farther from the window, so she is in silhouette. The two are in contrasting light and balance each other. Image **13.7** shows a bride writing her vows moments before she has to walk down the aisle. I turned off my flash to let the beautiful window light brighten her left side. The room was not painted white so the light was not reflecting off the walls much. Exposing for the brightest point in her face made the rest of the room go dark, creating the desired contrast.

13.6 The contrast of the bright dress and the silhouetted bride create a balanced composition.

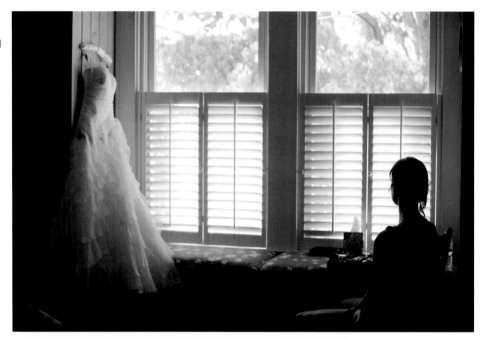

13.7 Exposing for the bride's face made the rest of the room go dark, creating the desired contrast.

CONTRASTING EXPRESSIONS

The contrasting expression is probably one of my favorite contrasts. When everyone is serious, have your subject smile. In a group shot, have everyone look away from the camera except for one person. These are just a couple of ideas you can use to create contrasting expressions. This technique forces the viewer to wonder why that one person is not following the others. The very fact that you have to think about it has already made the photograph more interesting to look at.

In Chapter 12, "Paintings and Artwork," I used image **13.8** to illustrate how to use paintings as backgrounds. Take another look at the photo and cover up the bride with your thumb. See how the photo looks without the contrast? Now cover up Picasso and focus only on the bride. It is apparent how the contrasting expressions are what make this photo so out of the ordinary.

Happy and serious are not the only expressions you can use to create contrast. Image **13.9** has two contrasts going for it. First, there's only one boy in the photo. Second, all the girls have a relaxed expression, but the boy seems to be very surprised. If the boy had also been relaxed, this photo would have lost its charm.

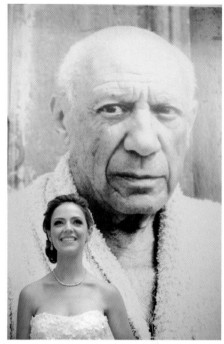

13.8 Take another look at this photo of Picasso and a bride; their contrasting expressions are a major part of what lifts the image beyond the ordinary.

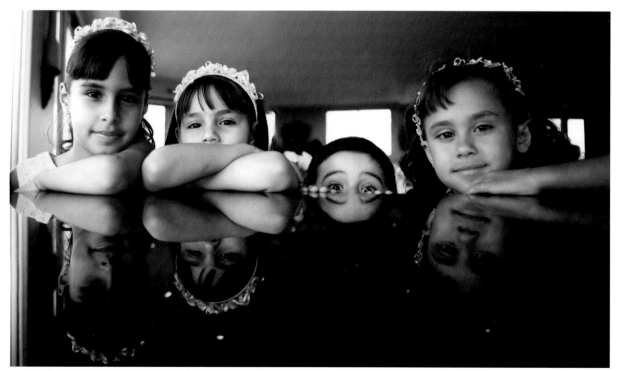

13.9 Two contrasts make this photo; there's only one boy, and his surprised expression plays against the girls' relaxed faces.

EXERCISE:
CREATE CONTRASTING EXPRESSIONS

Exercise: You need at least two people for this exercise. The more people you have, the better. Take the following photos:

1. Take a photo of everyone smiling and looking at the camera.

2. Now take a photo with everyone serious except for one person who should be screaming or doing something radically different.

3. Take a photo of everyone smiling and looking away from the camera in different directions except for one person who is very serious and looking straight at the lens.

4. Try different contrasts and see what you come up with.

Show the photos to friends who weren't involved with the exercise. Study their reactions when they go through the different photos. I can assure you they will spend a lot more time looking at the photos that have contrast.

Goal: The goal is to automatically think of contrasts during a shoot. Try to come up with five combinations of contrasting expressions.

Explanation: To most, creating contrasts in a shoot doesn't even cross their mind. You want to have the creative advantage to stand out among so many other photographers. Experimenting with contrasts will hone your skills so you'll know what works and what doesn't. Contrasts play a crucial role in creating interesting portraits in ordinary situations. Master them and take advantage of the creative edge they provide.

Another great contrast that's easy to create is putting together two or more people of different ages. The contrast usually generates an emotional reaction among viewers. For example, look at a father sharing a moment with his young daughter on his wedding day (**13.10**). As he is getting ready for the special day ahead, his daughter looks at him through the window. The fact that the young girl is his daughter makes this photo more emotional, but even if she wasn't, the fact that a child is sharing such a moment with an adult is adorable.

Image **13.11** creates a very different, but still emotional, impression because of its many contrasts. The most obvious contrast is the elderly woman in the same frame as a newly married young couple. The woman probably had already been married and had children and grandchildren. Block out the older woman and the photo is nice but ordinary—but putting her and the couple together makes the photo much more interesting. It evokes thought and perhaps makes you reminisce about your own life. That is precisely the power of introducing contrasts into otherwise ordinary photographs.

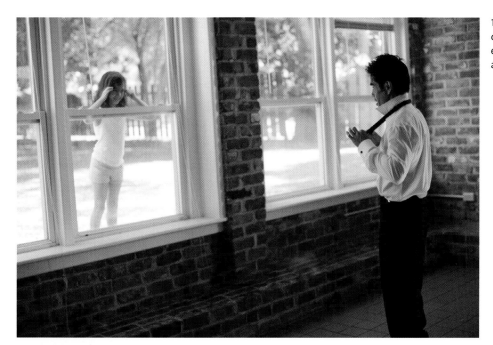

13.10 Photos of people of different ages usually generate an emotional reaction among viewers.

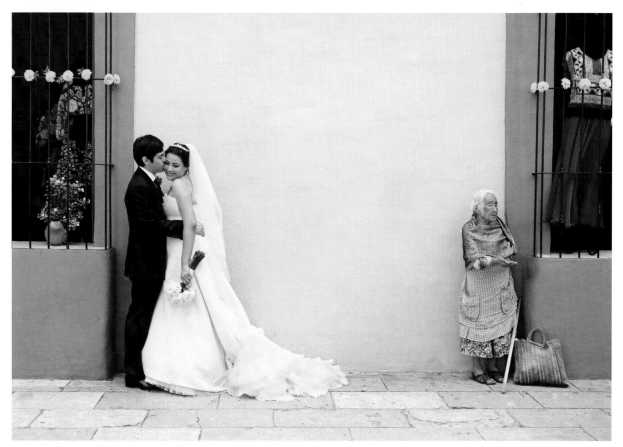

13.11 Block out the older woman and the photo is nice but ordinary, but putting her and the couple together makes the photo much more interesting.

Another great method is to use a more interpretative approach. In image **13.12**, the story and age contrast is told entirely through the hands. That was all I needed to relay my message. The difference in the size of the hands and the way the little fingers are holding on to the adult's hand stands on its own. If I had included their faces, the viewer would have been distracted and the message in the hands lost.

13.12 The hands alone tell the story; including faces would distract from the message.

CONTRASTING COLORS

Using a solid color wall as a backdrop will greatly emphasize your subject. It is also surprisingly simple because there is color everywhere. As a wedding photographer, I photograph white dresses and black tuxedos; therefore, any color will contrast nicely. I prefer solid color walls to avoid introducing conflicting colors in my backdrop. I want my bride to be the star of the photo, not the wall. Review Chapter 5, "Color Elements," for more information on this topic. During a wedding in Cabo San Lucas, Mexico, I asked the bride and groom to walk with me around the streets of a charming part of town. I loved the colors and the original adobe buildings surrounding us. This orange wall was my first choice, simply because of the color contrast that bright orange would create with the white dress and black tuxedo (**13.13**). This wall also has other elements I look for: It's a solid color and the iron gate on the left balanced the artwork on the right.

13.13 The bright orange wall contrasts nicely with the couple's black and white clothes.

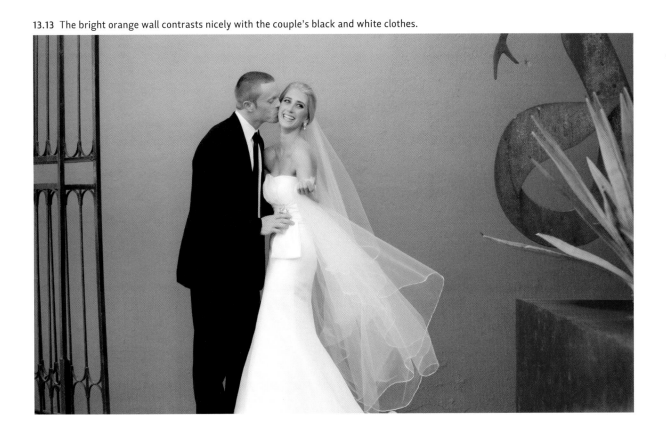

BREAKING THE STATUS QUO

The theory behind this technique is to use what is normally accepted in society and do the exact opposite. When people go about their day, many things happen that are normal; they are driving cars, walking, talking on cell phones, and so forth. None of those every-day activities cause anyone to turn around and stare because nothing is out of the ordinary. Sometimes we get so accustomed to what's normal that we only think in normal terms.

I have come across some vintage-looking photographs at stores where two little kids are dressed up as adults in the style of the 1920s, holding hands or kissing. The photos are cute because of the contrast. We don't normally see kids dressed up as little adults holding hands and making innocent romantic gestures. It's simply not the norm.

Photographer Anne Geddes became famous by using this type of contrast. She broke the status quo of baby photography with her unique props. Instead of placing the baby in the arms of his/her mother and taking a photo by the window, she created elaborate props such as giant flowers where the baby would be peacefully sleeping on the petals. She would also place babies inside pumpkins and photograph them.

Ask yourself, "When was the last time I tried to do something that people are not used to seeing in photographs?" I could dedicate a whole book to breaking the status quo; it's that important! In the past five years or so, photographers have started to pose the groom holding the bouquet instead of the bride. That is all it takes to break the status quo. If we see a photo where the bride is posing with her bouquet, we wouldn't think twice about it, but if the groom is posing with the flowers, it grabs your attention (**13.14**).

One of my inspirations for breaking the status quo comes from the work of acclaimed photographer Lauren Greenfield. In her series of Beauty Culture, she depicts what women do to themselves when heavily influenced by the beauty culture of Los Angeles to look, well, beautiful. Most of her photos in this series focus on teenage girls going above and beyond, altering their bodies in any way possible, so they can to fit into this beauty- and perfection-obsessed city. It's simply not normal to see what these teens are doing to them-selves, thus every photo breaks the status quo. It paints a dark picture of the lives of teen-age girls searching for physical perfection. Remember, Lauren Greenfield's work inspired me to not take photos of what is "normal" all the time. Break the visual habits of people, and you will have their attention.

13.14 Break people's visual habits; a groom posing with the flowers grabs your attention.

14

LENS FLARE

When light from the sun or any other light source directly strikes a camera's lens, the result is lens flare. The key word here is *directly*. Most light bounces off a subject, entering the lens indirectly. Lens hoods help reduce light from directly hitting your camera's light sensor. But I have had a long battle with lens flare in the early mornings or near sunset, which are notorious for both glare and lens flare.

Early in my career, I used to blame the time of day when all my photos turned out with huge circular halos of light all over my subjects. For this reason, I dreaded photo shoots that had to be taken during the late afternoon or early morning. Then I realized that if I was going to call myself a "professional photographer," I had to master shooting in such conditions. In this chapter, I show you how to manipulate lens flare so that it works *for* you rather than *against* you.

THE BENEFITS OF LENS FLARE

Using lens flare offers two main benefits. First, it can add a remarkable feeling and mood to a photograph, providing a dreamy effect and a sense of warmth. It's one of the most romantic lighting techniques available. Second, using lens flare takes away much of the contrast and harshness in a portrait. It reduces skin imperfections, blemishes, and wrinkles, replacing them with a creamy feel, which is important for beauty or fashion portraits.

EVERYTHING IN MODERATION

Lens flare and glare can be powerful photographic tools, but they can also overpower your photos. The idea of lens flare is to have light directly hitting your film or sensor, introducing halos and polygonal-like shapes of light in your photos. These circular halos of light are the side effects of using lens flare. As a wedding photographer, I often have to shoot bride and groom portraits in the late afternoon when lens flare and glare are almost inevitable. But that does not mean your clients will be happy with multiple halos blocking most of their bodies. Two or three photographs with halos can be nice, but take anymore and, trust me, you will have a lot of explaining to do.

MOVING HALOS AWAY FROM THE BODY

To obtain the romantic look of lens flare without halos blocking your subjects, simply change your angle relative to the sun. The halos will most likely still be there, but they can be moved to the side, top, or bottom of your frame away from your subjects. Try moving a bit to the right or left. If you can find something to stand on, use it to raise your angle to shoot a bit above your subjects.

EXERCISE:
ANTICIPATING THE LOOK OF LENS FLARE

Exercise: Photograph a friend outdoors in the late afternoon one to two hours before sunset. Take two photos, one with the sun in front of your subject and the other with the sun behind your subject. For the second shot, move your camera toward the sun until you have light rays directly striking your sensor and you see lens flare.

Compare the two images. Pay close attention to the texture of your friend's face. Notice how much smoother it is when flare is present. Remember, if none of the light rays strike your sensor, then you don't have a lens-flare photo, just a backlit photo.

Goal: The goal is to recognize lens flare in your photos compared to backlit photos.

Explanation: Knowing the look of lens flare and how to achieve it can be a great tool in your toolbox. This exercise will also make you quicker at lining up the camera with the sun to get the desired amount of lens flare.

Image **14.1** is an example of too much direct sunlight reaching my sensor. The mood of the photo is still romantic and dreamy, but the halos across the faces are a major distraction. Here the sun's rays are mostly hitting the top-left side of my sensor. Some halos are present at the bottom right of the frame as well, but they are small and not on my subjects' faces.

I simply moved to the left and raised my angle to make myself taller to get rid of the largest halo. Image **14.2** shows the result. The horizon line is now much lower and closer to my subjects' hips. In image 14.1 the horizon line runs behind their heads. I also moved to the left, placing my subjects closer to the right of the frame. The halos are now on the left, away from them. The resulting image harnesses the romantic benefits of lens flare, without the side effects of the halos over your subjects. I also love the beautiful rim light backlighting their heads. Remember, there is almost always a solution to every problem.

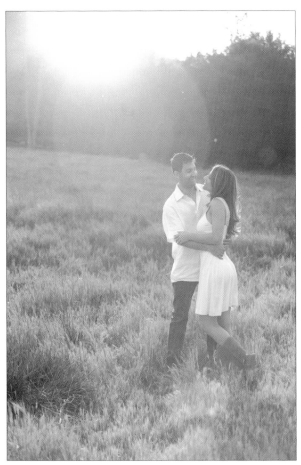

14.1 The photo's mood is romantic and dreamy, but the halos on the faces of my subjects are a major distraction.

14.2 By moving left and slightly higher, you get the romantic benefits of lens flare without the halos obscuring your subjects.

BLOCK AND CROP

"Block and crop" is a technique I use when the rays of light are too strong and they angle right into the front of my lens. I switch to my largest available zoom lens. Usually the 70–200mm lens works nicely. I stand farther back and zoom to the maximum focal length of my lens. That way, I crop out any unwanted lens flare in the photo. I then position my subjects where their bodies or heads block most of the sun from my lens. Now I'm ready to take my photograph.

Take a look at image **14.3**. I used the block and crop technique to create this beautiful portrait in difficult lighting. I took this photo at 200mm, and I used my subjects' heads to block most of the rays from hitting my sensor. The hazy feel of the photo shows that some rays still came in. However, there are no halos anywhere because of the tight cropping.

A variation of this technique is to crop but not block. In other words, crop the light source out of the frame. The light source, your subjects, and you no longer have to be lined up with each other, but you are still benefiting from that warm hazy light. For better understanding, let's look at some examples.

Image **14.4** was taken with a wide-angle lens. Here, I did not block or crop. The image is still beautiful and moody, but the lens flare is large and distracting. Also, the sun is the brightest part of the image, instead of my subjects. To add some contrast, I used Photoshop to crop out the sun (**14.5**). With the halos cropped out, the sun illuminates my subjects beautifully without overpowering them, and just the right amount of contrast is added.

14.3 I used my subjects' heads to block most of the rays, keeping the hazy feel without any halos.

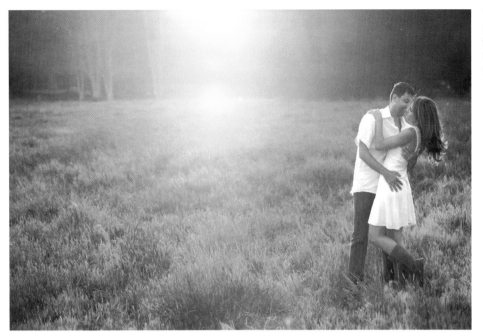

14.4 Taken with a wide-angle lens without cropping, the image is beautiful and moody. However, the lens flare is large and distracting.

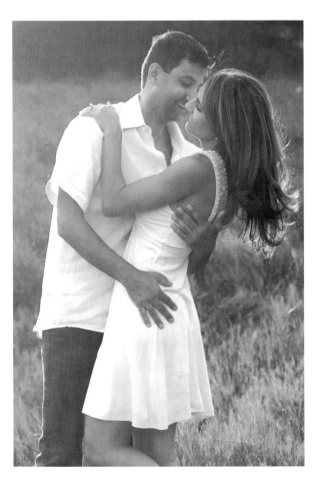

14.5 With the use of blocking and cropping, the halos are gone while still beautifully illuminating the subjects.

SETTING PRIORITIES

When shooting on location under time constraints, you will become familiar with juggling priorities and making sacrifices. For example, I know how to crop the sun out of a flare situation or to move the halos away from the body. But sometimes, I break my own rules to prioritize the dominant geometry of the location at hand, if you will.

To illustrate this point, take a look at image **14.6**. First and foremost, this staircase has beautiful geometry. But it also has depth, because it overlooks the city of Tucson, and the steps create patterns and repetitions. Those three elements were too many to ignore. I knew I had to use that staircase, but the sun's location relative to it was causing very strong lens flare. I could not use a tight crop as I normally would, because it would also crop out the staircase. Blocking the sun with the bride's body was not an option, because the bride was too far from the lens and I was using a wide-angle lens to exaggerate the perspective of the staircase. Under these circumstances, blocking the sun with her body would have caused almost 50 percent of her body to disappear.

14.6 Setting priorities and making sacrifices: To capture the patterns and repetitions of the steps, the sun became the brightest part of the image instead of the bride.

The solution involved a certain sacrifice: having the sun be the brightest part of my image instead of the bride, which allowed me to prioritize the beautiful geometry of the staircase using my wide-angle lens. I experimented with the angle to avoid any lens flare halos over the bride and I took the photograph.

QUICK THINKING

With practice, this kind of thinking will come faster and faster, and with skill, you will be able to assess a situation and know which techniques to ignore and which to prioritize.

ADVANCED LENS FLARE TECHNIQUES

With lens flare, you can achieve soft romantic images. However, because the sun or any other light rays are directly penetrating your sensor, you can also achieve photos that have so little contrast that they could become almost unusable. Too much haze can ruin your photographs.

To obtain the best of both worlds, you must supplement the light from the sun with reflected light coming from the front. What you need is a reflector, preferably a five-in-one circular reflector. They are easy to carry and quick to fold. The five-in-one reflector has five color skins: gold, silver, zebra, white, and a diffuser. During a shoot, simply supplement the sunlight causing the lens flare by bouncing it back to your subjects using a reflector. Use the silver side of your reflector to offset the orange light from the late afternoon sun. The result is an image that still has that romantic dreamy feel, without the complete lack of contrast. The bounced light from the reflector will add contrast to your image. The key is to allow a small amount of light rays to enter your sensor. Image **14.7** is backlit, as you can see, but no light rays entered my sensor. The image looks nice, but it is a regular photo. At the time of day I was taking these photos, the sun was not in the right place. I still wanted a lens flare look, so I used a flash with an umbrella. This will replicate lens flare conditions perfectly.

For image **14.8**, I moved just a bit to allow some of the light from my flash to penetrate the camera's sensor. I also placed a reflector in front of my subject to bounce some of that light back at her. This brought detail and some contrast back to the image. Without the reflector, the image would be too hazy, because it would not have very much contrast. Notice what a difference it makes in the mood and feel of the photographs by simply allowing some light rays to hit your sensor. Both of these photos are straight out of camera for a more accurate comparison. I almost always include some sort of light to illuminate my subjects in addition to the main light to create separation between them and the background.

14.7 The image looks nice as a regular photo without any lens flare.

14.8 Using a strobe to backlight the scene and let some of the light hit the camera's sensor, you can replicate lens flare from the sun.

EXERCISE:
CREATING LENS FLARE WITHOUT THE SUN

Exercise: Using a powerful flash such as the Canon Speedlite 580EX II, place the flash about two feet above and behind the head of your subject using a light stand. Angle the flash head so that its light will hit your sensor and create lens flare. Switch the flash from ETTL to manual and put it at almost full power: 1/1 or 1/2 should work well. Experiment with your ISO settings until you get the right amount of light on your subjects. If you see any lens flare halos on your subject's face, move a little until the rings are out of view or at least not in the person's face. Next,

experiment with your white balance. If possible, dial in your white balance manually using the Kelvin setting, or "K." Try both extremes of the Kelvin scale in your camera. Be sure to crop the actual flash out of your frame.

Goal: The goal is to master how to fine-tune the lens flare techniques in your photographic arsenal.

Explanation: The exercise will help you create the lens flare look with or without the sun. Using a strobe to create lens flare will improve your speed at setting up the flash correctly.

15

WALLS, TRANSLUCENT SURFACES, AND TEXTURES

At the start of my career as a full-time photographer, it was common for me to find refuge near walls during a portrait session. Walls were abundant and easy to photograph, and they also kept the photograph simple without any distracting elements behind my subjects. Most of my early portraits, however, had a flat dead end as the background. As most people do at the start of their photographic endeavors, my thought was, "Since I'm taking these photos with a professional camera, they must be professional photographs." Was I ever wrong! It turns out walls can be deceiving in their complexity.

WALLS AND SHADE

Walls and shade seem to be a popular combination for photographers just starting out shooting portraits. I can see why; walls remove distracting backgrounds, and shade offers an alternative to the harsh sun. The problem with this approach is that shade light is flat and cold. That's why you set your camera to a Shady white balance, because it warms up the color to compensate for shade's cold lighting.

Here's a shot taken in total shade with the camera set to Auto white balance (**15.1**). I took this photo because I was fascinated by all the stories going on here. Nobody suspected that they were being photographed. The result is pure photojournalism; the people have their guard down and are just being themselves. Unfortunately, this moment happened in shade. It is easy on the eye without the harsh sun, but the quality of light is flat and dead. There is no pop or glow on the subjects. Here are a few suggestions for solving this problem.

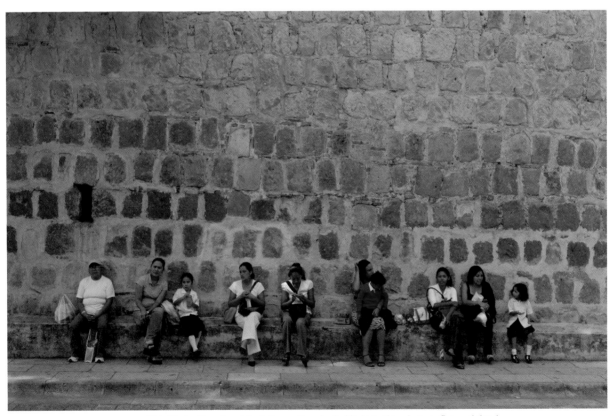

15.1 Shot with auto white balance, the shaded light in this photo is flat and dead.

PROXIMITY TO THE SUN

This technique works when the wall you are using is in shade but close to the sun (**15.2**). This beautiful rustic door is part of the historic city of Oaxaca in Mexico. Notice how the entire wall is evenly lit; this is because the wall is in shade. But as you can see by the circle on the pavement, direct sunlight is no more than a foot away from the wall. This is great because the sunlit pavement serves as a natural reflector bouncing beautiful sunlight evenly all the way up the wall. Anyone standing near the wall but within the shade will benefit from the shade's clean even light without the cold, flat, and lifeless quality of light commonly found in shade. It's the best of both worlds!

I asked my wife, who took this photo of me, to include the pavement so you can easily see how it's bouncing all that even light up the shady wall (**15.3**). Now we have a photo rich in color, texture, and life. If I had taken two steps forward, I would have been in direct sunlight, creating harsh light and unflattering shadows on my face. The portion of the pavement lit by the sun is about one foot away from the wall. If the sunny tiles were 30 feet from the wall, however, the quality of the sunlight bounced onto the wall would be greatly reduced. But your subjects don't have to stand right in front of the wall; they could move forward closer to the sunny area.

15.2 The sunlit pavement serves as a natural reflector, bouncing beautiful sunlight evenly all the way up the wall.

15.3 Anyone standing near the wall, but still in the shade, benefits from the even light—without its cold, lifeless quality.

Let's look at an example where I applied this proximity-to-the-sun technique (**15.4**). I could have chosen to take this wedding party photo anywhere. The private estate where this wedding took place had plenty of gardens. I ignored all of them because although the gardens were beautiful, they were no match for the quality of light you get when you place people in shade with proximity to the sun. Notice the very bottom of the photo where the sunlight is hitting the ground. All that light is being reflected up at the wedding party, giving them a rich glowing quality of light, not to mention the beautiful color combinations and the geometry of the background.

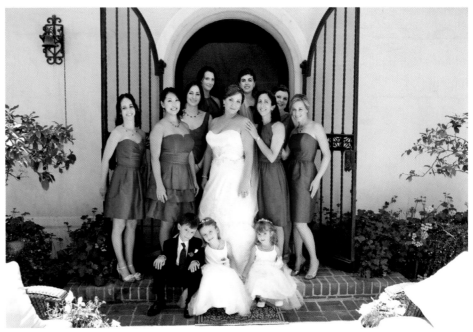

15.4 The sunlight hitting the ground is reflected up at the wedding party, giving them a rich glowing quality.

EXERCISE:
PROXIMITY TO THE SUN

Exercise: Train yourself to recognize when a shaded wall is less than five feet from the sun. Pose someone or something one foot from the sun. Make sure the sun does not hit any part of your subjects; they should be in complete shade. Take their photos head on, in profile, and from the back. Change your shooting angle as well, and try not to overshoot. Keep all your files so you can analyze the results when you get home.

Goal: The goal is to experiment with three different shaded walls near the sun. Focus on the quality of light illuminating your subjects at different angles.

Explanation: Looking for walls like this is about being aware of your surroundings. Learn to recognize locations or scenarios where good light likes to hide. The next time you are shooting on location, you will know what to look for.

REFLECTING A PATCH OF SUNLIGHT

What are you supposed to do if a beautiful shaded wall is not close enough to the sun? Find a patch of sunlight on the ground and have someone hold a reflector from that spot for you. That patch of sunlight could be 10, 20, or even 30 feet away. The reflector will bounce the sunlight to your subjects standing in the shade. In my experience, there is always a patch of sunlight somewhere in the area. Light travels far, so the distance to your subjects from the patch of sunlight should not be a problem.

Consider this illustration (**15.5**). The location is not exactly beautiful, but great light can be created anywhere. As photographers, it's our job to find the best light at every location. As you can see in the illustration, the patch of sunlight on the left is not very large, but it doesn't have to be. While someone is holding the reflector, you (the photographer) can move around and experiment with different angles.

Here's an example of a portrait using this setup (**15.6**). The light on the model is clean and soft, but most importantly, she pops from the wall because the light hitting her is being reflected from the sun. Notice that the brick wall is so out of focus that the bricks are no longer visible. I'm not a big fan of bricks for backgrounds, unless the bricks are old and have character.

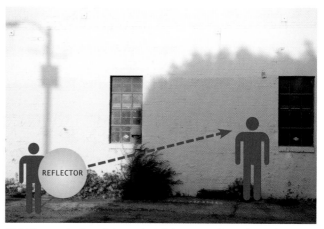

15.5 The patch of sunlight on the left is not very large, but it doesn't have to be if someone holds a reflector.

15.6 The light on the model is clean and soft, and she pops from the wall because the light hitting her is being reflected from the sun.

MONOCHROMATIC COLOR PALETTE

If a background wall is similar in color to a person's skin, clothes, or both, the viewer subconsciously focuses on other facial features, such as the eyes, lips, hair, or make-up. This occurs simply because when most of the color palette is monochromatic, anything different will stand out.

REFLECTING WINDOW LIGHT IN FRONT OF WALLS

Window light is one of the most desirable types of light in photography. If your subject is close to the window, the side closest to the window will be beautifully illuminated, while the other side will be much darker. This is perfect if you are going for a high-contrast portrait. If you aren't, then you need the light to also illuminate the darker side of your subject's face.

Here's an example with both sides of a subject's face illuminated by window light (**15.7**). To achieve this look, I placed my subject near the window and had an assistant hold a reflector in front of the window to light the other side of my subject's face. A reflector can easily put the light where you want it, enabling you to make sure the reflected light hits your subject's face and not the wall. This creates a strong separation between the light on your subject and the wall. This is one of the "must do" techniques that I prefer to use during job assignments. I love window light, but what I love even more is when that window light is reflected back at my subjects. Both sides of the face are illuminated and have enough shadow detail to give the photo dimension.

15.7 With the subject near the window, an assistant held a reflector in front of the window to light the other side of his face.

Exercise: This exercise requires you to be indoors. Look for a room with a window; the darker the room, the better the results will be. Stand so you are facing the window and position your subject between you and the window. Your subject should now be backlit with the side closest to you almost in silhouette. Take two photographs, one exposing for the face and the other exposing for the window. Now have someone hold a reflector and bounce the window light onto the dark side of your subject's face. Take another photo exposing for the face again. Notice how much more detail and dimension you gain when you add a reflector to the mix.

Goal: The goal is to understand the various looks that can be achieved indoors using window light with and without a reflector.

Explanation: This exercise has helped me to photograph brides when they are getting ready in their hotel rooms. I used to use the window as my only light source, and I still do from time to time. But now I understand what a difference a reflector can make. By bouncing the window light back onto your subjects, you can increase your shutter speed. This action changes the look completely, and it adds detail throughout. I usually shoot these kinds of photos with a very wide aperture, f/2 to f/2.8, and a prime lens such as the 85mm f/1.2 or the 50mm f/1.2.

USING AN EXTERNAL FLASH ON WALLS

There is a big difference between using a flash in a large open area and using a flash pointed at a wall. The difference is in the shadows. When a flash is used in an open area, you don't have to worry about casting a shadow behind your subjects. But if there's a wall behind your subjects, the shadow behind them will be crystal clear. That's great if the shadow is part of your composition; otherwise, it's a nuisance. If I don't have a reflector handy or there is no sunlight to bounce light into a shady wall, I use my trusty Canon Speedlites with wireless transmitters. I need these tools to take my flash off the camera's hotshoe, which allows me to cast the shadow where it will be the least distracting.

Let's look at an example where the rectangular patterns and reflective qualities of the wall caught my attention. Unfortunately, the light quality on the wall was poor. But it was a very cloudy day, so using a reflector was not an option. To give the couple a kick of light, I set my flash on a light stand directly in front of them about 15 feet away (**15.8**). I wanted the shadow behind them, so I raised the light stand until it was higher than the couple. This adjustment created the correct angle to put the shadow directly behind them. The result is an image where I took advantage of the wall's geometry without sacrificing the light's quality.

15.8 A high, stand-mounted flash to the left of the frame cast the couple's shadows directly onto the wall behind them.

USING WALLS AS REFLECTORS

When photographing at urban locations, chances are you are surrounded by tall buildings. The building walls are usually clustered close to each other. This creates opportunities for you to use the walls not only as backgrounds but also as reflectors. Photographs taken under these conditions can result in some of the most stunning portraits you will ever take.

You need two walls facing each other with one illuminated by the sun. Take a look at this illustration to get a better idea of this scenario (**15.9**). The wall on the left is white, so it's a perfect reflector because it will not create any colorcast. Take a close look at the wall on the right. Notice how the light gradually improves toward the back end of the wall, where it is at its absolute best. There, you could take a photo of anybody or anything with any camera, including a cell phone, and it would look magnificent. To illustrate this point, I asked my wife to take some photographs of me at different sections of the light brown wall on the right. This way, you can see how the light on a person's face improves as it approaches the spot on the wall with the best quality of light.

At first the light on my face looks average and a bit cold (**15.10**). As I move back along the wall, the light on my face begins to glow (**15.11**, **15.12**). Since the right side is illuminated by reflected light and not direct sunlight, the quality of light is soft. On the other hand, the left wall will provide hard light. Both sides are capable of superb photographs, as long as you understand how to work under both light conditions. Here's the result after working my way back to the best soft light (**15.13**).

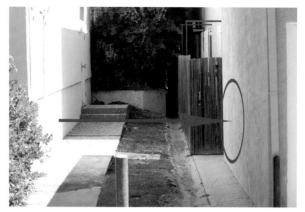

15.9 The white wall on the left is a perfect reflector without any colorcast. Notice on the right wall how the light gradually improves toward the back end.

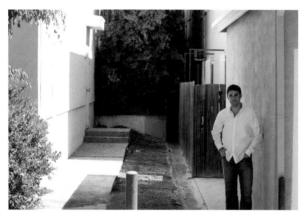

15.10 At first the light on my face looks average and a bit cold.

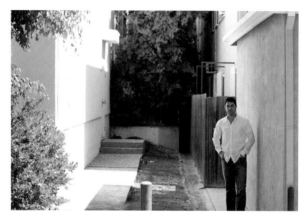

15.11 As I move back along the wall, the light on my face begins to glow.

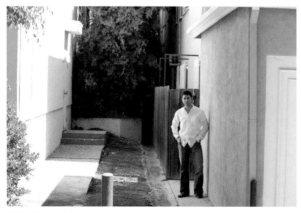

15.12 The light continues to improve as I move back.

15.13 The result after working my way back to the best soft light.

Finally, here's an example of how a correctly exposed and cropped portrait will look right out of the camera under this quality of light (**15.14**). Turning the subject's face toward the light (and converting the photo to black and white) lets you compare the different looks you can achieve (**15.15**).

15.14 Correctly exposed and cropped, a portrait using this light can look great, right out of the camera.

15.15 Another look created by turning the subject toward the light and converting the shot to black and white.

Exercise: It's time for you to try this technique. Find two walls facing each other outside at midday. The sun should be strong enough to clearly bounce. Position your subject at the wall that is not under direct sunlight just as described earlier. Your subject should be glowing from the reflected light coming from the opposite wall. Take a photo, move your angle, and take another one. Do this a couple of times. Then turn your subject's face slightly. Have your subject look at the sunlit wall and take a photo in profile. Keep a tight crop to focus on how the reflected light shapes your subject's face.

Goal: The goal is to find five opposing wall scenarios around your neighborhood.

Explanation: This is one of the most helpful lighting techniques I use when shooting on location. It combines the beauty of natural light without the harshness of direct sunlight. It has gotten me out of many binds with difficult locations. When I'm hired for a portrait assignment, this is the first type of light I look for. I recommend you do this exercise at least twice a month. Try different type of walls, colors, and distances between the two walls.

THINK LIKE A PHOTOGRAPHER

The previous section on using walls as reflectors is a crucial lesson in understanding how to think like a photographer. Computer programmers have to use step-by-step linear thinking, assuming that the computer knows nothing. Even the most obvious task requires the programmer to think in great detail and to write the code in a way the computer can understand. Photography is similar in the sense that it requires out-of-the-box thinking.

We often are drawn to take our photographs at locations that fit the "status quo" of what is beautiful, such as a park, a fountain, or a lake. Yes, these are beautiful locations but that's not what professional photography is about. Most people would walk right by that ugly alley I found in Los Angeles (15.9). That alley would definitely not qualify as their idea of beauty. But what they are not seeing is the amazing quality of light created by two walls facing each other, one lit by the sun, and the other lit by the reflected light from the opposite wall. That's the magic of photography!

SEE THE LIGHT, NOT THE PLACE

I encourage you to see locations based on their quality of light and not simply whether or not the location is pretty. I've taken some of my best work in the most ordinary places.

USING NATURAL WALLS

This section focuses on using walls made of natural elements. Outdoors, not too many flat, cement surfaces are available. However, you might still wish to use a wall-like element as a background for your subjects. There's a big difference between a photo taken of someone at the beach, for example, with plenty of depth behind them, and one taken with someone that includes a wall as a background. When photographing people outdoors, you'd be smart to have a combination of both styles for variety.

To create a wall-like background, look for a cluster of plants, trees, bushes, grass, even weeds if they are tall enough. If the cluster is tight, it can create the same effect as a concrete wall. During a bride and groom session in Hawaii for the wedding of the former Mrs. Korea, we were being driven around the "cool" places on the island. I placed the word cool between quotation marks, because I knew that what might be "cool" to the driver wasn't necessarily what I was looking for in terms of photography and light. As we drove to the targeted locations, I saw this cluster of dead blades of grass in front of a long row of trees (**15.16**).

All I needed to know was that the grass formed a tight cluster that would give me a wall. I asked the driver to stop the car, and everyone looked at me as though I was crazy. To them, there was nothing but dead plants and dirt. Confused and skeptical, the bride and groom got out of the car. I posed them in front of the cluster of grass and added a punch of light with an off-camera flash my wife held at a 45-degree angle to the couple (**15.17**).

15.16 This cluster of dead grass blades in front of a row of trees might not seem like a "cool" location.

15.17 By posing the couple in front of the grass and adding a punch of light with an off-camera flash, I created a great portrait.

SUPERIMPOSING DESIGNS ON WALLS

Walls can be used in more ways than simply as pretty backgrounds. I have already discussed how to use walls as reflectors. Now I'll show you how to use walls as blank canvases on which to paint designs. Your paintbrush will be external light and your paint will be the shadow the light will cast.

This site looks pretty average, and the window is not quite a wall (**15.18**). But the large framed windows are flat, and flat to me means wall. The piece of décor sitting on the side table had an interesting design that I could shine my light through. These two elements provided the means to cast the shadow of the design on the wall (**15.19**). I used an off-camera flash to create the shadow, but a video light would have worked as well.

15.18 This site looks pretty average, and the window is not quite a wall.

15.19 Using an off-camera flash to cast the décor piece's shadow on the wall transforms the setting.

15.20 You can even use the couple as the design element and cast their own shadow on a wall.

In the previous example, I used a piece of artwork with a unique design to cast on the couple. But if you find yourself with no such luck, use the couple as the design element and cast their own shadow on a wall (**15.20**). My thought process here was that there was a geometric element of interest on the left, created by the square patterned window. To balance the geometric element on the left (as discussed in Chapter 2, "Balance"), I had to position the couple on the right. Then, I noticed the flat white wall in between, which was the perfect color to contrast with a shadow. I took out my flash and had my assistant hold it where the couple's shadow would be cast perfectly on the wall, then I took the photo. The result: elements of interest on the left, in the middle, and on the right sides of the photograph.

WALL TEXTURES

Like everything else in photography, wall textures can be an asset or a hindrance. There are many reasons why a photographer would select a wall, but one of the main reasons is color. If the wall's color is what you want, then the wall texture can be distracting. Many of the walls I encounter are made with a fake adobe material with a bumpy texture. Posing someone on the wall with this texture will cause your viewer's attention to be divided between your subject and the wall's texture.

To avoid texture distractions in your photographs but still use the wall, position your subjects at least five feet from the textured wall. Use the largest aperture your lens can handle. I usually use my 70–200mm f/2.8 for these situations, shooting at f/2.8 if only one person is in the shot and f/3.5 if there are two people. This gives me more focal plane cushion to keep both subjects in focus. Shooting with a large aperture or wide open will throw the wall completely out of focus, leaving only its color behind.

MAKING TEXTURE WORK FOR YOU

Textures can also be very complementary and give photographs character. Textures are complementary if the texture is somewhat similar to the texture of your subject's clothing. When both of these elements come together, it appears as if the wall and your subjects are part of a set, instead of you just using an arbitrary wall that you found. For example, think of a creamy white smooth wall as the background for a bride wearing a silky off-white wedding dress (**15.21**). The photo looks synchronized and well put together.

15.21 With a creamy white wall acting as a background for the bride in her silky off-white dress, the photo looks well put together.

15.22 The texture and curves of the rock reminded me of the folds of a silky wedding dress.

15.23 Shot from a high perspective, the ground became a background. An off-camera flash to the left of the frame helped separate the bride's dress from the background.

Let's take a look at a more abstract example using a volcanic rock formation in Oahu, Hawaii (**15.22**). The texture of the rock and the curves reminded me of silky clothing similar to the folds of a wedding dress. Mostly, I was drawn to the drama and uniqueness of the rock. Although this is the ground and not a wall, the principle is the same. So I took the photo from a high perspective and the ground became the background, just like a wall would (**15.23**). My wife stood to the left, out of view with an off-camera flash pointed at the bride to create separation with light. That allowed me to darken my exposure without worrying about the bride being too dark.

For this group photo (**15.24**), I asked the bridesmaids to stand in front of the altar to take advantage of the similar fabrics of the altar and saris. Since the sun was backlighting the bridesmaids, I used my on-camera flash to add some fill light. Naturally, the textures are seldom a perfect match, but they do not have to be. It is a tool you should consider when dealing with so many kinds of walls and textures in any given location. I could have chosen to ignore the texture-matching technique and photographed the bridesmaids in front of a red brick wall, but the photo would have lost most of its charm.

15.24 I asked the bridesmaids to stand in front of the altar to take advantage of the similar fabrics of the altar and saris.

USING CONTRASTING TEXTURES

Contrasting textures can be an effective way to make a simple photo interesting. As discussed in Chapter 13, "Contrasts," your eye is innately attracted to contrasts. This fact alone creates endless opportunities for photographers. Imagine a photo where an elderly person is standing expressionless in front of Wall Street in New York during rush hour in his/her pajamas. You can't help but smile. Your eyes see the image but your brain is trying to make sense of it. It's like a game of tug-of-war between your senses.

A rustic wooden door offers a ready contrast to the young, beautiful, and modern couple (**15.25**). The bouquet in her hands is consistent with the color and texture of the vegetation surrounding them. For this reason, the bouquet ties it all together. If this photo had been taken at the beach, for example, it probably wouldn't be nearly as interesting.

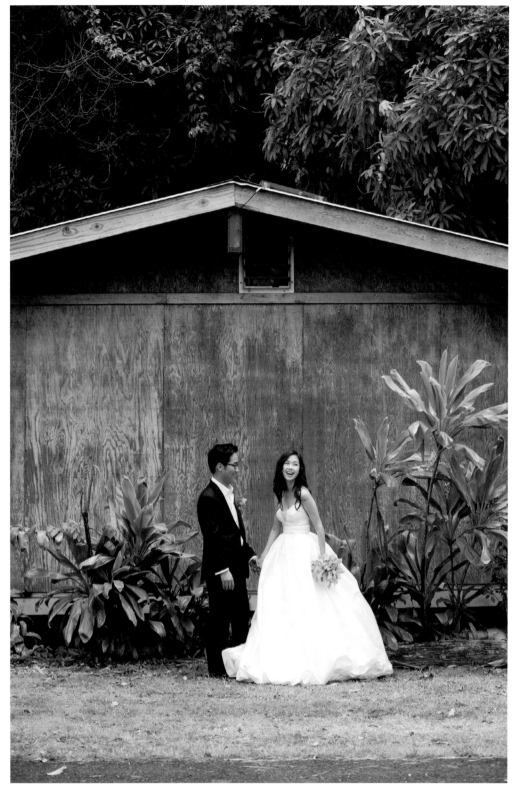

15.25 The rustic door provides contrast to the young, modern couple.

TRANSLUCENT MATERIALS

A translucent surface is simply a see-through material. For photographic purposes, I look for materials that are see-through but also have some texture. I love the look of frosted glass, for example. As a judge for one of the largest photography competitions in the world, I have seen some incredibly talented photographers use translucent materials in ways that boggle the mind. These materials are ideal for giving the viewer a mysterious perspective of the subject being photographed.

When photographing through a translucent material, you must consider specific technical settings. Wide apertures, such as f/2.8 or faster, will soften the material, creating a dreamy, aged effect. There should also be plenty of ambient light to clearly separate your subjects through the material. I usually backlight my subjects with an off-camera flash to enhance the separation and give the photo more impact value.

There are two main ways to photograph using translucent materials. The first is to have the material close to your subjects. If using frosted glass, for example, the glass would be between you and your subject, but the glass should be much closer to your subject. As the distance between your subject and the frosted glass increases, the more abstract and distorted your subject will appear, sometimes so much so that you can't even tell what it is. This is why it's important to experiment with the distance between your subject and the translucent material until you obtain the right amount of distortion.

As a basic example of this technique, I used the shower door in a hotel room, since it was made from a translucent material (**15.26**). I wiped out the background by placing an off-camera flash behind the bride and firing it at almost full power. The second method is to use a material, such as a light silky curtain, and place it right over your lens. The result is similar to the soft-focus filter photographers used in early film days.

15.26 A translucent shower door and backlighting from a flash created this mysterious perspective.

I took two photographs for the sake of comparison between using a fabric over the lens and not doing so (**15.27**). Without a transparent fabric, the photo looks pretty good, but it's not very creative. Now compare it to the shot using fabric (**15.28**). This photo was taken just seconds later with the same lighting conditions and at the same place. People usually think this effect was created in Photoshop, but it wasn't; I accomplished it by carefully stretching the fabric from the hotel room's curtain in front of my lens. For this portrait, I used only natural light and my dependable 50mm f/1.2 lens at f/2. This wide aperture exaggerated the soft feel of the photograph.

15.27 Here's the initial scene without fabric across the lens.

15.28 Stretching curtain fabric across my wide-aperture lens gave the same setting a soft focus effect.

EXERCISE:
SHOOTING THROUGH FABRIC TO CREATE A SOFT FOCUS EFFECT

Exercise: To get your feet wet, first try this technique with a silky curtain material. Put the material across your lens tightly so there are no folds. Pose your subject near a window and take a photo with your lens wide open. If you have an f/2.8 lens, for example, set your aperture to f/2.8. If the material is too thick, this won't work. The material needs to be very thin, see-through, and neutral in color. You might need to focus manually since most auto-focus cameras depend on finding contrasts to focus, and a piece of fabric over your lens will remove most of the contrast from the photo. That is precisely what creates that soft focus feel.

Goal: The goal is to recognize what materials work well with this technique and familiarize yourself with the effects they provide.

Explanation: This technique gives you a great tool for creating impressive effects in camera. Doing exercises like these also train your brain to think about how most items found in any given room can be used to create astounding photographs.

POSES

16

FIVE KEY POSING TECHNIQUES

POSING IS ONE OF THE most challenging aspects of photography. At workshops, when students are asked what they wish to accomplish, nearly 80 percent of them say "posing." For photographers, mastering what creates a great pose is a vital skill. Without it, it's pretty hard to succeed in the people photography business, which is why I'm shocked when photographers panic when it's time to pose the bride and groom for wedding portraits.

Usually the panic becomes apparent when the photographer starts to sweat for no reason. The sweating is followed by the repetitive use of the expression "huh," and then "Why don't we try this?" So the guessing game begins, and your clients are working very hard to make sense of what you are trying to describe. And the only sure thing going on in your head is the hope that something good emerges from the scrambled chaos.

The truth is that by breaking down posing and getting some practice under your belt, posing becomes simple, demystified, and fun. You will no longer worry and sweat profusely in front of your clients. Instead you will take charge. You will know exactly what you want, and you will be able to describe the pose to your clients like a master.

MY POSING SYSTEM

Posing is subjective. What looks good to some people looks bad to others. Photographers always have an opinion about how they would have done a pose differently or improved upon it. Therefore, I'm going to focus on the system I created for posing. That's why I call this chapter "Five Key Posing Techniques"—because techniques, unlike rules, give you general guidelines, which you can alter to make your own.

This system is based on you, the photographer, taking charge of the pose. No guessing is involved. You do this by breaking down the elements that make up a pose. It relies on the experience you gain from practicing these different elements and knowing exactly what you want—before trying to explain it to your subjects.

The first thought that comes to mind when I begin posing a couple is, "Do I want this photo to be a portrait or a candid moment?" In a portrait, the subject(s) are aware of the camera. In a candid moment, the subject(s) do not seem to be aware of the camera, even if they are. The subjects are *not* looking at the camera. This decision changes everything about the pose and how you go about creating it. So it's crucial that you answer this question before you begin to pose people.

TECHNIQUE 1: SYSTEMATICALLY SCULPTING THE BODY

Elegant posture is the key element to posing a person's body. If you compare posing the body to building a house, then posture is the foundation of the structure. It's what holds everything together. To achieve good posture is to achieve balance in the body's weight distribution.

The person's spine must be as straight as possible, an aspect that is usually overlooked. Many of the problems that arise in posing someone can be automatically fixed by straightening the spine and by making sure that the shoulders are down and relaxed. This applies to men and women, whether the subject is sitting, standing, or lying down.

DISTRIBUTING WEIGHT FOR NATURAL POSING

If you want to achieve natural looking poses, mimic what the body does naturally. Imagine you were told you had to wait for someone for 10 minutes—in an empty room with nothing to sit on.

Most likely, you would find a wall to rest your shoulders against, and you would shift your weight to one foot. When that foot became tired, you would shift your weight to the other foot. Either way, one knee would always be bent and the other straight. Assuming that your spine was straight, this would give you a relaxed and natural pose.

The problem with posing people for a photo is that when a large camera fitted with a telephoto lens is pointed straight at somebody's face, people depart from their instinctively relaxed position and stand up straight. They bring their arms straight down and stand

on both feet evenly, thinking that it will look better on camera. It doesn't! It just creates a robotic and tense feel. To keep things simple, focus on three main points:

1. Shift more weight to one foot.

2. Straighten the spine.

3. Lower both shoulders to a relaxed position.

Any slouching or a spike in either shoulder will completely ruin your pose. If you can just remember these three points, you will be well on your way to creating confident and powerful poses. Let's look at two examples of how these key points can affect your pose.

Although this image is not technically a portrait, I still made sure the bride's spine was straight (**16.1**). The bride was putting on her shoes with her mother's help; this action forced the bride to shift her weight from one foot to the other. I waited until the bride naturally fell into the position that I was wanted (bending her left leg) before pressing my shutter. The resulting image is very elegant and the bride appears to be very tall.

16.1 While this image is not technically a portrait, I still made sure the bride's spine was straight.

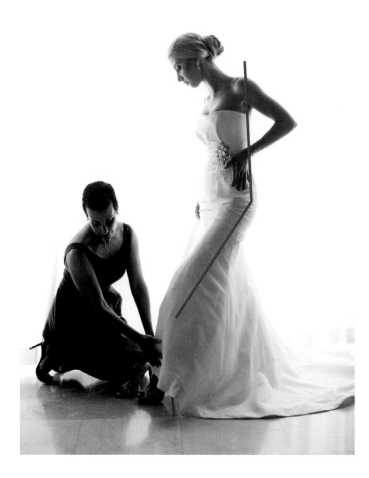

In contrast, this next image is deceiving (**16.2**). At first glance, the groom's back appears to be straight, and it is, except at the very top. Just below the neck, he slouched his upper back to try to match his dad's height. The groom is also standing on both feet with equal weight on each.

These subtle movements happen more times than you can imagine. It's your job as a photographer to pay close attention to such details. Notice how the pose looks quite awkward. This image also shows what can happen when you let people pose themselves. Even their hands are all over the place. They don't know what looks good; it's up to you to tell them.

16.2 This awkward pose shows what can happen when you let people pose themselves.

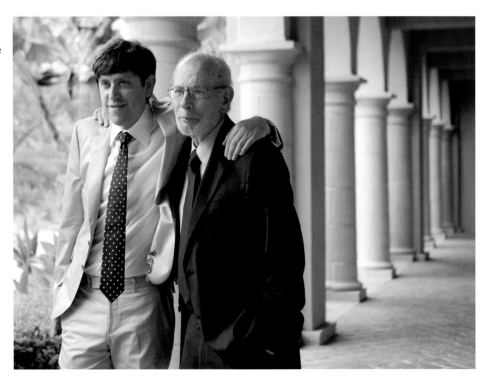

TILTING VS. SLOUCHING

Tilting your head forward is not slouching. You can keep your back perfectly straight while tilting your head in any direction. A slouch is when the spine is curved.

SYMMETRICAL POSING

Shifting the body weight to the back foot, curving joints, or tilting the head are all excellent techniques for creating relaxed portraits. To create a strong and powerful pose, however, I draw an imaginary vertical line down the middle of my subject and have their left and right sides mirror each other.

If the left hand is up, for example, then I have the subject match that with the right hand. If one leg is straight, I ask for both legs to be straight. You get the idea. Naturally, this look is not easy to achieve. But as long as it's close, it will be effective and will yield a more structured, fashion-forward pose.

Notice how the bride's pose feels strong even though her elbows are bent (**16.3**). The callouts further highlight the pose's symmetry (**16.4**). Note that as long as the sides are mirroring each other, the joints can be bent or straight.

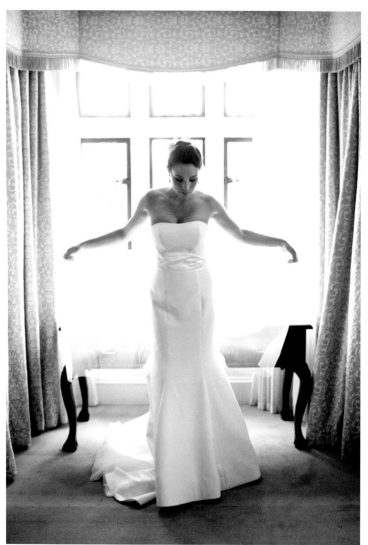

16.3 Because of its symmetry, the bride's pose feels strong even though her elbows are bent.

16.4 The callouts further highlight this pose's symmetry.

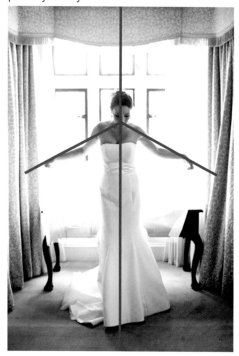

In an example of symmetrically posing a man, the face, arms, legs, and even the slight bend of the elbow are the same on both sides (**16.5**). Next time you are posing someone, try as many symmetrical poses as you can come up with. Also try photographing your subject from the back as well as from the front.

16.5 This man's face, arms, and even his slightly bent elbows are the same on both sides.

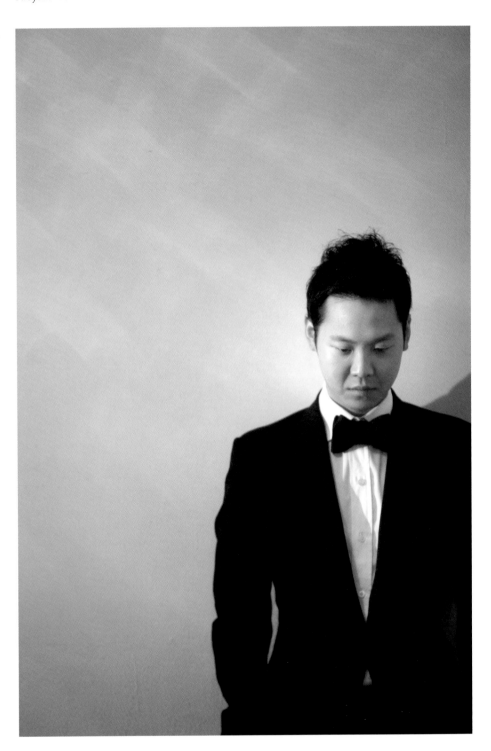

TECHNIQUE 2: POSING THE HANDS

Hands are just as important in a pose as the body, head, eyes, and expression. In studying what makes a good pose, I have come across countless beautiful photos where *something* was not right. The exposure was perfect, the lighting was complementary, and the expression romantic, but the hands were just dangling. This oversight completely killed the mood of an otherwise wonderful photograph.

Hands are such a powerful communication tool. Anything that can be said with our voices can also be said just using our hands. Regardless of whom you are photographing, always find a way to engage the hands. If posing a couple, for instance, place the bride's hand gently on the groom's chest with his hands softly around her waist. This is just one of hundreds of examples. Pay attention to both people's hands. They both don't necessarily need to be on each other, but they need to be engaged somehow; if both hands are in sight, then both should have a purpose.

Once the hands are in place, pay close attention to the fingers. The smallest movement of the fingers can change the story of a photograph. Take, for example, a photo where the groom is holding the bride's arm with his fingers spread apart. Spread fingers communicate aggression, power, and involuntary control of the other person. Imagine the same pose, except this time gently close the gaps in the groom's fingers (**16.6**).

16.6 By gently closing the gaps in the groom's fingers, the message becomes one of tenderness, love, and protection.

I cropped this image to focus only on the hands. The message now is tenderness, love, and protection. It is remarkable how subtle hand movements can completely change the message. Hands speak louder than the eyes. Therefore when I am posing someone, I ask myself, "What are the hands doing, and what are the hands communicating?"

Which of these two images looks more romantic to you (**16.7**, **16.8**)? The difference in the position of the fingers is subtle, but the message portrayed changes very quickly. If your answer was that the second image looks more romantic, you are correct. The first image has a bit of a claw-like appearance. This happens whenever the fingers approach a 90-degree angle.

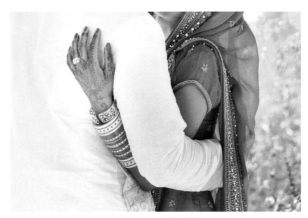

16.7 The difference in the finger position between this image and the next is subtle...

16.8 But most viewers immediately find this one more romantic.

AVOID 90-DEGREE BODY ANGLES

Your knees, your elbows, and even the joints in your fingers can form 90-degree angles, but you have to force your body to do it. Try holding up your arm at a 90-degree angle for a while. Your body doesn't like it. Even when you are sitting in chair, you move your feet closer to yourself or farther away. But you hardly ever keep your feet where your knees will be at a 90-degree angle. When people are at ease, none of their joints fall naturally at a 90-degree angle, so why do it in a pose? The only time I allow a 90-degree angle when posing somebody's arms is if the arm is resting on something that creates a natural 90-degree angle without effort from the person.

POSING HANDS IN LARGE GROUPS

Being aware of what the hands are doing becomes even more important when posing groups. With the exception of formal business group portraits, most group photographs are taken of close friends and families. For weddings, group portraits usually consist of the wedding party and the couple's families. Therefore, we can use the people's hands to physically connect everyone together.

In this group portrait, you can clearly see how I used the hands to solidify the relationships (**16.9**). The hands of every person in this group are doing something. If people are within comfortable reach of someone else, I placed their hands on each other. If not, I simply have their hands rest naturally on themselves. Nobody's hands are dangling—that's what's important. Before taking a photo like this, ask yourself if everyone looks completely natural. Check that all elbows are bent and do a final check of the hands. If everything checks out, push the shutter button.

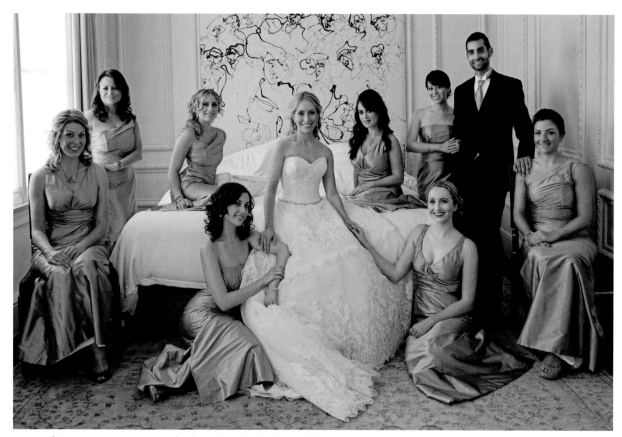

16.9 In this group portrait, you can clearly see how the hands solidify the relationships.

TECHNIQUE 3: POSING THE FACE

This section is about the actual position of the face, not the expression. When posing the face, keep in mind the neck. I look for contrast between the neck and the head. Without contrast separating the two, the neck will blend with the face, giving you one big mass of skin—which is not flattering to anyone. You can achieve this contrast through:

- Lighting, by making the face brighter than the neck.
- Depth of field, by focusing on the eyes and choosing a shallow aperture to blur the neck.
- Changing the angle of the chin by moving the head left or right so that at least part of the chin has a background other than the neck. The background can be the person's hair or hand or simply the actual background of a wall or foliage.
- Avoiding photographing someone from an angle lower than the chin. To make sure of this, I always try to photograph people from a couple of inches above eye level. Photographing someone below the chin will eliminate any contrast between the chin and the face, making him or her appear much larger than they are. I find this to be the worse angle to photograph anyone. Try it—they won't like it. The exception is if your subject is more than 20 feet away. At that distance, the head and neck will be such a small part of the photo that it will make the unflattering lack of contrast between the neck and face much less noticeable.

THE "X" FACTOR

This technique is relevant only when you are photographing a couple. Draw an imaginary line extending from the tip of both of your subjects' noses. Angle both of their faces so that these imaginary lines cross each other, creating an X (**16.10**). This technique creates one of the most flattering candid face positions between two people. If, instead, these two imaginary lines run parallel, the photo will look quite cheesy and old-fashioned.

Although there are many poses you can use that will create this imaginary X, remember that this head position is just one piece of the puzzle. Several more elements must come together, such as expression, to complete the pose. To visualize this X, let's take a look at some examples.

In this pose, look closely at how I had the groom tilt his head toward the bride's (**16.11**). The red lines show exactly how I saw the X while I was setting up the pose. Had I not visualized the X, his nose would have been pointed parallel to hers. To give the embrace more tenderness and candidness, I had the groom tilt slightly toward her left cheek and asked them both to close their eyes.

To show you what happens when there is no X in a pose, here's a photo where the couple's noses are pointed toward each other (**16.12**). Although beautiful, this image doesn't have that same natural, candid feel as the previous shot. You can almost tell that a photographer was posing them. That's the real difference. In one, you get lost in the moment between the couple, and in the other you have the feeling that the couple is trying to follow posing directions.

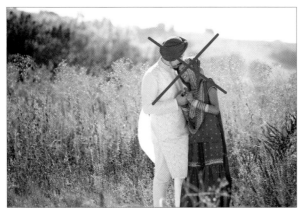

16.10 Drawing an imaginary line from the tip of your subjects' noses creates one of the most flattering candid face positions between two people.

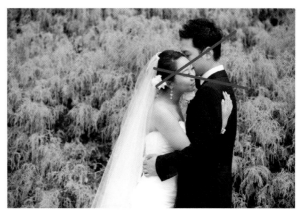

16.11 The red lines show exactly how I saw the X while I was setting up this pose.

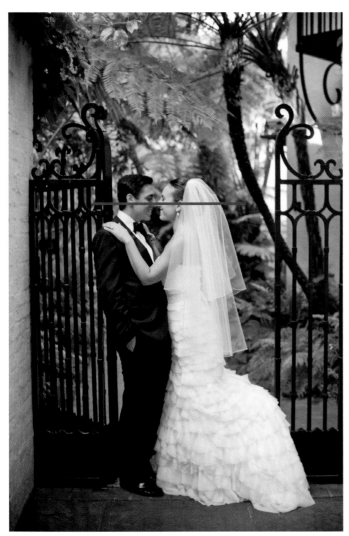

16.12 Here the couple's noses point toward each other. While beautiful, the image lacks the candid feel of 16.11.

TECHNIQUE 4: INJECTING EXPRESSION AND BALANCING ENERGIES

Getting great expressions in your photographs requires more than just a few tips and tricks. Over the course of my career, the expressions of my clients have become more and more dynamic, natural, and most importantly, believable. I say believable because let's face it, when you ask someone to laugh on command it's not exactly a candid moment, is it?

Coaxing a truly candid expression on command requires energy. It's quite exhausting having to react naturally over and over again in a photo shoot. The reason my clients now have beautiful and believable expressions when I photograph them is because they trust me. They have complete confidence in my ability. They see me as an artist. Most importantly, they respect me as an expert. There is a certain unspoken confidence between us that makes it more pleasant to work together.

At the beginning of my career, I tried so hard to bring out good expressions from my couples, only to fall short every time. My clients had already paid me, so they were committed, but they were just not feeling it. Why would they?

I fumbled around with my camera settings, and they could tell I was just guessing when trying to pose them. I offered clichés to get them to react, and I shot at my camera's highest burst rate, hoping that one or two photos would work out. I spent a lot of time looking at the back of my camera and scratching my head because what I saw on the screen wasn't looking good.

My clients could see the fear in my eyes from a mile away. If this sounds like you, then start with this: People don't like to react to someone they don't respect. You will gain their respect when they see confidence and assertiveness in your eyes, not fear. This assertiveness comes from practicing. By practicing poses, you will know what to anticipate when you position a couple in any way. You will know what looks good and what does not, removing much of the guesswork.

CLICHÉS DON'T WORK!

Removing clichés from your posing arsenal will be one of the best decisions of your career. Clichés work with children but not with adults. I often see photographers speaking to their clients as if they were children. I will spare you the specifics, but sometimes I'm shocked at the belittling tone photographers use to get their clients to react, smile, or look sexy.

Instead, try being direct and specific about what you want. When people are treated as adults, they will want to follow your lead. Say things like "I need a lot of movement here," "Give me a hint of a smile," or "Look straight at the camera without a thought in your head." People can follow these types of directions without feeling patronized.

EYES *MUST* BE POSED

Often, I have taken beautiful photos of a couple only to see them on my large screen and realize that the groom's eyes are totally "not into it." Even though their bodies are posed graciously and their heads have that X factor, if their eyes don't seal the deal, the photo is ruined.

The eyes and hands say more about a person's expression than anything else. When people are being posed, most photographers don't tell the couple what to do with their eyes. I have heard clients ask the photographer, "Where am I supposed to look?" To address this issue of the lost eyes, I try to be particularly specific about where the eyes need to be.

If I ask a groom to gently kiss his wife on the upper cheekbone, both usually look up, completely killing the mood. Now I say, "Give her a gentle kiss on her upper cheekbone without pouting your lips and do so while gazing at her lips." The word *gentle* sets the mood for a soft kiss. The upper cheekbone gives the groom a target for his kiss. This puts his face exactly where I want it. Asking them not to pout eliminates the natural reaction people have when kissing their significant other in public. I notice people pout much less when they kiss in private.

Gazing at her lips is the final step; this gives the groom help on where to look. By choosing the lips, it forces the groom to look down, almost closing his eyelids. When eyelids are mostly closed, the mood is romantic and sometimes sensual. When the eyelids are completely closed, the feeling is intimate.

That's why people close their eyes when they kiss: to block out everything else in the world and to focus their senses on the kiss. If one person has his or her eyes closed and the other has eyes wide open, there is an energy mismatch. No matter how beautiful the photo may be, something will be off.

To avoid this issue, always give every person in the photo exact directions on where to look. Posing the eyes meets two objectives: It gives the eyes a place to look, and it changes how open or closed the eyelids will be. Both are crucial to successfully match the energies of the people being photographed. Pose the eyes correctly, and the expression on your subject's face will appear candid, natural, and believable.

This image was taken at a hotel in San Diego (**16.13**). The background is the bed's headboard cropped to remove the context, leaving only the artwork. I asked the bride to lean slightly forward and look up at a specific spot on the ceiling. If her eyes had looked to one side instead of straight up, it would have changed the message. Being aware of these subtleties will make you much more effective at posing people.

During an engagement session in Pasadena, I first established the pose (**16.14**). I then had the groom close his eyes, and I asked the bride to look at her left elbow. The request was so strange to her that she started to laugh. The groom was probably reacting candidly to what I had just asked his fiancé to do. Either way, the photo looks gorgeous and their energies match.

I sometimes put an object on the ground like a rock or a leaf, and I tell my clients to look at it. Regardless of the expression or reaction, I tell them to keep their eyes locked on that object. This technique is one of the most useful strategies and consistently gives me great results.

16.13 Offer exact directions: Here I asked the bride to look up at a specific spot on the ceiling.

16.14 Strange but effective: I had the groom close his eyes and asked the bride to look at her left elbow.

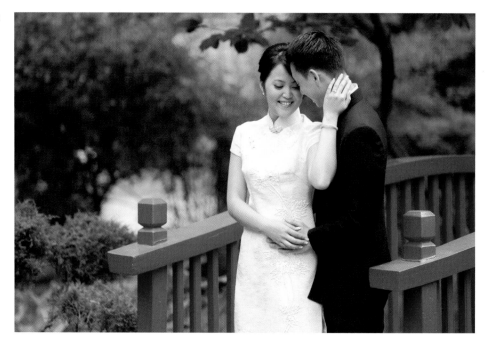

This example was a bit trickier (**16.15**). The bride was Mrs. Asia, so she was very aware of the camera and kept looking at it and smiling. I wanted to create a beautiful candid moment, so I asked her to kneel down and straighten her veil because it was slanting to one side. Her veil was a bit off, but I was really trying to get her completely focused on something else. That way her eyes would look so fixed on something that it would make the photo look candid. See Chapter 17, "Posing Chart," for two images that show what happens when you forget to pose your client's eyes (17.75, 17.76). Keep this in mind next time you are posing someone. If you don't pose the eyes, your pose will be incomplete, and you will have to rely on luck to get the exact expression you're looking for. It's all in the eyes!

16.15 To get the bride focused on something other than the camera, I asked her to straighten her veil.

TECHNIQUE 5: GIVE SPECIFIC DIRECTIONS

It is amazing how fast you can gauge someone's skill just by the way they give directions. In workshops where my wife and I have been asked to model, students pose us for 10 minutes. Then we rotate to another photographer for another 10 minutes.

When the students ask us to pose, I can tell in seconds that they don't know what they want. Everything that comes out of their mouths is a guess. But when the photographer teaching the workshop poses us, it's crystal clear what he wants. He describes it so well, it's almost impossible for us to foul it up.

Be specific when giving posing directions. I can't stress that guideline enough. It gives your clients great confidence in your skill and makes them glad they hired you.

17

POSING CHART

I created the Posing chart (page xvi) out of a strong desire to stop guessing
while I was posing my clients. I wanted a map with certain destination points
that could easily be followed; I could go from one point on the chart to
another without stress or the hope that I'd get a lucky pose here and there.
Now, I have complete control over the poses. Each pose requires individual
practice. Every week, I practice one specific pose for about 10 minutes.
The goal is to discover the pose's weak points and strengths, the different
feelings each pose evokes, and ways to create variations of each pose. If you
consult this chart at a wedding or engagement photography session, and
you are equipped with knowledge of each pose from your practice, it will
be almost impossible to ever run out of ideas again. You will be in full com-
mand of every pose, and your clients will feel it. Master this chart and your
work will improve exponentially.

GETTING THE MOST OUT OF THIS CHAPTER

This chapter is structured as a critique of my own images. I will use many of the same images you have seen throughout this book so you can see the building blocks of how these photographs were created. I will display three to five photographs per pose. For each pose, there will be some photos that did not work well and one or two that did. I will explain why some of the photos failed and why the others succeeded.

Reading through these critiques and explanations will train your brain to spot the small details that make the difference between a nice shot and a well-polished photograph. As you go through your own images, critique yourself. Write down what went right and what went wrong. Keep in mind that posing is subjective. Read this with an open mind and a willingness to learn. Let's get started!

TRADITIONAL

17.1

Location: This photo did not work out because the horizon line is going right through their heads. Also, when there are strong horizontal lines in the background, such as this horizon, the camera should not be tilted.

Body: The bride's arm is straight down. Even a slight bend would help the pose look more flattering.

17.2

Background: The background on this photo contains many strong horizontal and vertical lines. Not tilting the camera at all here was the right call because it keeps these lines parallel with each other, not causing a distraction. However, this background does have a lot going on, so a shallower depth of field would have been preferable to blur out the background a bit more.

Hands: The bride's left hand is coming from nowhere, and her right shoulder is a bit too high. Although the slight rise of her left shoulder is not significant, it is not the body's normal relaxed position. The problem is subtle, but it makes her appear tense.

17.3

Body: The bride's arm forms a 90-degree angle. This may not seem like a big deal, and it's not. But to finesse a completely natural look, little details make a difference. As explained previously, a 90-degree angle on the arms may not look bad at first glance, but it's not a comfortable position for someone trying to look relaxed.

Hands: There are two hand issues here. The first is that the groom's right hand is peeking out from her waist by just two fingers. People usually place their hand near the lower back, but in that case, you should be able to see where those fingers come from. Showing more of his hand by moving the bride's arm would fix this issue. It's always better to not have the fingers coming out from behind a person's back or shoulders, but if fingers do show, make sure more of the hand or arm is also visible. Fingers popping out of nowhere look creepy.

The second problem is the bride's wrist. Notice that she is trying to raise her hand from her wrist, which is not a natural or relaxed movement. The hand should be either straight with the wrist slightly down, but certainly not up. Try it for yourself and see how much more effort it takes to hold your hand up from the wrist rather than down.

Expression: The expressions don't match. The bride is smiling only with her mouth. To create a candid smile, both the mouth and eyes should be smiling. The groom, on the other hand, is not quite smiling; instead, he is observing. Be sure that both energy levels are a match.

17.1 A few problems: The horizon runs right through their heads, and the bride's arm is straight down.

17.2 Here, the bride's left hand comes from nowhere, and her raised right shoulder makes her appear tense.

17.3 The bride's arm forms a 90-degree angle, which is not a big deal. But it keeps her from looking relaxed. Also, the groom's barely-there right hand is a bit creepy.

17.4

Explanation: This photo shows how to fix all the problem areas in the previous photo. Notice how both their smiles now match because they're smiling with their mouths *and* eyes. The bride's arm now has a slightly more comfortable bend, allowing more of the groom's hand to be visible, not just his fingers. Also notice how much more flattering her waistline looks due to the slight bending of the arm. That gap between her elbow and her waist creates contrast, showcasing more of her waistline. Compare it with image 17.3. Which one looks more flattering to you?

17.4 Problems solved: The bride's lowered arm looks more comfortable and provides a better view of the groom's hand and her waist.

17.5

Explanation: This is a traditional pose where the bride and groom face each other. With this pose, it is important to make sure that the bride's arms don't block her waistline. The groom can place his hand either on her arm softly or in his pocket, as in this case. Notice how the groom's arm is slightly bent. This is very flattering for a man—it looks confident. The bride's left arm was placed gently on his right shoulder to show the engagement ring and to make sure it doesn't block her waistline. The angle of her arm is about 30 degrees—perfect for a relaxed look while keeping the physical connection romantic and trusting.

17.5 With this pose, it's important to make sure the bride's arms don't block her waistline.

HIM BEHIND HER

17.6

Body: Their bodies look static. There has to be more movement to create a moment you can connect with. The bride is tilting her head toward the groom, which is a good thing, but the groom should return the favor.

Expression: Although they are both smiling, the pose shows a lack of connection between them. This issue can be fixed by the photographer tilting their heads into position, then making the couple react by saying something to them. What you choose to say depends on your personality as a photographer, your clients, and the relationship you have with them. Sometimes, you have to say something out of your own comfort zone to get them to react. Remember not to use clichés, or the only reaction you will get from your clients is annoyance.

17.7

Body: To make a connection, I had the groom kiss her shoulder, but to do so he had to hunch his back. This position also blocked half her face, and you don't see enough of his, either.

Expression: Although the pose didn't work out, it did do wonders for a candid expression on their faces. When the groom kissed her shoulder, she reacted to the kiss naturally.

17.6 The problem: too static with little connection between them.

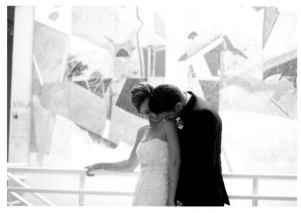

17.7 A kiss to fix the problem creates another: The groom blocks her face. But she laughed.

17.8

Explanation: Building on the candid reaction from the previous image, I counted on the fact that the bride reacted beautifully to his kisses. So I gave him different spots to kiss on her face. This shot was taken in between kisses. More often than not, the best and most candid shots occur between poses. Be aware of this, and you will create many more stunning photos.

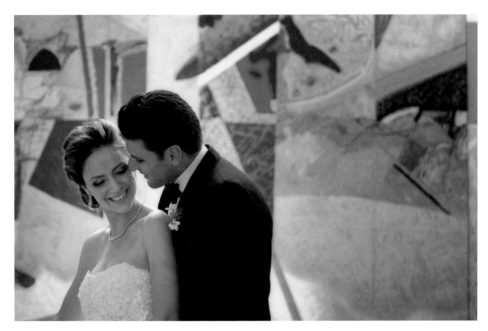

17.8 The solution: I ask him to kiss different spots on her face and they smile between kisses.

17.9

Explanation: In this photo, there is no way for the groom to kiss the bride's face without completely bending over. Just because the pose worked in image 17.8, that doesn't means it will work for all couples. Be prepared to adapt the pose if physical challenges exist. As explained in Chapter 16, "Five Key Posing Techniques," I knew I had to keep their spines as straight as possible, so I decided to go with a more traditional variation of the "him behind her" pose. I used a reflector to create some separation between them and the background.

17.9 Be prepared to adapt the pose. Given their height difference, I went with a variation of the "him behind her" pose.

HER BEHIND HIM

17.10

Body: This pose can be tricky because it can so easily look awkward. Keep a few things in mind when using this pose. If the bride places her arms up near his chest, it can make her arms look quite large because they will be pressed against his arm. In this case, the bride is obviously fit, so it's not an issue here, but most people don't have arms like that. Another issue is that the groom must remain fairly straight for this pose to work. The bride can hug him from behind, but she should not pull him toward her or his center of gravity will change. That's exactly what happened here. Look how the groom is leaning too far back for the pose to look natural.

17.11

Body: In the previous photo, the groom was leaning too far back; to compensate, I told him to lean forward. I was trying to straighten his back, but I gave the wrong directions. The groom did exactly what I asked of him, but he leaned too far forward. As a result, the bride's right shoulder went way up, and his shoulder blocked most of her face. The moral of the story is to make sure you practice enough to be aware of what chain reaction will occur with the directions you give.

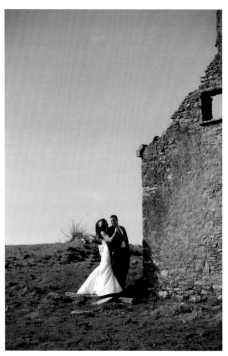

17.10 See how the groom is leaning too far back for the pose to look natural?

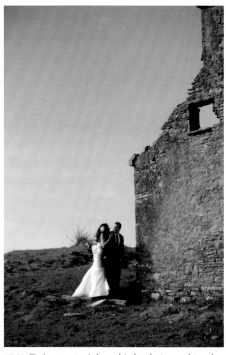

17.11 Trying to straighten his back, I gave him the wrong directions. Now the groom is leaning too far forward.

17.12

Explanation: Considering the last two photos, I started giving much more specific instructions. I asked the groom to straighten his back. I asked the bride to keep her hands in place, but to not pull on his shoulder. I also asked her to raise her chin to avoid her face from being blocked. Now the photo works.

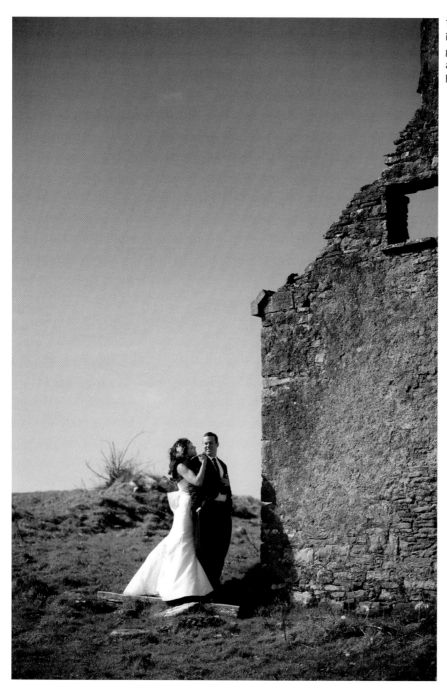

17.12 Using more specific instructions, I asked the groom to straighten his back and the bride to not pull on his shoulder.

17.13

Hands: Too many hands are bunched together. When posing hands on hands, be sure to have one set of hands low near the stomach and the other set high near the chest. This will eliminate the clutter of hands all at the same level.

17.14

Explanation: This is a variation on the other "her behind him" poses we have looked at. Here, we have much more of the groom's back showing. Instead of a straight side view, this is more of a three-quarter view of the groom's back. I positioned the bride near his right shoulder and I asked them to look at a specific spot in the field I picked out for each of them. This keeps their eyes focused on that object, making the expression more believable.

Having them look in opposite directions also creates contrast. Since the attention is not on the photographer, it makes the viewer wonder what they are looking at or what's going through their heads at that moment. You might have noticed the 90-degree angle on the bride's left arm. In this photo it works because she is naturally resting her hand on his waist.

17.13 To avoid this clutter of hands, keep one set low and the other high near the chest.

17.14 A variation on the "her behind him" pose, having the bride and groom look opposite directions adds contrast.

WALKING

17.15

Location: You'll find that walking shots are common when photographing couples. But in my opinion, asking a couple to walk can yield a contrived-looking photo. Before I decide to take a walking photo, a strong environmental or architectural element must exist. In this example, I circled the trees because they are not interesting enough for a walk pose to work. If the leaves were changing color or they were special trees like California redwoods, that would be a different story.

Body: Another problem is that both feet should be making contact with the ground. The groom's left foot is not touching the ground, making his entire left leg look awkward.

Hands: The bride's left arm is at a 180-degree angle and her right arm is bent at a 90-degree angle. Both are undesirable angles.

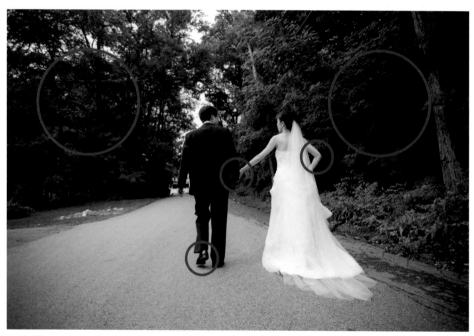

17.15 The trees aren't interesting enough to carry this walking photo, plus the feet and arms look awkward.

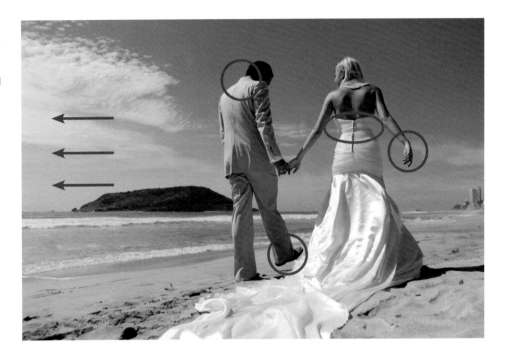

17.16

Location: Although it's really overdone, clients getting married near the beach tend to expect a walking photo on the beach. I find that a wide-angle lens can shine here. An extra-wide lens, such as the Canon 16–35mm f/2.8, can make a scene look more dramatic. However, this photo, taken with a 24–70mm, was not wide enough to give this photo the necessary environmental context.

Body: Again, the groom's right foot is not touching the ground. Also, at this angle his right shoulder blocks his chin. Both the bride and groom are walking with each foot in its own track. This creates an unfavorable flat look to the bride's waist. To fix this issue, I should have asked them to walk as if they were on a balance beam. This would force them to put each foot immediately in front of the other, creating more hip movement.

Hand: The bride's right hand is not doing anything. To solve this, the bride needs something to hold with her free hand. Her bouquet, sandals, shoes, or a purse would work well. If there's nothing to hold, she could gently hold up her dress.

17.17

Explanation: This walking photo has a great deal of architectural interest since it was taken on Michigan Avenue in downtown Chicago. The bride is holding her bouquet, which helps avoid her hand from wandering off. Both of them are walking in a single straight line, which creates more hip movement. Last but not least, the photo was taken with a wide enough lens, to capture the essence of Chicago. Try to imagine this photo taken up close with a telephoto lens; it would have lost most of its impact.

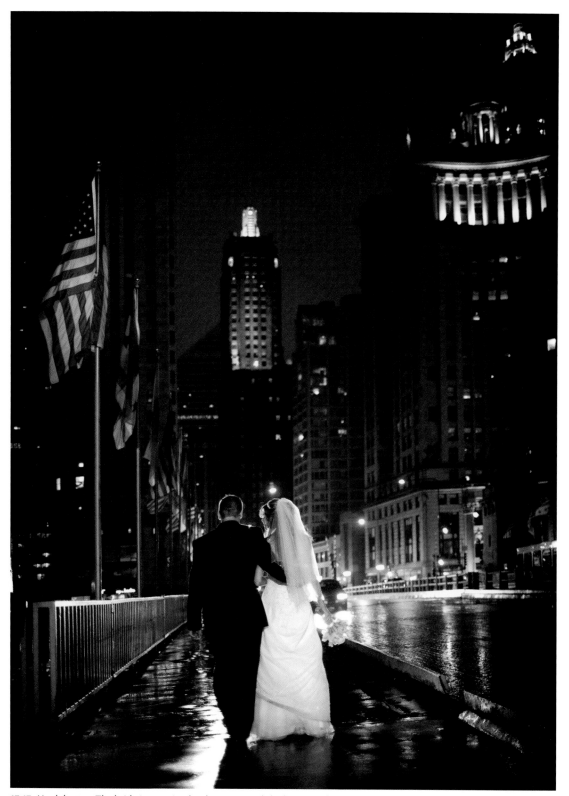

17.17 Much better: The bride is carrying her bouquet, and the lens is wide enough to capture Chicago's big city essence.

17.18 I asked the groom to walk a couple of steps ahead of his wife so that he would not block the camera's view of her.

17.18

Explanation: I wanted to illustrate an important point with this photo. Before you send a couple somewhere far enough to take a walking photo, be sure to give specific directions about how you want them to walk, what they should do with their hands, where they should look, and how to move their feet. I've noticed that when couples are asked to walk, they usually do so right next to each other. If you are photographing them from the side, one of them will completely block the view of the other person. For this photo I asked the groom to walk next to his wife, but just a couple of steps ahead of her. And I asked them to make sure to never close that gap between them, or they would block each other.

17.19

Explanation: Pay close attention to the way the couple is walking in this photo. Notice how the groom's feet are crossing each other and his left hand matches his enthusiastic walk? On a piece of paper, write down all the necessary instructions you would have to give a couple to achieve a photo like this.

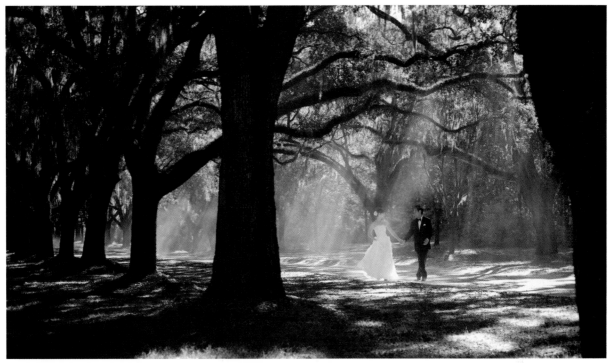

17.19 See how the groom's feet cross each other and his left hand matches his enthusiastic walk? What instructions would you need to replicate this pose?

KISSING

17.20

Hands: A rainy night in Chicago. With the streetlights and buildings, it looks like a beautiful, candid moment. But then you see the hands crossing each other, and immediately the photo looks posed. This is how people kiss in front of a camera when they are asked to kiss. It is not very romantic.

If you show hands in a kiss shot, they must match the intimacy of a kiss. Experiment with the placement of the hands until both are positioned in different places. For example, her hands could be on his waist with his on her shoulders.

17.21

Explanation: After noticing the static look of the hands in image 17.20, I quickly asked the groom to place both of his hands underneath her jaw. Placing hands on the cheeks usually blocks too much of the face. The most important tip when placing the groom's hands on her neck is to make sure his thumb is on her face, just as shown in this photo. This avoids the appearance that he is choking her. Next time you pose a couple to kiss, keep the thumb's position in mind and direct your clients accordingly.

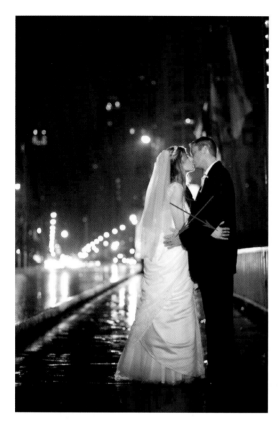

17.20 It looks like a beautiful, candid moment—until you see the hands crossing each other.

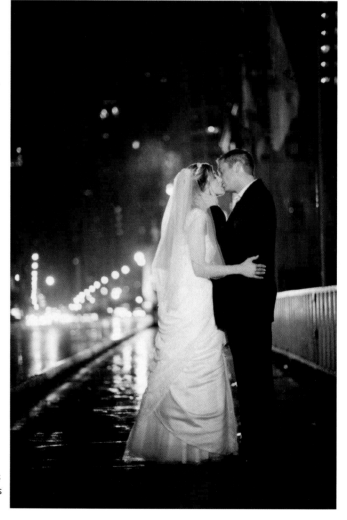

17.21 When the groom places his hands on her neck, make sure his thumb is on her face.

17.22

Explanation: This is the same couple from earlier in the chapter with the significant height difference. The strategy here was to reduce some of his height by having him take a couple of steps back and then leaning forward to kiss his wife. I asked the bride to stand up straight and raise her chin so her husband could kiss her forehead, which is the highest point on a person's face.

I asked the wedding party who had just arrived via trolley to make noise and cheer. The photo was meant to be fun and playful, so the bride needed to have a candid lively smile on her face. The cheering of the wedding party provides a fun background and the bride can't help but react energetically. The pose of the bride and groom appears as if it just happened, but behind the scenes my specific instructions brought out the best of the situation at hand.

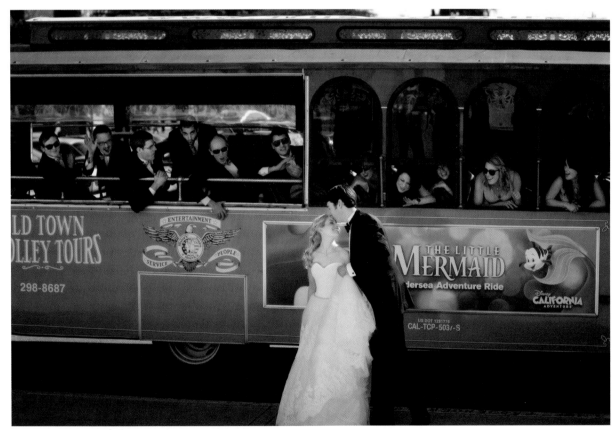

17.22 To reduce their height difference, I asked the groom to lean forward while his bride offered her forehead for a kiss.

17.23

Explanation: I'm not a fan of kiss photos because they're so overdone. If I do decide on a kiss pose, I try to make it more interesting than just a couple kissing in front of a building or a wall. In this case, I found those little plants with peculiar flowers on top. This was all I needed to make them my focal point.

This is a three-layer photograph. The flowers are the foreground, the couple kissing is the middle, and the mountains behind are the background. Due to the height difference, I also asked the groom to take a couple of steps away from the bride and then lean over to kiss her. The layering and the fact that the couple is out of focus create a more interesting kiss photo than the norm.

17.23 Kiss photos are overdone, so look for something interesting such as these peculiar flowers to put in front of the out-of-focus couple.

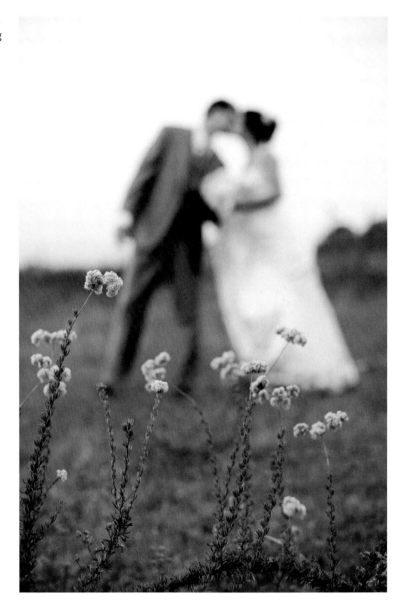

17.24

Explanation: This is a similar technique as image 17.23. The emphasis here is on the framing. The groom's height was similar to the bride, so I was able to have them stand next to each other and I asked the groom to kiss her left cheek. The bride's hand was positioned on the groom's shoulder to make the pose more intimate. To preserve the mood of this private moment, I asked the bride to close her eyes, relax her entire body, and to have just a hint of a smile on her face.

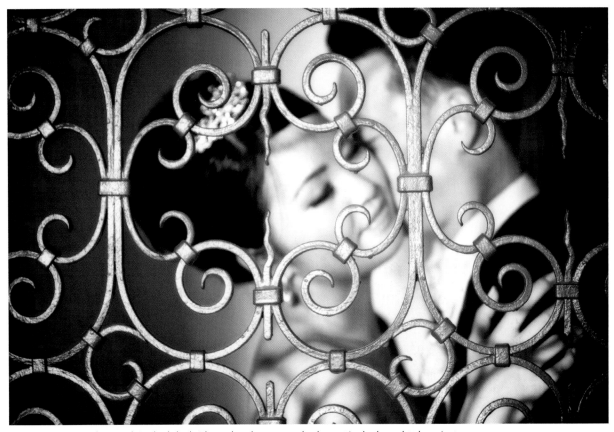

17.24 To preserve the mood, I asked the bride to close her eyes, relax her entire body, and to have just a hint of a smile on her face.

PLAYFUL, ACTION, MOVEMENT

17.25

Technical: This photo represents the beginning stages of a well-executed "playful, action, movement" pose. But many problematic areas are noticeable here. To begin with, I was using a 16–35mm f/2.8 lens at 16mm to distort the perspective and to make the photo more dramatic. However, these ultra-wide lenses create unflattering and extreme distortion at the edges. Notice how her arm appears to be six feet long and his left shoulder engulfs almost half the frame. This can be easily fixed by placing your subjects in the middle of the frame, where the least amount of distortion will occur.

Expression: The bride's expression is off. It's focused on the camera and too serious for a portrait where she is being featured. This is supposed to be a pose with movement and action so that "happy" and "energetic" come to mind. How would you fix the expression problem?

17.26

Technical: The distortion issue became my priority so I recomposed to put the couple in the middle of the frame. Now it looks more acceptable.

Expression: I was looking for happy and energetic in her expression. Having the bride's chin down says "shy" more than "happy and energetic." Although the photo looks good, it could be better.

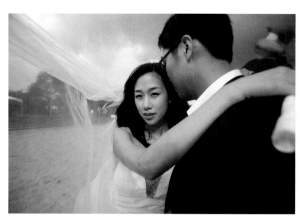

17.25 A few problems keep this from being a well-executed "playful, action, movement" pose, starting with the lens angle.

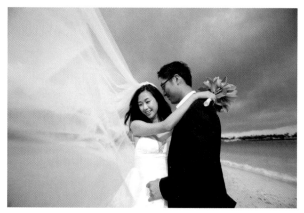

17.26 After fixing the first shot's distortion, the bride's expression says "shy" more than "happy and energetic."

17.27

Explanation: This is the final push to create a great expression. I had to speak with the same energy level I wanted to elicit from her, so all my instructions were delivered with a lot of energy in my voice. I was holding her veil with my left hand, moving it up and down. My camera was in my right hand with a bit of fill flash to fill in any shadows. What makes this photo work is the bride's beautiful smile with her chin up and her eyes looking up as well. You can feel the energy in the shot!

17.27 This photo works because of the bride's smile with her chin up and her eyes looking up as well.

17.28

Body: The amphitheater and arches set the scene perfectly for a "playful, action, movement" pose. A dance performance style pose would work beautifully here. I began by giving the couple a set of instructions such as "I need plenty of movement here," "Keep your knees and elbows bent at all times," and "As you move, laugh out loud." If you recall from Chapter 8, "Silhouettes," to create a successful silhouette, there should be as many gaps in the body as possible so that the sky can show through. When I started taking the photos, the movement was minimal, as you can see here. Just like the previous photo, great instructions help, but they're not enough. The photographer has to perform as well. You are like the battery that gives the subjects energy. My normal tone of voice just wasn't cutting it, resulting in a weak pose with few gaps in their bodies.

17.29

Explanation: As the energy in my voice increased and I was cheering them on as loud as I could, they started moving and dancing as if they were alone in the world. I could hear their laughter and the energy level was just right. Now count how many gaps are in their bodies where the sky can show through. If you are confused by the gaps, refer back to Chapter 8.

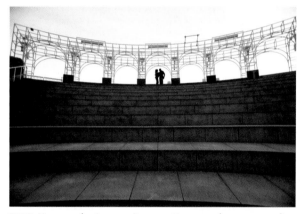

17.28 My normal voice wasn't generating enough energy, resulting in a weak pose without enough silhouette gaps.

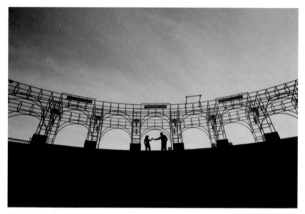

17.29 As the energy in my voice increased, the couple started moving and the energy level was just right.

17.30

Explanation: This photo was inspired by the bride's memory of a bar she and her friends used to visit while attending college in Savannah. Although the photo is comical, I had to think how to make it compositionally interesting. I include this photo to encourage you to never forget that there must be great lighting and composition in every photograph you take, no matter how serious or comical. I positioned the groom on the very left, the bride in the middle, and the dartboard on the right. This way, all three key elements hold important positions, making the photo visually interesting all around.

17.30 I placed the groom, bride, and dartboard at key positions to keep the photo visually interesting.

17.31

Explanation: This particular photo represents why I love this kind of playful pose. I admire how simple and playful this photo is. Although you can't see their faces, the photo is romantic and charming. This is the greatest benefit of the "playful, action, movement" pose.

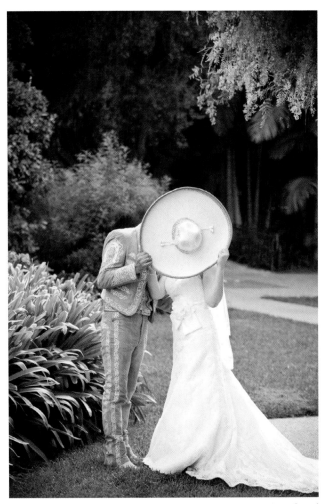

17.31 Simple, romantic, and charming, this photo shows the benefits of the "playful, action, movement" pose.

HOLDING HANDS

17.32

Hands: Physical touch in a pose always enhances the connection between two people. You want this connection to be smooth and effortless so that it doesn't become a distraction. Here are a few pointers to keep in mind when posing a couple holding hands.

First, the wrist should always stay within its natural curvature. Do this quick exercise: Hold your arm straight up in front of you and let your hand relax. Notice how your wrist falls down at around a 45-degree angle? Now keep your arm up and this time try pointing your hand up at the same 45-degree angle. It takes real effort, right? This photo suffers from the bride's wrist going the wrong way. Her knuckles are pointing up instead of down.

The second point to remember is to not let the fingers send the wrong message. Wide-open fingers appear aggressive and controlling; and fingers completely closed are not relaxed. There should be just a natural, small gap between the fingers. Simply asking your couple to soften their hand will create a relaxed feel with the perfect gap between the fingers. The third point is to double-check that the couple is *not* squeezing each other's fingers.

17.32 Notice how the bride's wrist is going the wrong way, and her knuckles are pointing up instead of down.

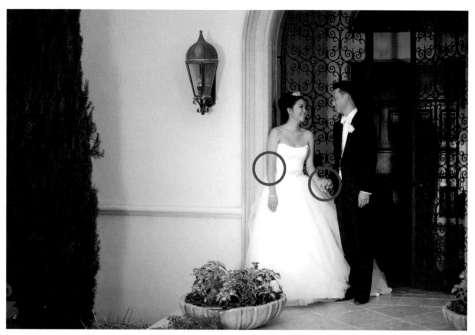

17.33

Hands: This photo is an example of a finger squeeze. Although the pose looks great and the couple looks happy, at closer look, the groom is squeezing her hand a bit too hard. Notice the bride's index finger is overlapping her middle finger due to the squeeze. This might seem picky, but these little details make a difference.

17.34

Hands: When a couple is asked to hold hands without any further instructions, they will most likely interlock their fingers. There is nothing wrong with that, as long as they don't interlock all the way. Ask them to hold hands softly, creating a loose interlace. The groom here is grasping the bride's hand so tightly that her wrist is bent the wrong way.

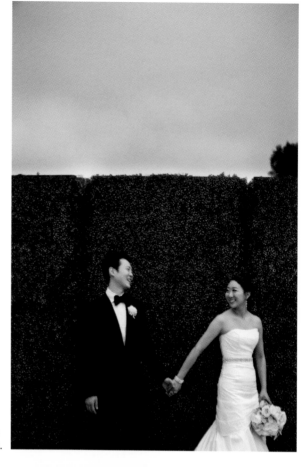

17.33 While the pose looks great, the groom is squeezing her hand a bit too hard. These little details make a difference.

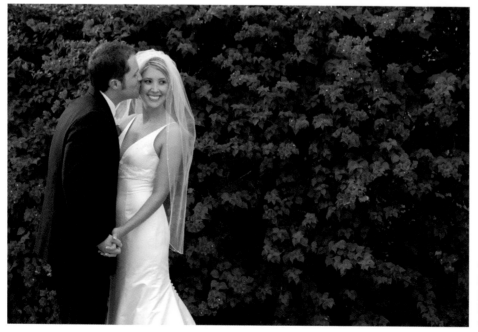

17.34 Ask couples to hold hands softly. The groom here is grasping the bride's hand so tightly that her wrist is bent the wrong way.

17.35

Explanation: Asking the couple to hold hands using specific directions creates a loose interlace between their hands. Notice how the bride's wrists, as well as her fingers, are curved naturally. I asked the groom to shift his weight to his back foot to create a relaxed feel. The challenge I faced here was the horizon line. I had to make a choice; do I put the horizon line through the bride's head or the groom's? Neither is ideal, but their height difference left me with little choice. I decided to go with the groom's head. To minimize the inevitable distracting horizon line, I placed both the bride and groom at the same exact distance from the camera, allowing me to change my aperture from f/3.5 to f/1.2. At this extreme f/stop, the focusing plane is so shallow that the horizon line goes completely out of focus.

17.35 Notice how the bride's wrists and fingers are curved naturally. I also asked the groom to shift his weight to his back foot to create a relaxed feel.

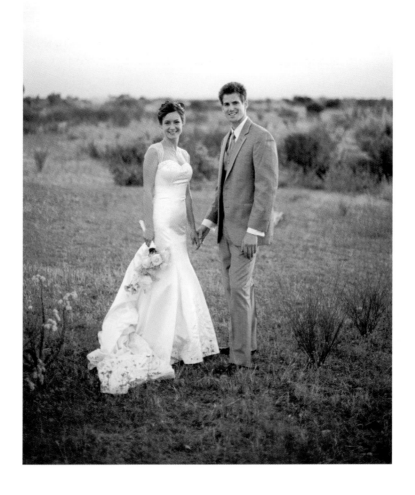

SITTING

17.36

Location: Posing a couple sitting down is a great way to reduce height differences, and it offers a different perspective than the usual standing-up shots. I always try to include a few sitting shots at every wedding. The location in this photo comes with many challenges, but it also provides great opportunities.

Strong directional light is very romantic and therefore sets the stage for this photograph. The cars, road, trees, dirt, and buildings are major distractions, but they can be cropped out. The obnoxious horizon line between the park and the road was harder to overcome. I had to find something to stand on for a higher vantage point, allowing me to remove the horizon from my frame.

17.37

Location: Most of the distracting elements have now been cropped out except for the horizon line, which we will deal with later. I needed that directional light to illuminate the bride's face directly to give it a romantic window-light feel. All I had to do was ask the bride to turn her face to the right.

Body: As the pose stands in this photo, the connection is not there yet. They are sitting together but that's it. Have them turn their faces toward each other and the problem is fixed.

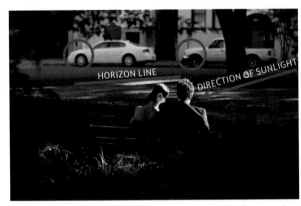

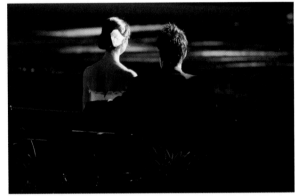

17.36 Strong directional light set the stage for this photograph. The distracting cars and buildings can be cropped out. But I needed a higher vantage point to eliminate the horizon.

17.37 With the distractions gone, I asked the bride to turn her face to the right. The couple, however, still lacks connection.

17.38

Explanation: In the final image with a higher vantage point, I was able to crop out all the distractions, including the horizon line. The patches of light hitting the ground are distracting, but when I converted the photo to black and white, the patches became part of the photograph's casual mood. To keep the groom's head from blocking the sunlight on the bride's face, I asked her to move forward a bit.

The result is a gorgeous image, a quiet moment between a bride and a groom sitting comfortably on a park bench. The sunlight caressing the bride's face draws your eye right to her. At the start of the photo session, this was nothing but a generic park with awful distractions all around. By recognizing the hidden photographic treasures of any location, you will have no problem creating striking images anywhere, anytime.

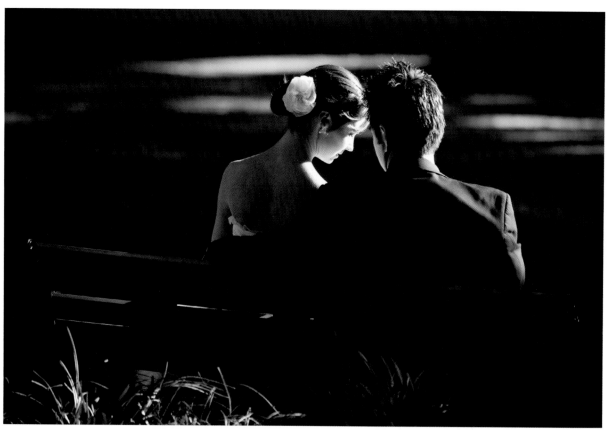

17.38 To keep the groom's head from blocking the sunlight on the bride's face, I asked her to move forward a bit. The result is a gorgeous image.

17.39

Location: If you recall Chapter 5, "Color Elements," you know why I was attracted to this location. Not only is the wall behind the couple painted a solid color, which keeps the background clean, but it is also a neutral color and easy on the eyes. The bench was conveniently right in front of a clean single color wall. I used a combination of a sitting and T-pose, which I explain later in this chapter. The metal rail needs to be cropped out to avoid adding a strong horizontal line.

Expression: The pose is working nicely here. There are only two issues to address. First, the bride's chin is touching her right shoulder. It's important to have some separation between the two. Raising her chin will fix the issue. The second problem is the groom's expression. The bride is happy and in the moment, but the groom needs to match her energy.

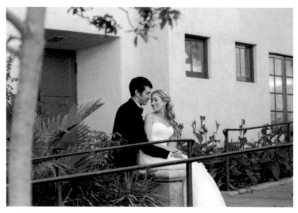

17.39 The wall behind the couple keeps the background clean and the rail can be cropped out. But the bride's chin is touching her right shoulder, and the groom's expression lacks energy.

17.40

Explanation: The final image crops out the rail and the rest of the distractions. What's left behind is the neutral, single-colored wall. The most noticeable improvement in the photo is that the groom's expression matches the mood and energy of the bride's. Also, I asked the bride to raise her chin and to tenderly look at his eyes. The groom was asked to keep his eyes locked in on her lips. I knew from practicing and experimenting that having him keep looking at her lips while she is staring at him would be a bit awkward and would cause him to smile. As soon as he did, I pushed my shutter button.

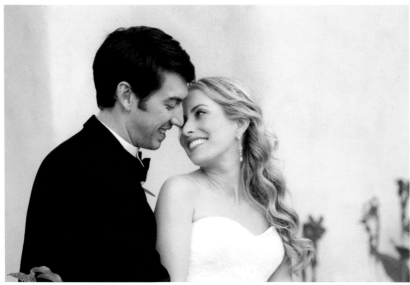

17.40 After cropping out all distractions, I asked the bride to raise her chin and tenderly look at the groom's eyes. I asked him to look at her lips, which I knew would cause him to smile.

TOGETHER SIDE BY SIDE

17.41

Explanation: Having a couple standing side by side, directly facing the camera, and expressionless, is something most portrait photographers try to avoid. But I borrowed this pose from some photographs from the early 1900s and then modernized it. The pose is old but the locations are new, which is why this contrast makes the pose attractive. I wanted to keep the old-pose feel, but I felt it could use a twist. I had the groom bring his left arm back and the bride to move her left leg forward just a tad. This subtle touch made the photo different from others and more interesting to look at.

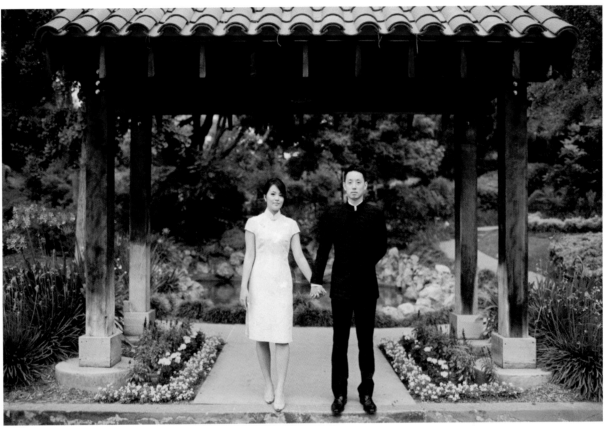

17.41 The pose may be old but the locations are new, which is why this contrast makes the pose attractive.

17.42

Explanation: Standing side by side doesn't mean that both people have to be facing the same direction. During a practice session with this pose, I began to change which direction the bride and groom were facing. By keeping the five key elements for posing in mind, no pose will look bad. To charge it up a bit, I had the bride face me and close her eyes. The closed eyes served two purposes: the sun was right in her face, and it also gave mood to the pose. I chose this background because the colors are all in the same family, which, as you'll recall, is one of the techniques discussed in Chapter 5.

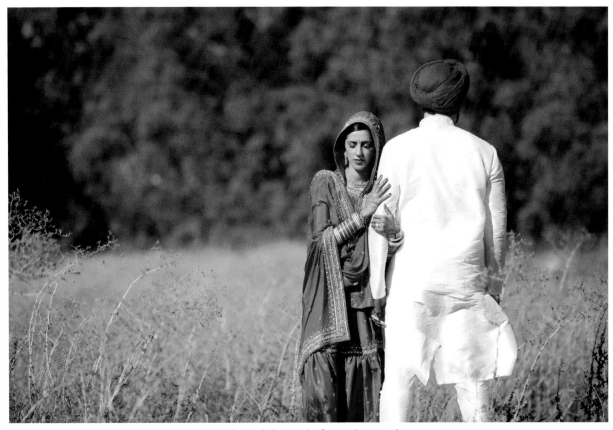

17.42 Standing side by side doesn't mean that both people have to be facing the same direction.

17.43

Explanation: This is another variation of the "together side by side" pose. I recommend that you try this pose when the couple is backlit. It will make them glow, and the pose will be quite romantic. For this pose, I created a "V" shape with their collarbones to get them to touch their foreheads together more naturally; otherwise, it would be a far reach.

17.43 The V shape formed by their collarbones helps the couple look more natural as they touch their foreheads together.

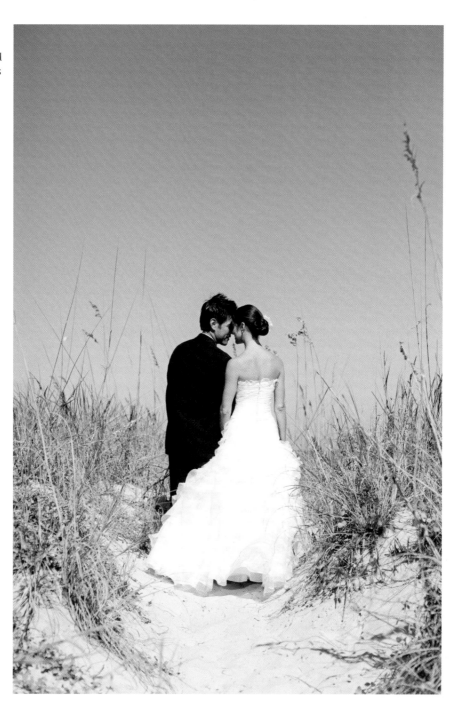

INTERPRETIVE

17.44

Location: The final image from this sequence also appeared in Chapter 9, "Reflections." Let's go over how it was constructed. To obtain a wide variety of poses in a single photo shoot, it's a good idea to throw one or two interpretive photos into the mix. With an interpretive photo, people can interpret it however they please. It's deliberately open-ended, and it creates more questions than it answers.

With a little imagination and some practice under your belt, you can create an interpretive photo anywhere. In this case, there was not enough natural light when the photo was taken, so I used an off-camera flash and the wireless Canon ST-E2 transmitter to simulate window light on the bride.

Expression: I took this photo but I wasn't feeling it. There was too much space on the right and the expressions were not working. However, I did like how my flash illuminated the bride, and how the unlit groom created a silhouette.

17.45

By using the mirror on the right side of the room, the reflection creates photographic balance in the frame. Now we have activity happening on the left side of the photo as well as on the right side.

Expression: The photo was coming together but the bride's expression was still off. I couldn't have her smile because the photo was moody and there was really no reason to smile. But a serious face would look like I was trying too hard to be creative. So that was quickly ruled out.

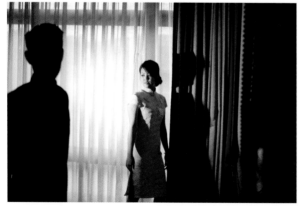

17.44 Despite her flat expression and the empty space on the right, I liked the flash on the bride and the groom in silhouette.

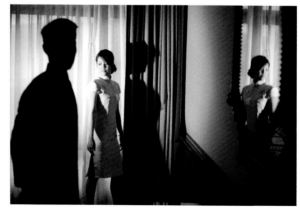

17.45 With the mirror added, the photo was coming together, but the bride's expression was still off.

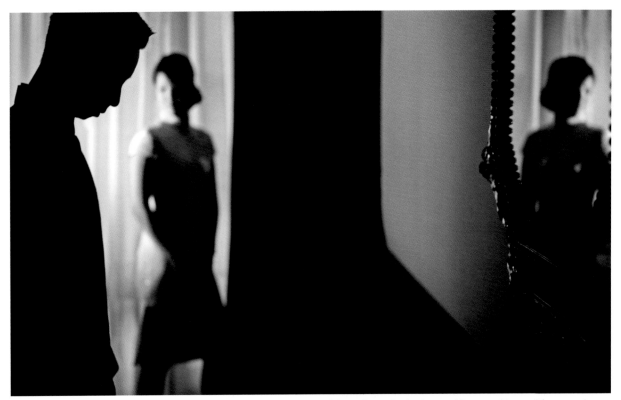

17.46 The solution for the expression problem: Throw the bride out of focus and instead focus on the silhouetted groom.

17.46

Explanation: I decided that the best solution for my expression problem, in this case, was to remove the expressions altogether. Instead of focusing on the bride, I decided to throw her out of focus by focusing on the groom. He was in silhouette anyway, so his expression was not important. The result is an interesting image that is well balanced and fun to look at, and all I did was use the elements available to me in an average hotel boardroom.

17.47

Body: Sometimes we get inspiration for an off-the-cuff photograph from random objects we run into in our everyday lives. This couch in front of the window with the street reflecting on it reminded me of The Doors' *Morrison Hotel* album cover. At first glance, I thought the bride sitting with her arms on the couch and the groom sitting with his legs and arms perfectly straight would work well, but as I took the photo, I thought, "Why do they both have to be sitting on the couch?"

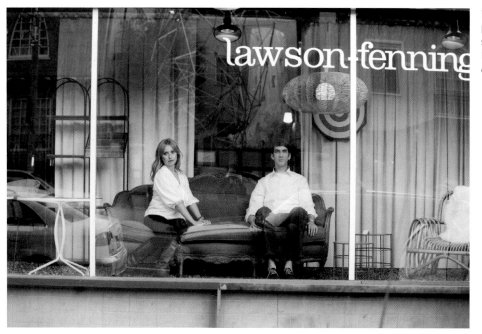

17.47 Random objects can provide inspiration; this scene reminded me of The Doors' Morrison Hotel album cover.

17.48

Body: I asked the bride to stand in front of the window and look straight but without focusing on anything. Now I liked the way the bride looked but both she and the groom looked rigid. I had to make a change to create some contrast. I thought, "Why shouldn't one person be rigid and the other relaxed?"

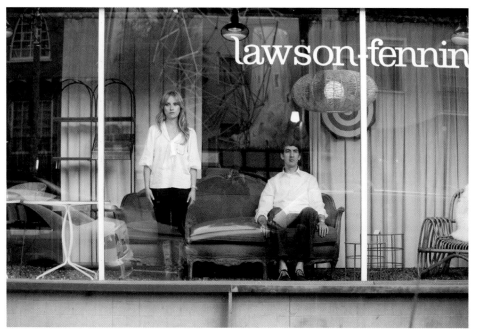

17.48 Realizing that they didn't both need to be sitting on the couch, I asked the bride to stand and look straight ahead. But there wasn't enough contrast between them.

17.49

Explanation: By having the groom cross his legs and rest his right hand on his ankle, he appears to be more relaxed. Creating contrasts such as this rigid/relaxed scene makes the viewer think more when looking at the photo. The brain wants to know why he is so relaxed and why she is standing with her arms straight down. I don't recommend that you do many of these unless that's your thing, but as I said before, one or two might be kind of fun. Also, make sure your clients are okay with this kind of funky photo. Some people may not feel comfortable with this kind of shot, so that should be considered.

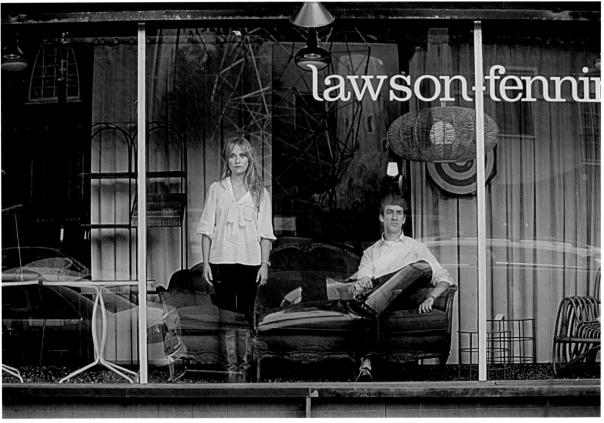

17.49 Asking the standing bride to remain stiff while having the sitting groom relax generated the needed contrast.

17.50

Explanation: When stories are too literal, they can be boring because they answer every question in a moment's glance. So sometimes a story can be better told by showing just a part of the other person. In this case, I wanted to show the tender relationship between the bride and her husband. I noticed how softly he was holding her hand. Throughout the day, he was very gentle with her.

To create the sensitive mood, I asked the bride to take a few steps away from the groom while he held onto her hand. I had her look straight ahead, while asking the groom to caress the hand he was holding with his thumb. That soft caress took care of his expression, softening it.

If you ask someone to do something rough, like hit a punching bag as fast as they can, their face will squeeze up and their teeth will show. The same technique works when you ask someone to do something soft and gentle. I cropped the bride out, leaving only a bit of her arm in the frame. That gentle touch is where the story resides. Showcase that and leave the rest to the imagination.

17.50 To create the sensitive mood, I asked the bride to take a few steps away from the groom while he held onto her hand.

DISTANCE APART

17.51

Body: A nontraditional pose keeping the bride and groom some distance apart can resemble the conceptual nature of the "interpretive" and "foreground/background" poses. Think of distance apart as a way to tell two different stories in one photograph. For this photo, I wanted to create a feeling that both were taking a stroll on the beach, each enjoying their own time with their own thoughts. However, this photo does not tell that story. Here the groom is not walking; he is just standing and waiting while the bride catches up. Their energy is connected to each other; I wanted the energy to be autonomous.

17.52

Explanation: To break the couple's connection and keep their thoughts independent, I asked the bride to find something she found attractive or interesting to her left. At the same time, I had the groom do the same but look straight ahead. That way their minds are preoccupied with the task at hand and not with the camera in front of them.

17.51 I wanted to create a feeling of both people lost in their own thoughts. However, this photo does not tell that story.

17.52 To keep the couple's thoughts independent of each other, I ask each to look in a different direction at something interesting.

17.53

Hands: For some unknown reason, when men are waiting, they put their hands over their crotch. Perhaps it is for self-protection; I don't know. For photographs, it doesn't look good. However, the bride's hands are perfectly positioned. Her left arm is bent just enough to show her waistline, but not so much that her arm forms a 90-degree angle. In my opinion, a woman's hand straight on her waist is not very elegant, but to each their own, right?

Expression: I like the bride's candid smile, but the groom's energy did not match that of his wife's. I had to find a way to make him react.

17.54

Explanation: This was a fun and relaxed couple, so I decided that the best way to make him react and crack up laughing was to make a joke about his hands over his crotch. I'll spare you the joke, but you can see his reaction was good, and his hands automatically moved to the side.

17.53 Not good for photos: For some reason, when men are waiting they put their hands over their crotch. I had to find a way to make him react.

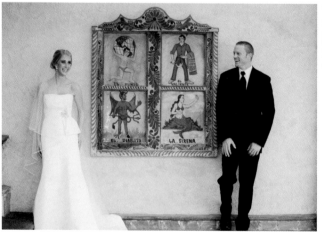

17.54 I decided the best way to make him react was to make a joke. I'll spare you the joke, but you can see his hands automatically moved to the side.

17.55

Explanation: You can create more variations for every pose than you can imagine. For a change of pace, I decided to create a cute, childlike variation of this pose. What gave me the idea was the railing that was splitting the staircase. It reminded me of Catholic school, where they sat the boys and girls on different sides of a room. But that never stopped them from admiring each other. I posed the groom in a more childlike way to better convey this message. I loved the bride's expression and her hand under her face. Together, it makes for an adorable photo.

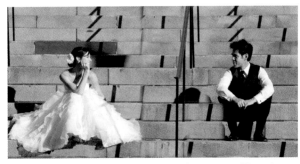

17.55 Inspired by the railing that splits the staircase like a classroom with the boys and girls on opposite sides, I posed the groom in a childlike way to convey that idea.

17.56

Explanation: I saved the best for last because this photo showcases the effectiveness of a well-composed "distance apart" pose. Before I took this photo, I went through all the poses in my posing chart to try to imagine which pose would look the best in a room like this. Usually two or three poses come up as good possibilities, but this time, "distance apart" was the clear winner. The key to this photo was keeping it perfectly straight and well balanced. Keeping the couple's backs ramrod straight was my second priority.

17.56 This photo showcases the effectiveness of a well-composed "distance apart" pose.

HUGGING

17.57

Body: There's a big difference between spontaneous hugs and hugs in photos. Similarly, actors have to learn how to do an on-screen kiss scene because it differs from a real kiss in their personal lives. Photography hugs require some finesse.

This photo resulted from asking a bride to hug her husband with no additional instructions. The hug is nice, but it doesn't work for photography because her arms, specifically her elbow, is the closest part of the body to the camera. Her arm should be underneath his arms, not over them. The little rule I follow for camera hugs is, "If there's anything pointy like an elbow closest to the camera, it's a no-go, but if there's something flat, like an arm, it's fine."

What's nice about this hug is that both their faces are featured. It's not as easy to pull off as you may think. Usually, you have to choose whether you want to feature the bride or the groom. Featuring both—and keeping the hug looking natural—is a bit trickier.

17.57 The hug is nice, but it doesn't quite work because her arm should be underneath his arms, not over them.

17.58

Explanation: This is an "I love you so much" camera hug. There are also sentimental hugs, traditional hugs, and many more. Each type of hug requires knowledge of how to position the body in order for the hug to look natural. In this case, we have an "I love you so much hug" and therefore, the bride's chin should be up, as it is in this case. If the chin is down, then the hug becomes a "You are my warm, cozy blanket" hug.

The two-sided arrow points out something very important about hugs: If one hand is higher than the other, the hug becomes more believable and romantic to the viewer. I learned this from watching people at the airport say good-bye to loved ones. Those truly sad to see them go were the ones who had one hand higher than the other. Trust me, it's true!

17.58 This is an "I love you so much" camera hug. If one hand is higher than the other, as shown here, the hug becomes more believable.

17.59

Explanation: The mood in this hug photo is more sentimental. Compare this photo with 17.58. To create a sentimental hug, three things must happen: The chins must be pointing down, the eyes must be closed or looking down, and one hand must be higher than the other.

17.59 Compared with 17.58, this hug photo is more sentimental because their chins are pointing down and their eyes are closed or looking down.

17.60

Explanation: This is a traditional photo in hug form. I like this kind of traditional photo quite a bit because it's more lovey-dovey than having the couple standing next to each other looking at the camera and smiling. This hug alternative just has more heart.

During a practice session with this pose, experiment with lowering or raising the couple's chins. If the woman raises her chin while she is hugging her husband and looking at the camera, it can appear either glamorous or intimidating. If her chin is up and her lips are parted, it will be glamorous. On the contrary, if her chin is up and her lips are closed, it will be intimidating. So make sure you get the right one.

17.60 Compared with the equally traditional pose of having the couple stand next to each other, while looking at the camera and smiling, this hug alternative just has more heart.

FOREGROUND/BACKGROUND

17.61

Head: Focusing on one person and throwing the other out of focus creates a story without being too obvious. Since one of the two is out of focus, it leaves something to the imagination. It can also create a sense of sneakiness, as if the viewer is looking at someone through the eyes of another person. This attribute alone makes the foreground/background pose a powerful storytelling tool.

In this photo, I wanted to show the bride from her husband's point of view. I chose to shoot through his shoulders to bring the viewer as close to his perspective as possible. However, her head is pointing the wrong way, and her cheek is illuminated instead of the front of her face.

17.62

Expression: By turning her body away from the light and turning her face back toward it, the pose makes the face the brightest part of the photo, which it should be. The problem now is something about her eyes is making the expression disturbing. Although she is posing, it is our job to make it look as natural as possible.

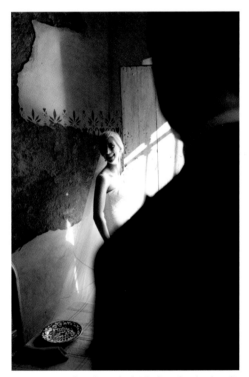

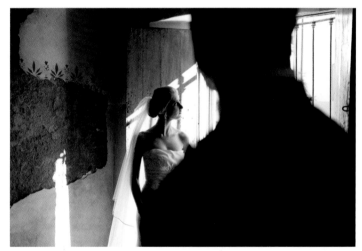

17.61 I wanted to show the bride from her husband's point of view. However, her head is pointing the wrong way, and her cheek—rather than the front of her face—is illuminated.

17.62 Repositioning the bride makes her face the brightest part of the photo, as it should be. But her expression doesn't look right.

17.63

Explanation: For the final image, I addressed the eye issue by asking the bride to focus on the ground outside. I also had her bring her chin down a bit and take one step closer to the door, so she would be illuminated by a higher intensity of light. Notice how turning her body away from the light creates gorgeous shadowing on her body. Her right arm is bent just right to show the waistline, and her fingers are gently placed at her side.

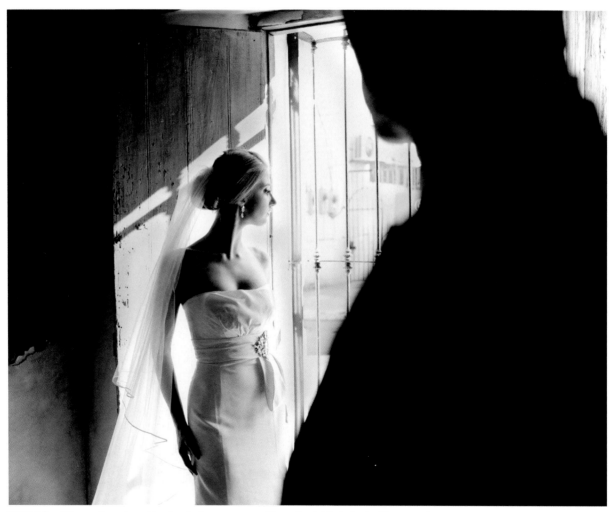

17.63 I fixed the eye issue by asking her to focus on a specific spot outside. I also had her step closer to the door to improve the lighting.

17.64

Body: There are two things that don't work here; the bride's arm is completely straight, and her chin is up. You are probably wondering what's wrong with her chin being up. The answer is, it's not the most flattering look. It places too much emphasis on her mouth, since in this position her lips are the closest part of her face to the camera.

Expression: This is an alternative approach to 17.63 where the groom is silhouetted and we're looking over his shoulder. In this pose, you can see the groom's expression because he's facing the camera. For that reason, it's important that his expression be candid and not contrived. In this case, I love his expression, but the bride's is not quite right.

17.65

The final image has a more believable feel. The bride's arm now has a slight bend and her chin is down. The groom's expression was exactly right, so I did not change it, but I did give him a specific spot on the ground to look at to make sure that his eyes would not wander off.

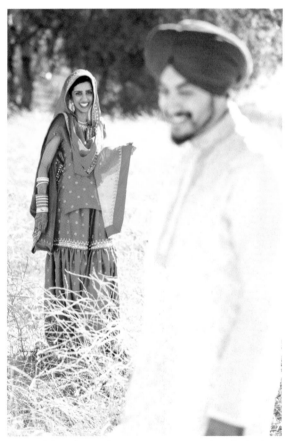

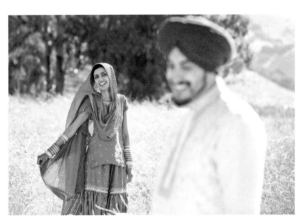

17.64 Having the groom face the camera allows you to see his expression. The bride's pose, however, needs some adjustment.

17.65 I didn't change the groom's expression, but the bride's arm now has a slight bend and her chin is down. Overall, it has a more believable feel.

17.66

Explanation: Coming up with variations is a tough task for your brain because it means getting out of your comfort zone and trying something different. When photographers are under pressure during a shoot, they don't want the extra stress, so they stick to familiar poses.

During this shoot, I wanted to create another variation of the foreground/background pose. What I like about this photo is the way the bride is looking at the camera. Only half her face is showing, making it even more enigmatic. If you stare at her eyes long enough, it almost appears as if her expression changes. Or, maybe that's just me writing this at 3:00 am. If it happens to you, please let me know.

17.66 What I like about this variation of the foreground/background pose is the way the bride is looking at the camera.

FACING EACH OTHER

17.67

Body: The facing-each-other pose is a staple for most photographers, which makes it very important to use finesse creating the photo. The main difference between a hugging pose and a facing-each-other pose is the couple's heads overlap during a hug.

When a couple is posing close, it can be awkward for them to also look at each other. Most people can't keep a straight face for more than three seconds before the awkwardness gets the best of them and they start laughing. Placement of the arms is the second biggest issue in close poses.

In this photo, the couple's arms are doing the same thing. For a more candid look, remove all telltale signs of uniformity. If the groom's hand is around her waist, then the bride's arm could be resting over his arm. The second issue here is that the bride is pointing her elbow toward the camera. As I mentioned before, this makes the pointy elbow the body part closest to the camera. Her elbow should have been pointing down toward the ground.

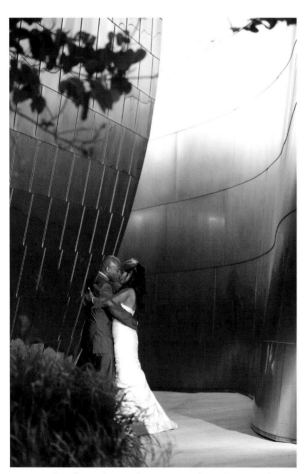

17.67 In this photo, the couple's arms are doing the same thing. For a more candid look, remove all signs of uniformity.

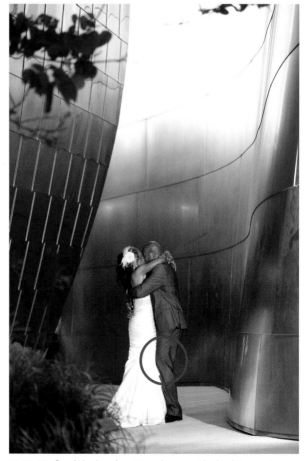

17.68 We fixed the hand position, but now the bride's arm is blocking a quarter of the groom's face.

Expression: Their eyes are closed, but the expressions still don't look believable. You feel that they are just posing for a photo. To address this, create a reaction in each of them. That way, both are looking in different directions. Just make sure their energies still match.

17.68

Body: When standing, both knees should never be bent. One knee bent looks relaxing, but both knees bent makes the person look like a defensive linebacker or a wrestler ready to make a tackle. Be very cautious about having both knees bent: It will wreck even the most beautiful photo.

Hands: We fixed the hand position but created a bigger problem. Both of their arms are now in different positions, except the bride's arm is now blocking a quarter of the groom's face. This happened because her elbow is still not pointing down toward the ground.

17.69

Explanation: For a more relaxed look, I had the groom lean on the wall to shift his body weight and lose some height. Now, there is no reason for him to have both knees bent. The couple's arms are in different places and most importantly, not blocking each other's faces. To improve the expressions, I asked the groom to look at her chin and the bride to look at his eyes and try to read his expression. This will automatically make them laugh, and because their eyes are locked in, there is no chance they can wander off and wreck the photo.

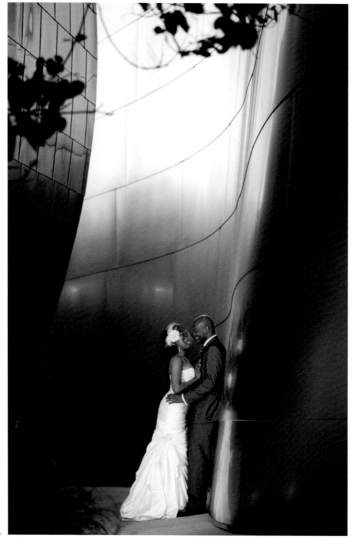

17.69 For a more relaxed look, I had the groom lean on the wall to shift his body weight and lose some height.

17.70

Explanation: Remember the "X factor" in Chapter 16, "Five Key Posing Techniques"? I applied the X factor on the head positions to eliminate some of the awkwardness of standing so close together and staring at each other. By crisscrossing their heads, the bride can look away and still have a candid reaction, while the groom could be grazing her face with his nose. Notice how the arms are in different places and both their elbows are pointing down, a big improvement from the pose in image 17.67.

17.70 Here I applied the X factor on their head positions to eliminate some of the awkwardness of standing so close together. Now the bride can look away and still have a candid reaction.

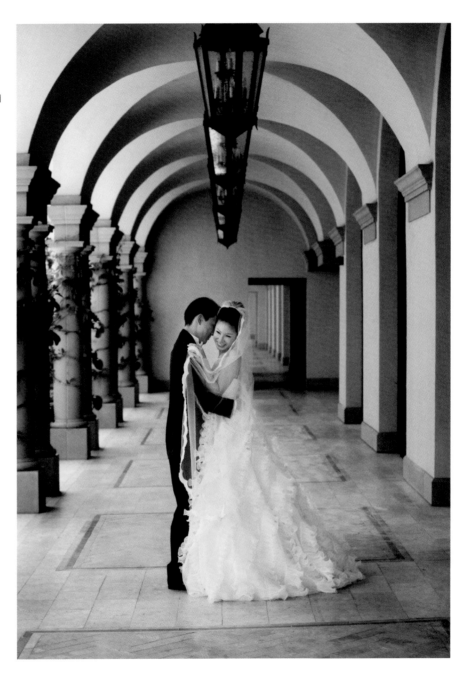

17.71

Explanation: I wanted to show this photo to showcase the best way create a romantic X factor by crossing their heads. Line up the curve of the groom's face, from the forehead to the tip of the nose, with the side of the bride's face, from the temple to right underneath her cheekbone. If done right, it should be a perfect fit, like two puzzle pieces coming together. When attempting this pose, pay close attention to the position of the hands and the posing of the eyes.

17.71 The best way create a romantic X factor: Line up the curve of the groom's face, from the forehead to the tip of the nose, with the side of the bride's face.

KISS ANTICIPATION

17.72

Explanation: I decided to make kiss anticipation its own category because it would take longer to explain that it's not quite a kiss when both of their lips are locked and it's also not quite "facing each other" because there is not enough separation of their faces. Two unique looks can be achieved with a kiss anticipation pose. The first is sensual, where a close-up photo is taken of just a couple's lips parted less than half an inch from kissing. The second is endearing, where the bride has a tender smile right before the moment where their lips touch, as showcased in this photograph.

17.72 The "kiss anticipation" shot.

FEATURING HIM

17.73

Body: Featuring one person rather than the other requires using the secondary person to be more of an accessory to his or her partner. A balance must exist between the featured person and how much of the "accessory person" you actually show. Just a hint of a face is necessary to create this balance. This photo displays too much of the bride's face. This is not a hint; this is almost the whole face. The message is lost about whom you are trying to feature. The featured person's eyes must deeply connect with the camera, while the other's eyes almost don't show but you can see, as described before, a hint of one of the eyes.

Hands: Take a close look at the groom's left hand. Notice how he is grasping her. To fix this issue, simply place his thumb on the same side as the other fingers. By doing so, you ensure that the opposable thumb is not being used as a gripping tool.

17.74

Explanation: This is a well-executed "featuring him" pose with the exception of the position of the thumb position. The groom's face is making strong contact with the camera. I prefer a nonsmiling face for this pose, but that is a personal style. You can see only a hint of the bride's right eye and her head is not covering much of his face. This is a great alternative to always showcasing both people. For album purposes, I strongly recommend that you supplement this pose with a photo where the bride is featured and the groom becomes the accessory.

17.73 This photo, which features the groom, shows too much of the bride's face.

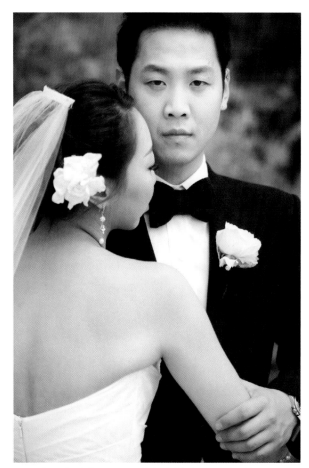

17.74 Just the right amount of the bride is shown in this "featuring him" image.

FEATURING HER

17.75

Expression: Here is a great example of how important it is to specifically pose the eyes. This photo has everything going for it. The bride's expression is not perfect, but overall it is quite good. Now, bring your attention to the groom's expression, particularly his eyes. They are wandering off to nowhere. This little detail renders an otherwise beautiful photo useless.

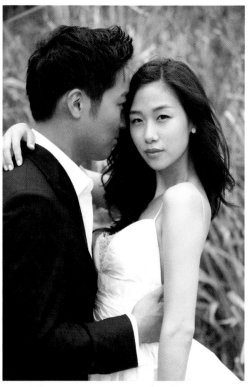

17.75 The groom's expression makes this image useless.

17.76

Heads: The groom's head is now too far away from the bride. There is no reason why his head should be there. If he were trying to kiss her, he would be much closer. In other words, now his head and eyes are lost in space, not to mention that much of her hair is on his face. These are details that need to be taken care of when doing a shoot. Train your eye to notice these details, so you can do something about them when they are happening, instead of coming back from the shoot only to wish you had noticed the hair. Otherwise, the expression on the bride is quite glamorous, mainly because her lips are slightly parted while she is looking at the camera.

17.76 The groom's head is too far away from the bride's, and her hair is too much in his face.

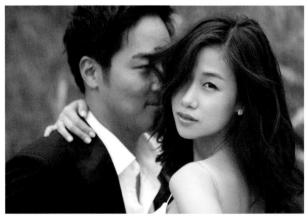

17.77

Explanation: In order to pose the groom's eyes and head, I asked him to softly kiss her jawbone. The jawbone sits at the back of the face underneath the ears. It is a perfect place to hide most of his face and really feature her. Had I asked him to kiss her cheek, most likely he would have chosen the middle of her cheek or near her lips. This would have resulted on too much of his face showing up. From posing practice sessions during the week, you should know what the results are from the directions you give.

17.77 Directing the groom to kiss her jawbone makes the shot work.

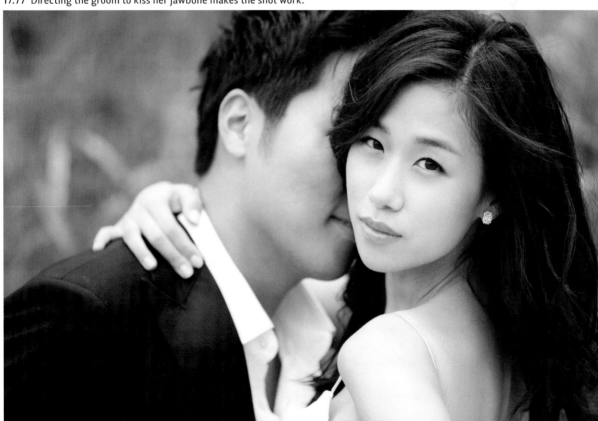

T-POSE

The T-pose is one of my favorite poses for a couple. I gave it the name because the pose requires that the couple's collarbones be perpendicular to each other, forming a T. The pose starts by having them face each other; then one of them rotates 90 degrees to either side.

17.78, 17.79, AND 17.80

Explanation: By now, you should have a pretty good idea of what it takes to pose someone gracefully, to be direct and specific with your directions, and to develop a sharp eye for small details. I encourage you to explore these images and think of what you could say to get the same reactions you see in these photos. Take notes on how the elbows, hands, fingers, heads, and so forth are positioned and why. Also, look at the photo and ask yourself if the energy between the couple matches. Good luck and have fun!

17.78

17.79

17.80

18

EXECUTION

This execution portion of the book ties everything together. Four elements remain foremost in my mind whenever I'm doing a photo shoot: Lighting through Direction, Simplicity through Subtraction, Beauty through Angles, and Perspective through Lenses. By remembering these four elements, I know I will produce great work, regardless of what equipment I'm using and who, where, or when I'm shooting.

I created the Execution chart out of my own needs. As a wedding photographer, I shoot in locations chosen for me, at a time of the couple's choosing, and with more emotions and family dynamics swirling around than a TV drama. With so many variables, I need something to be constant. I purposely keep this list of constants short and to the point to make them easy to remember. Write them down and put them in your camera bag. I promise they will come in handy.

LIGHTING THROUGH DIRECTION

Lighting is the most important aspect of photography. By calling ourselves professional photographers, we claim to be masters of light: how it behaves in and outside a room; how to read its intensity and color; and how to add, subtract, and shape it. Anyone can take pretty photos—having a thorough understanding of light is the expertise of a true professional photographer.

During a photo shoot, I always look for ways to improve the light falling on my subjects. I bring four tools to every shoot: a 6-foot rectangular light diffuser, a 5-in-1 reflector, my flashes, and a video light. These tools are used to improve and direct the lighting of my subjects. I rarely accept the light as it is because there is always a way to improve it. Let's look at some examples to better illustrate this point.

This photo of the groom uses the window as the light source, a common technique (**18.1**). There's nothing wrong with the lighting, but it could be better. Most of his face is dark, with only the window side lit properly.

Finding a better angle helps him pop from the background (**18.2**). I added a reflector to bounce the window light back toward the side of his face farthest from the window. Neither photo was altered in Photoshop to improve the light quality. You can achieve beautifully lit photographs just by finding a way to improve the direction of light.

18.1 With only the window side of the groom's face lit properly, there's room for improvement in this photo.

18.2 Adding a reflector bounced window light onto the side of his face farthest from the window.

Simply finding good backgrounds for your photos is not enough, since your light tools can improve the lighting at almost every time of day. Here's an example of how you can manipulate light by having an assistant bounce an off-camera flash off a reflector and onto the bride (**18.3**).

The lighting in the next image required a bit more resourcefulness (**18.4**). I stood to the bride's side so the sun would light her from the left. What you can't see is a cream-colored piece of furniture about 10 feet behind the bride on the right. This tall piece of furniture bounced just enough light back at her to give the photo more depth. If that piece of furniture had not been there, the backside of her dress would have been much darker. Pay attention to the items around you—everything can be used!

18.3 This shot was improved by having an assistant bounce an off-camera flash off a reflector.

18.4 An off-camera cream-colored piece of furniture behind the bride bounced just enough light back at her dress to give the photo more depth.

SIMPLICITY THROUGH SUBTRACTION

The saying "less is more" has never been truer than in photography. Photography is a subtractive art. It requires that you look at a scene and choose what to include—and what to leave out.

One of the biggest problems I see with new photographers is that they include too much. When taking a couple to the park, they usually photograph the couple from head to toe with their choice of background. Inexperienced photographers simply do not consider which elements could be distracting. They just shoot the whole park behind them, including, for example, the parking lot, the neighborhood houses, and the fountain.

Because it has too much context, the photograph leaves nothing to the imagination and provokes no questions. To be brutally honest, it is boring. I want to encourage you to ask more from your work and then do something about it.

Learning how to narrow your vision in a busy scene is a crucial skill, especially if you are a wedding photographer. It is not uncommon to be expected to create an amazing photo in rooms like this one (**18.5**).

Imagine shooting on a busy shopping street with hundreds of stores, people walking, kids crying, and so on. As a starting point amid so much stimuli, you might look for light bounced from one building to another, as described in Chapter 15, "Walls, Translucent Surfaces, and Textures." If you can't find great light, can you create it using a diffuser, flash, or reflector? Maybe you can find a section of the busy street with good solid colors, perhaps three or fewer or all in the same color family. What about finding good geometry within the window frames?

18.5 Narrowing your vision is crucial, especially when confronted by typically busy scenes like this one.

By looking around carefully, you can find some anchor points to at least try. If the scene's geometry is intriguing, crop out the rest of the surroundings and focus your attention on just that. Or it could be any other element from the chart. The goal is to help you filter out the rest of the scene and focus on a small portion that contains photographic interest. Don't wait until the day you have a paid assignment to try this; you can practice this selective vision technique any day of the week.

For example, my wife and I visited Paris on our way to a wedding assignment. I took this extreme wide-angle photo at the Louvre Museum (**18.6**). As a tourist, I wanted to convey a sense of the place, so I included everything and everyone in the background. Afterward, I turned around and noticed the wonderful geometry of the Louvre's pyramid with the sky backlighting every metal beam of this remarkable structure. That's what I found most impressive, and therefore, it was what I wanted to exhibit in my photograph, and nothing else.

Using a 70–200mm f/2.8 lens, I zoomed in all the way to 200mm, leaving out everything except the tip of the pyramid and the sky (**18.7**). The viewer of this image has no choice but to notice the beautiful geometry I found so fascinating. I say "no choice" because I used creative cropping to single out a tiny piece of the entire scene. The image is the result of selective vision and thinking like a photographer.

While comparing 18.6 and 18.7, think about your own work. Does your work resemble 18.6, or are you constantly using selective vision and creative cropping to single out something you found beautiful, as in 18.7?

18.6 As a tourist, I wanted to convey a sense of the Louvre, so I included everything and everyone in the background.

18.7 As a photographer, I used creative cropping to single out a tiny piece of the entire scene.

BEAUTY THROUGH ANGLES

Before becoming a photographer, I recall that many people looking at photos would say things like "Wow, that's such a great angle for you" or "This is my better side." I wanted to know why people had a "better side." And I asked myself, "Does that mean buildings, objects, or other environmental elements also have a better side?"

People's faces are as different as our fingerprints. Some people have round faces, others thin and long. Some have full lips whereas others have thin ones. The shape of people's eyes is probably the most obvious difference from one individual to another.

This means that as a photographer you cannot approach every person in the same way. Because of the different bone structures, when light illuminates a face it will behave differently every time for different people. Every person can be photographed beautifully, if you take the time to study his or her face and choose angles and lighting that best complement it. One size does not fit all!

For example, older folks look slightly younger when photographed with direct light on their faces because the light has the same intensity on both sides. The light will fall flat on their faces, filling in the shadows created by wrinkles and making them appear younger. With the right combination of angles and light direction, anyone can have a photo of themselves where they look truly amazing. It is your job as the photographer to find the correct formula for each client.

In Los Angeles (where I live), I have run into people wearing t-shirts reading, "I'm a photographer, not a miracle worker." I feel like telling them that it doesn't take a miracle to take a great portrait of someone; it takes skill! Another line I frequently hear everywhere I teach workshops is that we get beautiful photos because we only photograph beautiful people. It's a shame that people think this way because they are discounting the hard work and practice required to be a good photographer.

Our job is to consistently deliver the best photographs our clients have ever seen of themselves, regardless of their weight, ethnicity, age, or color. Solid, deliberately focused practice sessions can transform you from just a person with an expensive camera to a true artist at the highest level.

To illustrate the point of finding the correct light-and-angle combination for specific face structures, consider these two images taken only minutes apart (**18.8**, **18.9**). Although the woman is beautiful in both, you can see how the second image is clearly the better angle for her. These are the steps I took to go from 18.8 to 18.9:

1. The first characteristic of her face that stood out to me were her striking eyes. That was the base for everything that followed. Once you find something that grabs your attention, run with it. Every decision you make should be based on featuring a person's best features.

2. I noticed that her face was a bit round, so I used her hair to partially cover her face to deemphasize the roundness and give her face a more oval shape.

3. The last step was to turn her body away from the light and turn her face toward it. I made sure her chin was down, but I had her fix her eyes on an object slightly higher than her face. Remember that posing the eyes is just as important as posing the body. Once the eyes were in the right place, I asked her for a gentle smile and finally pushed my shutter button.

18.8 Consider these two images taken only minutes apart. Although the woman is beautiful, the first image is not the best angle for her face.

18.9 I used her hair to partially cover her face and make it more oval. I then turned her body away from the light and her face toward it.

THE TOURIST TEST

I had a wedding assignment the next day at the church of Santo Domingo in the city of Oaxaca, Mexico, so I was taking some angle shots to study later in my hotel room. This is the typical angle most people take when they stand in front of a structure like this (**18.10**). The entire church is beautiful, but you want to train yourself to be more selective.

If you are a professional photographer and you are taking a photo from the same angle as the usual tourist, it should raise red flags, and you should look for a better angle. The center portion is clearly the best part, featuring the greatest architectural detail. The left and the right sides are plain, so you can remove them from the final photograph.

Think about all the photos in which you see your life, from the old family album to vacation photos. Probably 95 percent of them were taken from the perspective of the average adult, who is 5 to 6 feet tall. Your eyes are so accustomed to seeing the world through this perspective that it's no longer interesting.

That's why people are so intrigued by those aerial photography books found in any bookstore. With a fresh perspective, even a building you see every day can suddenly look exciting. Remember this the next time you are on a shoot. Look around and find a way to offer a perspective other than the 5 to 6 footer. To keep this in mind during a shoot, ask yourself, "What would this scene look like from a bird's or a dog's point of view?"

BIRD'S PERSPECTIVE

Let's continue with the example from the church of Santo Domingo in Oaxaca. Standing in front of the church, I turned around and noticed a two-story building across the street. Here's the church from a bird's perspective (**18.11**). I circled the plants in front of the church because they caught my interest as possible leading lines to the church. From where I was standing, the plants don't form straight lines, but take a few steps to the right and you have perfect leading lines (**18.12**).

18.10 The entire church is beautiful, but the left and right sides are plain, so you can remove them from the final photograph.

18.11 Here's the church from a bird's perspective. I noted the plants in front because they caught my interest as possible leading lines.

18.12 Once I take a few steps to the right, the plants form perfect leading lines to the church.

This may seem like a lot of work, but by practicing being selective and trying out different perspectives, you'll find that the process becomes intuitive to you. The results are worth the effort, as seen in the final photo (**18.13**). The bird's-eye perspective is more dramatic, with the cactus plants on the ground acting as leading lines. The vertical crop focuses on the best features of the church, eliminating its distracting weaker elements.

The result is a photo that resembles a piece of art, rather than just another photo of a couple kissing in front of the church. In case you are wondering what happened to all the guests, there was a small window, literally just a few seconds long, when nobody else was in my frame. Even if I hadn't been so lucky, you can always Photoshop the people out. What you can't Photoshop is the creativity, thought, and skill that goes into making a photograph like this.

18.13 The results are worth the extra effort with a more dramatic perspective and a crop that focuses on the church's best features.

DOG'S PERSPECTIVE

A small dog would see the world from one to two feet above the ground. From that perspective, everything must look gigantic, especially if the object or person is close to the dog. Keeping this in mind can help you make objects you are photographing look much larger than they are. This is a very useful tool in your visual repertoire.

Let's put this technique to use at a typical small outdoor wedding in Beverly Hills (**18.14**). At first sight, there is absolutely nothing magical here, nothing that is screaming to be photographed. Let's apply what you have learned in this book to see if you can locate the diamond in this haystack. Study the photo and ask yourself if there is anything from our chart that could be used to simplify this scene.

18.14 At first sight, there is absolutely nothing magical here that needs to be photographed.

Looking at this scene I was clearly uninspired, so I closed my eyes and had a little dialogue in my head about how to bring out the magic in an average location.

Q: What do I like the most about this scene?

A: The parasols' circular geometry and the fact that they repeat themselves.

Q: If the repetition is intriguing, what lens should I use to show the largest number of repetitions?

A: A 16–35mm or a 15mm fisheye lens.

Q: If I shoot with an extreme wide-angle lens too much of the scene would show. I only want to display the repetitive circular parasols, nothing else. How do I crop out the rest of the scene but still use the wide-angle lens to show the largest number of parasols?

A: I can get much closer and shoot from above or below the parasols. I would have to be so close that even with the fisheye lens, nothing but parasols would show in my frame.

Q: Should I shoot from above (bird) or below (dog)?

A: Above would require me to stand on something and it might be too disruptive during the ceremony. Below will be more subtle since I can be closer to the ground and hide. Below (dog's perspective) will be my angle of choice.

Q: Once I get really close to the guests and point my camera upward, what should I expose for?

A: It would be neat to enhance the contrast created by the harsh sun and shadows. Therefore, I'll expose for the parasols making everything else a silhouette.

Here's the image that resulted from this dialogue (**18.15**).

18.15 I shot this after running a list of creative possibilities through my mind.

PERSPECTIVE THROUGH LENSES

Eventually many of us wind up with all types of glass, from wide angles to telephotos, from zoom lenses to primes. But a photo taken with a 16–35mm f/2.8 lens at 35mm differs greatly from one taken of the same scene with a 35mm prime lens at f/2. That 0.8-difference makes all the difference, but every such lens choice comes with trade-offs.

A lens that can open up to f/1.2 is remarkable, but you also exponentially increase the chance of missing the focal point. When taking a portrait at these apertures, focusing on the eyebrow will definitely throw the eyes out of focus. Your focus has to be dead on, or your photo will be a blur. That's why you must weigh the risks versus the rewards before attaching any lens to your camera.

In a portrait session, every lens offers a different perspective of your subject. A person looks very different photographed from far off with a 200mm lens than closer in with a 100mm. The crop may be the same, but the person will look very different. It takes a great deal of experience to correctly match a lens with the perspective you want.

While I own many lenses, I have done at least 10 photo shoots of couples in which I used just a single lens. Most of these were practice sessions with friends, and each photo shoot only lasted 30-45 minutes. But through these mini photo shoots, I learn the different feel and perspectives I get from each lens. And I'm still learning.

When assisting friends during engagement sessions, I'm shocked when a friend never changes his lens for the whole shoot. Every photo he took, from the first to the very last frame, was taken with a 70–200mm f/2.8 lens. If the goal is to just get the shoot over with and go home, then the one-lens strategy works just fine. If you are looking to improve the quality of your work, though, you need to bring a collection of lenses and match the correct lens to the scene.

For example, photographs taken on a location with great geometry would look even more remarkable with a wide-angle lens because these lenses exaggerate the perspective, making the geometry more dramatic. Or maybe you are in a location with repeating structural elements. That situation might benefit from a telephoto lens because it pulls elements together, making them appear closer than they really are.

All of this chapter's photos offer examples of matching the right lens to the environment. Go back and look at the photos and study how the lens I chose helped with the message I was trying to convey.

In 18.13, for example, I chose a 200mm f/2.8 lens to compress the scene and make the leading lines of the cactus plants more defined. Compare it with 18.12, taken with a 24–70mm f/2.8 lens. The two photos are like night and day. Yet the only major difference between them is the lens used. In my opinion, 18.12 looks like a tourist snapshot whereas 18.13 looks like a work of art. The same can be said for 18.14 and 18.15.

Your surroundings and the lenses you choose to photograph those elements need to be a perfect match. If you use the wrong lens because you don't want to change it, as my friend did during his engagement sessions, you will miss out on some of the best photos of your career.

For example, these two images were taken seconds apart with the only difference being the lenses (**18.16**, **18.17**). Geometric elements, such as the leading lines from the structure, look much more dramatic when shot with an ultra-wide angle lens. The first image was taken with a 70–200mm f/2.8 lens, which is why the photo is a complete failure. But the second image was shot with the 16–35mm f/2.8 at 16mm, a perfect match for this location.

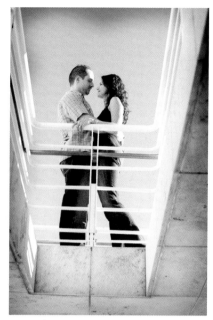

18.16 This version was taken with a 70–200mm f/2.8 lens, which fails to take advantage of the structure's leading lines.

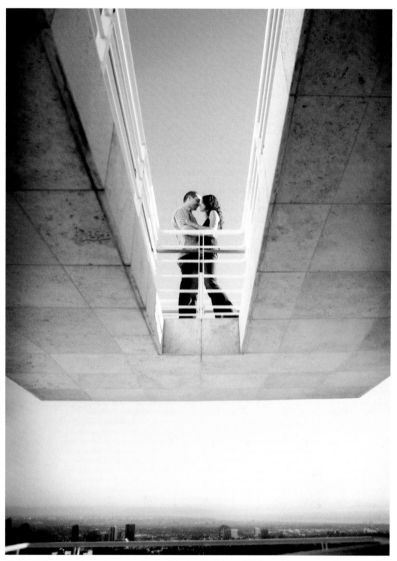

18.17 This second version was shot with the 16–35mm f/2.8 at 16mm, a perfect match for the location.

DELIBERATE PRACTICE

19

DELIBERATE PRACTICE

The concept of practice has different meanings for different people. Based on my research and personal experience over a decade, I have developed a practice method that has proven extremely effective. I believe it will work for most photographers, regardless of their method of learning.

Contrary to common belief, I think artistry and talent can be learned through deliberate practice. Talent is nothing more than the result of deliberate practice, not necessarily something you are born with. When people approach me and tell me that they think I am talented, I certainly hope they don't think I just woke up one day and a photography gene appeared in my DNA. Although I appreciate the comment, and it's definitely flattering, I want people to realize that behind my so-called "talent" are literally thousands of hours of hard work, deliberate practice, and a relentless desire to always keep improving. The purpose of this method is to train your brain to perform tasks in a way that becomes instinctive. There is a major difference between someone who can perform a task and someone who can do the same task instinctively, almost without thinking.

Figure **19.1** illustrates the four components of your training journey: *perform*, *discover*, *break down*, *analyze*, and then, back to *perform*. To improve, you must be willing to devote the required energy and effort. Constant improvement and mastering an art form do not come easily. Let's get started and discuss each component.

19.1 The four components of deliberate practice training: perform, discover, break down, and analyze.

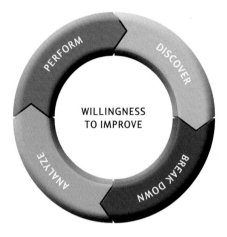

PERFORM

The Perform step serves as the starting point for the system. The purpose is to examine your mistakes and weak points because they hold the key to what you must do to improve. To obtain an accurate reading of your performance, you must photograph a job the way you normally would. Don't change a thing. Location scouting, lens choices, camera choice, natural light, flash, posing the couple, posing groups, technique, and approach should be done exactly as you always do.

Another option is to use a wedding shoot or a job that you have already completed. Choose a job where you have kept every image that you shot. If you categorized the images into folders and selected the best for each category, ignore all those folders. Use only the master folder containing all the photos—in the order that you took them.

Once you have your images, you'll need a comparison point. Without this comparison point, your efforts to find weaknesses will resemble Pieter Bruegel's famous painting of the blind leading the blind. To whom should you compare your work? Find the best photographers in the world for your type of photography and become familiar with their work.

If you are, for example, a wedding photographer, look at the work of top wedding photographers. But be careful not to confuse "top wedding photographer" with "popular wedding photographer." In this industry, photographers can become popular using social media and still have little idea of how to take a decent photograph. Look for photographers respected worldwide for the *quality* of their work. Study the best wedding magazines and the best wedding blogs, and attend wedding photography conventions.

Once you are immersed in world-class photography, ask yourself the following questions about this work, and then about your own work. On a piece of paper, for the following questions write your answers about your top photographers on the left and your answers about your own work on the right. Be honest when answering these questions; it will help you distance yourself from your work and see it in a different light:

1. What attracts you the most about the other photographers' work?
2. What is the quality of light?
3. What attracts you most about their poses and the expressions on their client's faces?
4. Compositionally speaking, how do they use the photographic frame to convey their visual message?
5. What do their locations or backgrounds have in common? Are they clean, busy, colorful, muted? How do the backgrounds affect the main subject?
6. How do the other photographers use creative cropping and selective focus to draw you to the main subject? Can you quickly identify the visual story they want to tell?
7. Can you recognize a consistent style in their work?
8. How do they use their environment?
9. Is your eye quickly drawn to the main focus on a photograph?
10. What is the overall feel of their photographs: romantic, fashion-driven, energetic, candid, staged?

These questions can help you gain a deeper understanding of what elements are missing in your own work relative to others at the top of their field. They are necessary to help you break down the strengths and weaknesses in your work. Sometimes it is obvious what your work is missing—more often than not, it will be subtle. In fact, the better you become, the more you will notice increasingly subtle differences.

DISCOVER

Now that you have made your list, you are probably feeling overwhelmed. Don't worry, just keep moving forward, and take it one step at a time. Your answers will help you with the Discover step, so keep that list handy.

You must address five major problem areas to master photography: technical problems, location problems, lighting problems, pose/expression problems, and approach problems. There are also artistic/creative problems. Let's look at each one.

TECHNICAL PROBLEMS

Any problems with exposure or focus can be categorized as technical problems. Examples include photos that are over- or underexposed, blurry from slow shutter speeds, improperly lit because of flash issues, or out of focus due to focus point selection or poor aperture choices. These technical problems are the most urgent to master. Having a strong grasp of all aspects of your equipment should be a priority if you present yourself as a professional.

LOCATION PROBLEMS

Recognizing a location problem takes some experience. One giveaway is when the background takes the focus away from your main subject. This can occur for many reasons, but the most common is that the location is too busy and your main subject becomes lost. Another common reason is that the colors in the background distract from your main subject. (These topics are all covered in Chapters 1–15.) Nothing should outshine your main subject or even be at the same level of importance. If your main subject doesn't clearly and immediately pop from the photo, you most likely have a location problem.

LIGHTING PROBLEMS

Recognizing the quality of light at any location, indoors or outdoors, is probably the single most important skill a photographer should have. This skill alone separates the amateurs from the professionals. Not only should the quality of light be of primary importance, but your main subject should also be the brightest part of the photograph. That doesn't mean you blast him or her with light; it can be a subtle difference, but clear separation must exist between the background and your subject.

For example, when you are taking a portrait outside without additional or reflected light, the background and subject are often lit with equal intensity and quality. There is no separation between the two. Using a reflector, diffuser, or a flash can easily fix this by throwing just enough light on your main subject to create some separation. When photographing outdoors, you often will find that trees create patches of shade and strong sunlight. A portrait taken in such conditions will be most unflattering. Again, a simple diffuser overhead can eliminate the problem.

Not having good control of your flashes can also create a long list of lighting issues. Improving the lighting quality of my work through deliberate practice has been responsible for the largest increase in client bookings. I live in Beverly Hills, where great photographers are a dime a dozen. To separate myself from the competition, I decided to focus on consistently achieving great light on every job. It has paid off!

POSE/EXPRESSION PROBLEMS

Posing and getting candid expressions from your clients are probably the most daunting problems for most photographers. As discussed in Chapters 16 and 17, it takes a great deal of attention to detail when posing, as well as a great deal of energy to bring out candid expressions. During a job, the biggest posing challenge is to make a person look flattering, confident, and relaxed.

For expressions, the challenge is to make the expression believable. If your subjects are not looking at the camera, the feeling should be candid, as if a moment was caught without any intervention or manipulation from a photographer. Your clients should be mentally focused on something other than the camera. If the photo is a portrait, then your subject is looking straight at the camera. The goal is to make the expression confident, natural, and relaxed.

APPROACH PROBLEMS

An approach problem occurs mainly because of the angle at which you approach the photograph. As described earlier, angles can make or break a photograph. You may have all the other elements right, but if your angle of approach is wrong, it could ruin your photograph. The second leading approach problem relates to what lenses you are using. An ultra-wide-angle lens close underneath a person's face will look just awful. A lens with apertures such as f/1.2 can yield remarkably beautiful results, but it might not be the right tool for the job at hand. Getting to know how to best match the environment, your vision, and the lens for every situation will greatly minimize approach problems, and your photos will exceed people's expectations. This environment, vision, and lens combination is an art form in itself.

ARTISTIC/CREATIVE PROBLEMS

If you ever feel that all of your photos look the same, that you are not using locations to their maximum potential, or that they just feel dull and stale, you are experiencing an artistic/creative problem. While looking at the work from a photographer you respect, you may keep asking yourself, "Why didn't I think of that?"

It is easy to fall into automatic mode, where you don't try anything new with your poses or try to harness the beauty and photographic potential of your surroundings. This is the main reason why photographers pay large amounts of money to attend workshops. Unfortunately, after attending a very inspiring workshop on how to be more creative, most attendees go home pumped up but never practice what they have been taught. Inspiration alone does not make you better.

As I mentioned earlier, creativity and artistic talent can be learned through deliberate training. Yes, some people have an easier time than others, but everyone can learn how to be more creative. It just takes getting out there and doing something about it and gaining experience of your own. I have dedicated many years of my career to continually training myself through practice to be more and more creative every year. It is a goal that I hope never ends.

BREAKING IT DOWN

The Break Down step turns problems and their solutions into manageable bite-size pieces. One of the reasons people give up on a problem is because they become overwhelmed by it. But if you focus on smaller portions of the solution, little by little you will have built the knowledge to fix or improve anything.

My system works by building a knowledge database of the typical environments in which you work. For example, I'm a wedding photographer, so I do most of my photography inside hotels, hotel rooms, churches, urban streets, busy environments, open fields, parks, gardens, and private homes. For every one of these environments, I write down the physical characteristics and common objects normally found in such places.

For instance, inside hotel rooms, there is always artwork and mirrors. I created little exercises to explore the photographic possibilities of using only mirrors and the artwork decorating hotel rooms. After two or three practice sessions, limiting myself to just those two items, I will have pushed myself enough to discover many more ways to use these simple objects to create high-impact photographs.

The point of such exercises is to know what to do and to be aware of the photographic possibilities when facing commonly found items. I have created little exercises for each object on my list, regardless of how minute it may be. My theory is, "If it made the list, it deserves to be practiced."

The exercises or practice sessions are short but effective. My average practice session is 20–30 minutes; most are done inside my house and around my neighborhood. During a practice session, your complete and undivided concentration is paramount. I turn off my phone and close my laptop to avoid any distractions. We will go through a few practice sessions in their entirety together.

ANALYZE

By now you have performed a photo shoot, discovered your problem areas, broken them down, and practiced each problem area in manageable mini-sessions. Now it's time to look at the results of your sessions and write down why something worked and why it didn't.

The Analyze step represents the bulk of the new knowledge that you acquired through your 15–30-minute practice sessions. During a session, do not erase any of the images you shoot since you will need these for your analysis. When looking at your images, consider one issue at a time. If you are experimenting with one off-camera flash to complement the ambient light falling on a subject, then pay attention to only images involving that specific issue. You don't want to confuse your brain with five different mini-session results, so break it down into chunks and look at only one chunk at a time.

During an off-camera flash session, you probably practiced the following:

- Using the flash's through-the-lens (TTL) technology to fire the unit
- Using the camera's flash-exposure compensation (FEC) to adjust the power from the flash
- Adjusting the power output using the flash itself, instead of through the camera
- Placement of the flash in respect to your subject
- Swiveling and tilting the flash head
- Zooming the flash head
- Taking the flash off TTL and controlling it in full manual mode
- Placing a CTO gel on the flash head to add warmth to the light

These eight items represent the chunks for the larger issue of "one off-camera flash to complement the ambient light falling on a subject." Let's analyze the sixth item: zooming the flash head.

Most Canon and Nikon flashes can read the information from the lens attached to the camera to match the lens's focal length to the flash's head zoom. For example, if you are shooting your subject at 85mm, the flash head will also zoom to 85mm. However, you can manually overwrite the flash's zoom to, say, 105mm to narrow the beam of light into more of a spotlight. The light will then be focused more in the middle of the frame, rather than having the same amount of light throughout the frame.

During the Analyze stage, you would write down the differences, both advantages and disadvantages, of manually zooming the flash head to light a subject. Keep your written results well organized in one place. This way, it is much easier to refer to them over and over again, eventually committing them to memory.

STEP-BY-STEP PRACTICE SESSION

This typical practice session shows how and why you should take out your camera in the middle of the week and spend 30 minutes improving your professional skills.

SITUATION

After photographing the groom for a beautiful wedding in San Diego, I proceeded to the bride's room to begin her getting-ready coverage. The hotel had Swiss coffee–colored walls, which are off-white and reflect much of the sunlight. After the bride put on her wedding dress, it was time for some portraits of her. I usually do a variety of poses for the bride portraits: some wide-angle shots to show off her dress, some close up, sitting, looking at the camera, and a few not looking at the camera, and finally a creative portrait to finish the mini-session.

These bride portrait sessions are usually done under time constraints from the coordinator, who is urging clients to leave for the church and stay on schedule. Time is usually never on my side, but the client's expectations for the photographer are high, regardless of the circumstances.

BREAKDOWN EXERCISE LOG

For years I have kept an exercise log in which I write down situations, environments, and items I find in the types of places I frequent the most during a job. This list is always changing, and every item on the list has been thoroughly practiced one way or another. Here is my log from 2005 (**19.2**), which was my first year as a wedding photographer, and a typical practice list (**19.3**). These lists slowly develop from carefully observing the different items commonly found in wedding locations—items that if used creatively, can help create photographs that will astound your clients!

19.2 My practice log from my first year as a wedding photographer.

19.3 A typical practice list from my log, which has dozens and dozens of such lists detailing things I might encounter when shooting a wedding.

INTEGRATING THE LOCATION CHART AND PREVIOUS PRACTICE SESSIONS

While the bride was getting her make-up finalized, I used that time to take a few quick detail shots. I'm not a fan of taking a photo of the dress hanging on a door or by a window, but I always take one or two, just in case the bride asks for it (**19.4**). Although the shot is not exciting by any means, it did trigger an idea I practiced in an earlier session of using an embroidered veil (**19.5**). I have done several practice sessions through the years using veils because they are made out of a translucent material, which has a place in my Location chart (see page xvi). Here are the photos from those sessions, which sparked my idea for a more creative portrait.

19.4 I'm not a fan of shots of the dress hanging by the window, but I always take one or two.

19.5 Shooting 19.4 triggered a memory of an earlier practice session where I had used an embroidered veil.

PRACTICE SESSION PHOTOS AND ANALYSIS OF RESULTS

A year or so before that wedding in San Diego, I bought a piece of veil fabric for $20. I put it in front of my new 100mm macro lens to get a soft-focus feel for a portrait, as described in Chapter 15, "Walls, Translucent Surfaces, and Textures." The objective of the practice session was to find answers to these questions:

1. What is the ideal distance between the veil and the subject to achieve the highest impact photograph?

2. How different does it look to have the subject close to the veil as opposed to farther away from the veil?

3. How does having a veil in front of my camera affect my camera's focusing capabilities? Do I have to manually focus?

4. If I use an off-camera flash in addition to window light, does it flatten the photo? Does it illuminate too much of the veil?

5. What is the main difference regarding the appearance and feel of the photo with and without using an off-camera flash?

6. What is the best aperture to use for a photo with a translucent material?

Once I had my questions ready, I pulled out my piece of fabric (translucent material) and my teddy bear (main subject).

I used thumbtacks to secure the fabric on the ceiling, and I placed the teddy bear on top of a light stand (**19.6**). The experiment began with the teddy bear about 18 inches from the fabric.

Setting my 85mm lens f/1.2 at f/1.2 and focusing on the veil did not work, because you can't see the main subject, the teddy bear (**19.7**).

To remedy the situation, I tried focusing on the teddy bear. The camera's autofocus began to fail, so I flipped the lens to manual focus. That kept the camera from focusing on the veil. But I kept the aperture at f/1.2, so the veil just looks strange, almost as if my lens was extremely dirty (**19.8**). The photo looks like I'm trying to be creative and it's just not there.

19.6 In the practice session using an embroidered veil, I hung the fabric from the ceiling and positioned my subject (the teddy bear) about 18 inches away.

19.7 Focusing on the veil did not work because you can't see the subject.

19.8 Next I focused on the teddy bear but left the lens at f/1.2. As a result, the veil just looks dirty.

Realizing that 18 inches between my main subject and the fabric was too much, I changed the gap to about six inches (**19.9**). I then added the off-camera flash to see how that would look. As expected, it was hard to control the blast of flash to only light the main subject and not so much of the veil (**19.10**).

I could narrow the beam of light using black flags and other modifiers, but that would take too long. The flash created out-of-place highlights and shadows on the teddy bear, and it overpowered that nice soft window light. So flash was not working either. However, I did like the results of increasing the aperture from f/1.2 to f/5, which better balanced the fabric and subject's face.

I brought the teddy bear within just two inches from the fabric. I wanted the fabric and the teddy bear's face to be almost in equal focus (**19.11**). I kept the aperture at f/5.

19.9 Realizing that 18 inches between my main subject and the fabric was too much, I changed the gap to about six inches.

19.10 Adding an off-camera flash, it was hard to control the blast of flash to only light the main subject. But I liked how shifting to f/5 better balanced the fabric and bear's face.

19.11 Keeping the aperture at f/5, I moved the teddy bear to within two inches of the fabric, so that it and fabric were almost in equal focus.

For the final shot, I eliminated what I didn't like and kept what I did like. The teddy bear was now two inches from the fabric. I manually focused with the aperture at f/5; the lens was switched from the 85mm f/1.2 to a 100mm macro lens. I removed the flash and just used the window as the only light source. I thought the results looked pretty good (**19.12**).

My friend and neighbor finds these practice sessions quite amusing. She took this photo of me practicing, so I could see how silly I looked (**19.13**). Personally, I think it looks awesome!

19.12 By removing the flash and just using the window as the only light source, I thought the results looked pretty good.

19.13 My neighbor finds my practice sessions amusing and took this photo so I could see how silly I look.

REAL-LIFE APPLICATION OF NEW SKILL SET

The "embroidered veils" practice session was just one of several pulled from my practice log. Let's see how it was applied in our next example for the bride's portrait session. When I took the photo of the dress hanging by the window, I noticed the bottom of the dress was decorated with lace (**19.14**). It didn't take much for me to associate that lace with the "embroidered veil" exercise that I did using the teddy bear and the piece of fabric, which looks similar to the bottom of the bride's dress.

Looking at the lace, I found myself thinking of where I could position the bride's eyes. As you recall from Chapter 11, "Framing," you can understand how I thought the lacing would make a great frame for the bride's eyes. There were two potential spots where the eyes could be positioned and still be framed by the lace (**19.15**).

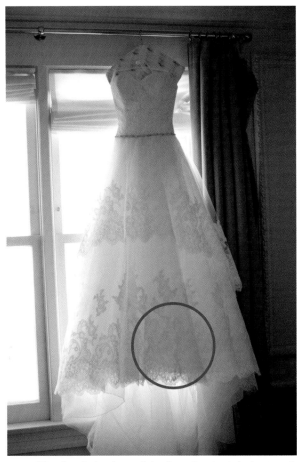

19.14 When I took the photo of the dress, I noticed the bottom of the fabric was decorated with lace.

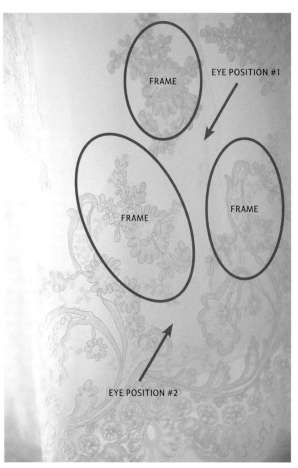

19.15 You can see how I thought the dress lacing would make a great frame for the bride's eyes.

I had to make sure I knew exactly what I wanted and what my setting needed to be because this is the bottom of her dress, not a veil as practiced. My assistant had to hold the dress over the bride's head without touching her hair. Once she was under the dress, I only had seconds to take the photo and pull her out. It was a good thing I practiced this beforehand! Here is the final photograph that resulted from a combination of some location chart elements: Framing and Translucent Materials, plus the previous embroidered veil practice session (**19.16**).

19.16 While my assistant held the dress over the bride's head, I only had seconds to take the photo. It's a good thing I practiced this beforehand!

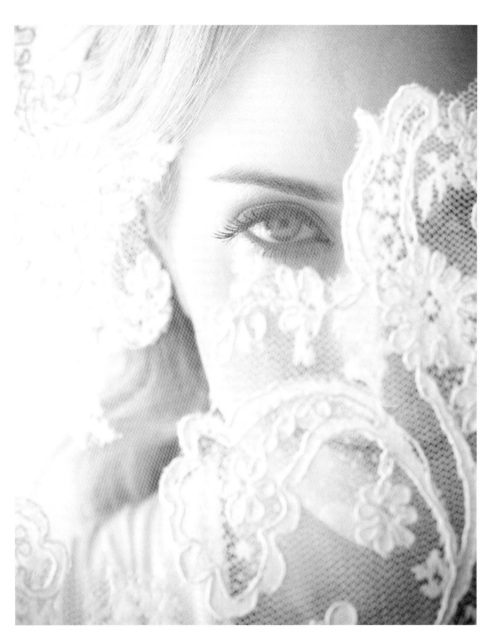

FINAL PRACTICE EXAMPLES

I would like to end this chapter with a few more practice session examples that will whet your appetite for practicing your craft. Each of these examples ends with a photograph taken at an actual wedding, using the skills I learned beforehand from the practice sessions.

WEEDS OR PLANTS

From photographing wedding clients in parks and random landscapes, I realized that I needed to learn how to use weeds to take visually interesting photographs. So weeds made it into my practice log (**19.17**).

Here's an actual place where a bride and groom asked me to take photos (**19.18**). My practice sessions with weeds and plants had taught me that a wide-angle lens, with a shallow aperture such as f/1.2, was the way to go. Choosing a shooting angle below the plant would exaggerate the plant's size and make it more interesting as a foreground element. In other words, the weeds were used to create a layering effect.

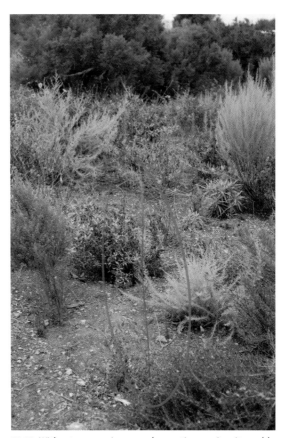

19.17 After regularly encountering weeds while shooting clients outdoors, I added them to my practice log list.

19.18 Without my previous weeds practice session, it would have been difficult to create a visually interesting photograph at this spot requested by the bride and groom.

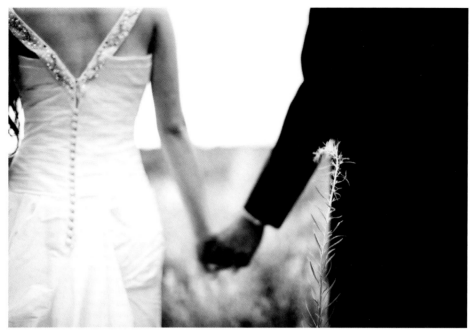

19.19 In the final photograph, the weeds create a layering effect with the couple and background.

In the final photograph, the weed becomes the foreground, the couple occupies the middle ground, and the surrounding landscape becomes the background (**19.19**).

NARROW HALLWAYS

Most of my clients get ready inside hotel rooms, and long, narrow hallways are a constant element in all hotels. I wrote down "narrow hallways" as part of my hotel practice log, because I felt that if I practiced photographing hallways, I would find a creative way to use them to create high-impact photographs (**19.20**).

I found this hallway near my house, so I used it as my practice environment (**19.21**). Models can be expensive to hire for a simple practice session, so I improvised with my broom and dustpan. I placed the broom near the middle of the hallway as a starting point (**19.22**). As you can see, this is not exactly inspiring stuff. I had to find a way to take an interesting photograph using just this hallway and my broom. Not easy!

19.20 Since narrow hallways are a constant element at weddings, I added them to my hotel practice log.

As an experiment—and hoping that something good would come from it—I moved the broom and dustpan back toward the brightest part of the hall (**19.23**). Again, nothing there; in fact, the photograph looks worse because it's now harder to see the main subjects.

After moving the broom and dustpan back to their original position, I thought maybe the photo could be made more interesting by using creative camera settings instead of fixating on where the broom was positioned. I put the camera on a slow shutter speed and zoomed my lens in and out while the exposure was being taken. That created this explosive effect (**19.24**). It was far more interesting than the other two photos. So one secret to long narrow hallways lies with creative camera settings. Of course, there are many other creative ways to make an interesting photograph in a boring hallway.

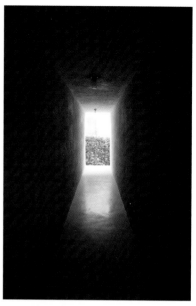

19.21 This hallway near my house provided a perfect practice environment.

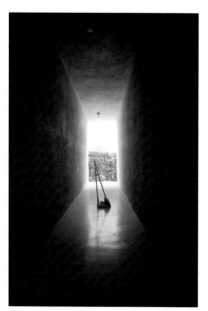

19.22 Models can be expensive, so I used a broom and dustpan as stand-ins.

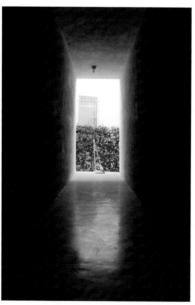

19.23 Moving the broom and dustpan back toward the brightest part of the hall didn't help.

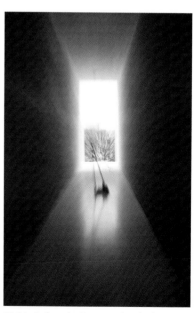

19.24 A slow shutter speed and a lens zooming in and out during the exposure created an explosive effect.

The bride wished to get ready at her grand-mother's house for traditional reasons, but she was concerned the house and neighborhood weren't exactly glamorous. She actually brought me photos of the house, so I could be mentally prepared to work in a "difficult" environment. At her grandmother's house, we had to go up the stairs to knock on the door. When I got to the top, I turned around and saw this photo (**19.25**). I couldn't have been happier. The stairs were inside a hallway with a light source at the end, just like the one I had practiced. I knew exactly what to do (**19.26**)!

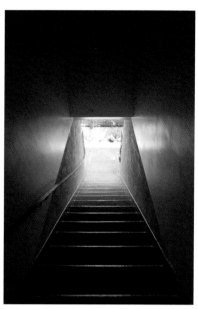

19.25 At the top of the stairs, I turned around and saw this photo. I couldn't have been happier.

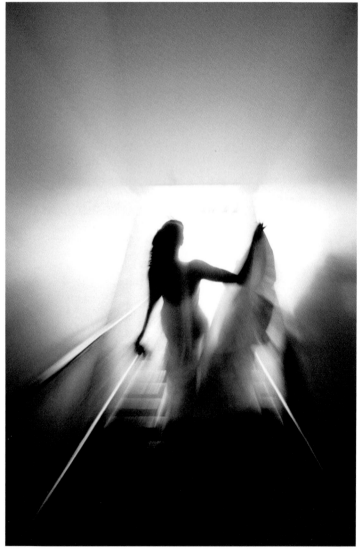

19.26 The backlit stairs were just like the hallway where I practiced with my broom, so I knew exactly what to do.

FOREGROUND/BACKGROUND AND SILHOUETTES

From the Location chart, I used Depth, Contrasts, and Silhouettes.

Many years ago, I came across a National Geographic book in which the photographer used the photographic frame more creatively than anyone I had seen before. He used the frame to tell stories in all three axes: *X* (left to right), *Y* (up and down), and *Z* (front to back). This photo represents one of my latest practice sessions to explore all three axes in the frame to tell visual stories (**19.27**). I used the teddy bear as my main subject and some bananas as the other subject. Remember, you don't need models for practice sessions. Anything around your house can be used to represent a subject, so make it easy on yourself.

Banana skins behave similarly to a person's skin when illuminated. Therefore, I placed the bananas near the window to benefit from the beautiful, soft window light (**19.28**). I placed the bear much closer to me to create depth and explore storytelling through the Z axis. First, I focused and exposed for the bananas, shooting over the teddy bear's shoulders. I liked the contrast between the bright bananas and the teddy bear in silhouette. I balanced the frame by placing the bananas on the left and the bear on the right side of the frame.

I then switched the focal point from the bananas to the teddy bear, but I found the out-of focus bananas distracting (**19.29**). Not always, but usually the brightest point on a photo should be the focus point. Another detail I did not like is how you can't see the bear's face, since he is looking at the bananas—but the bananas can't be seen either because they are also out of focus. Additionally, both main subjects are not visible, so this was not going to work.

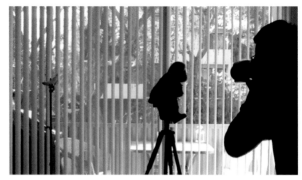

19.27 You don't need models for practice sessions, so I used the teddy bear as my main subject and some bananas as the other subject.

19.28 Banana skins behave very similarly to a person's skin when illuminated. I placed the bear much closer to me to explore story-telling through the Z axis.

19.29 I switched the focal point from the bananas to the teddy bear, but found the out-of-focus bananas distracting.

I brought the focus point back to the bananas, but this time I turned the teddy bear away from them (**19.30**). I thought this type of pose had potential, although I still liked 19.28 more. At first glance, 19.30 appears as if the bear has no interest in the bananas. If there was no connection between the two subjects, then this pose might work. But if the subjects are a couple, it's probably best if there is at least a visual connection between them (**19.31**).

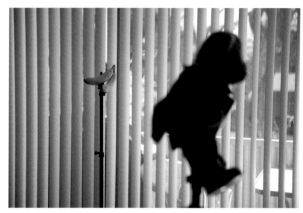

19.30 I brought the focus point back to the bananas, but turned the teddy bear away from them.

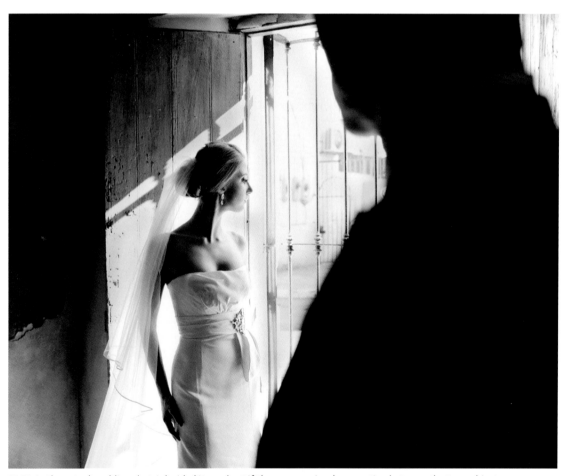

19.31 In the actual wedding shot, I decided it was best if there was a visual connection between the two subjects.

RUFFLED DRESS

From the Location chart, I used Textures.

As I continued photographing weddings, I noticed that more and more of my clients were buying ruffled wedding dresses with incredible textures. I figured it was this ruffled texture that inspired them to buy the dress. I thought that it would be a shame to photograph a ruffled dress in the same way as a silky dress; it simply would not do the ruffled design element any justice. Therefore "ruffled wedding dresses" made the practice log (**19.32**).

Usually, most wedding dresses hang on a window curtain rod, so they're often backlit (19.4). Through practice or experience, you'll find that when shooting into a window directly behind an object or person, some of the light rays hit your lens and soften all your textures (**19.33**). That might be fine if, for instance, you want to reduce a person's wrinkles. But in this case, we want the texture of the dress to stand out, not to be softened. In my efforts to find a way to increase the dress's contrast, I tried placing the dress below, to the side, and above the light source (**19.34**). With the light not directly in front of my lens, the sharpness and contrast increased greatly.

19.32 As I noticed more of my clients buying ruffled wedding dresses, I added that item to my practice log list.

19.33 When shooting into a window directly behind an object or person, some of the light rays hit your lens and soften all your textures.

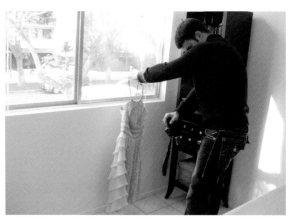

19.34 To find a way to increase the dress's contrast, I tried placing the dress below, to the side, and above the light source.

I discovered that placing the dress "below" the light source best shows off its ruffles (**19.35**). This final wedding image shows the result from having the ruffled dress below the light source (**19.36**). Notice how much the ruffles stand out, and how the beautiful contrast between the light and shadow areas gradually wraps around the dress.

After reading this chapter, you can see how becoming a great photographer has little to do with innate talent and much to do with a solid foundation of hard work. By following the Perform, Discover, Break Down, and Analyze steps for every problem area you encounter, you will essentially master any technique with which you have problems.

My practice log shows how I broke down common elements in my work environment. I practiced each one of these elements multiple times and in different ways so that one day, I could:

- Have complete control in producing highly artistic photographs using those elements.
- Say goodbye to all those technical difficulties that did not give me the results I envisioned.
- Gain the confidence to pose anybody flawlessly with clear and specific directions.

This chapter only shows a few examples from the practice log chart and the resulting images from practicing them. Imagine the possibilities of what you could do!

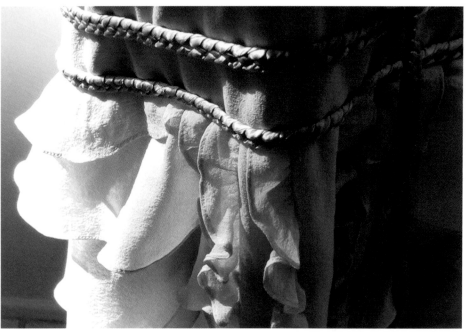

19.35 Placing the dress "below" the light source best shows off its ruffles.

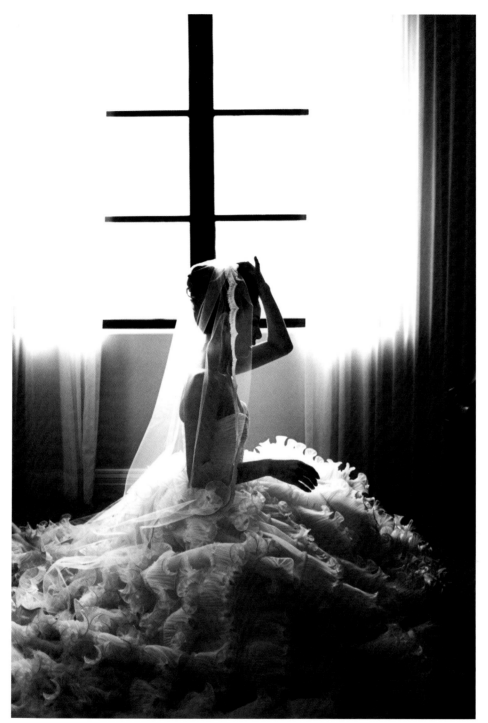

19.36 Notice how much the ruffles stand out and how the beautiful contrast between the light and shadow areas gradually wrap around the dress.

V

veil exercise, 271–274
vertical lines, 24–25
 balance created with, 13
 camera tilt and, 24
 exercise on working with, 26
 symmetry related to, 27, 28–29
vertical lines of symmetry (VLS), 27
 combining with people, 29
 exercise on seeing, 28
video lights
 shadows created with, 63–65
 silhouettes using, 68, 69, 75
vision
 narrowing, 250–251
 tunnel, 94

W

walking photos, 197–201
walls, 147–161
 exercises about, 150, 153, 157
 external flash used on, 153–154
 natural elements creating, 158
 proximity to sunlight, 149–150
 shaded, 148–154
 sunlight reflected to, 151
 superimposing designs on, 159–160
 textures on, 160–161
 using as reflectors, 154–157
 window light reflected to, 152, 153
water reflections, 86–87
wedding dresses, 283–285
weeds in photos, 277–278
weight distribution, 172–174
wide-angle lenses, 128, 198, 257
window light
 improving the direction of, 248
 reflecting in front of walls, 152, 153
wireless flash, 45, 47

X

X, Y, and Z axes, 281
"X" factor, 180–181, 236, 237

Z

zooming for balance, 18–19